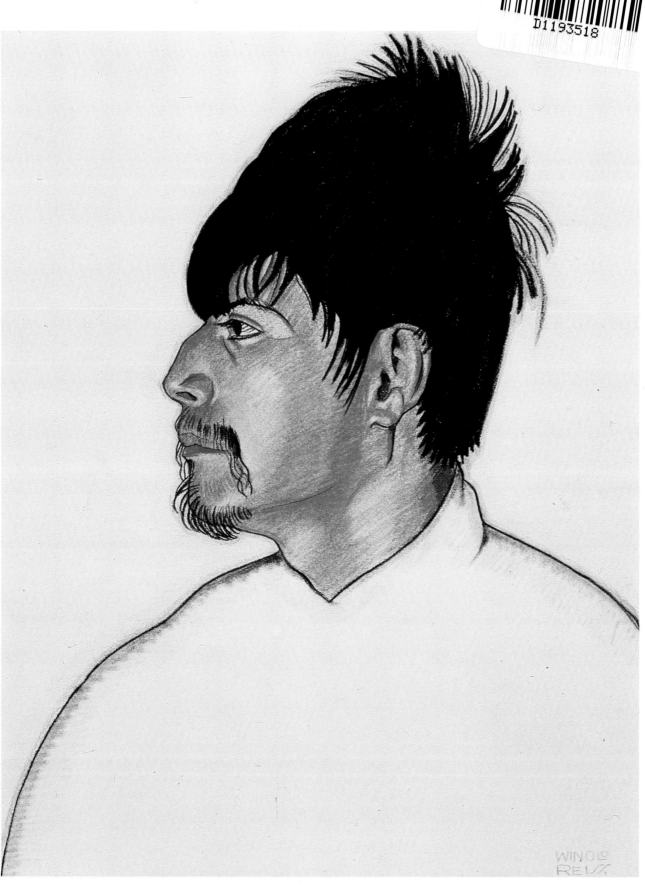

AZTEC INDIAN FROM TEPOZOTLAN, MEXICO Mixed media on paper, 1920 Private collection

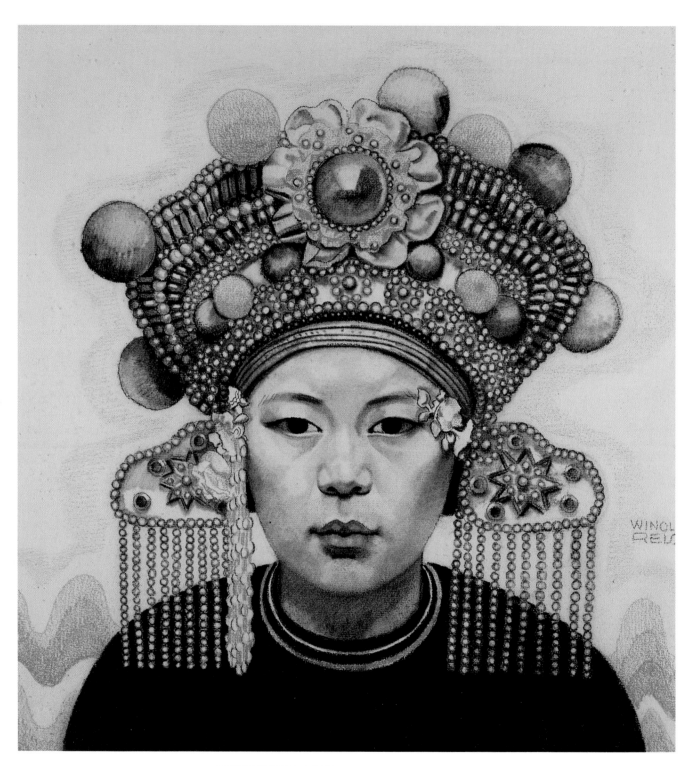

CHINESE WOMAN IN HEADDRESS Pastel on board, 1926 W. Tjark Reiss

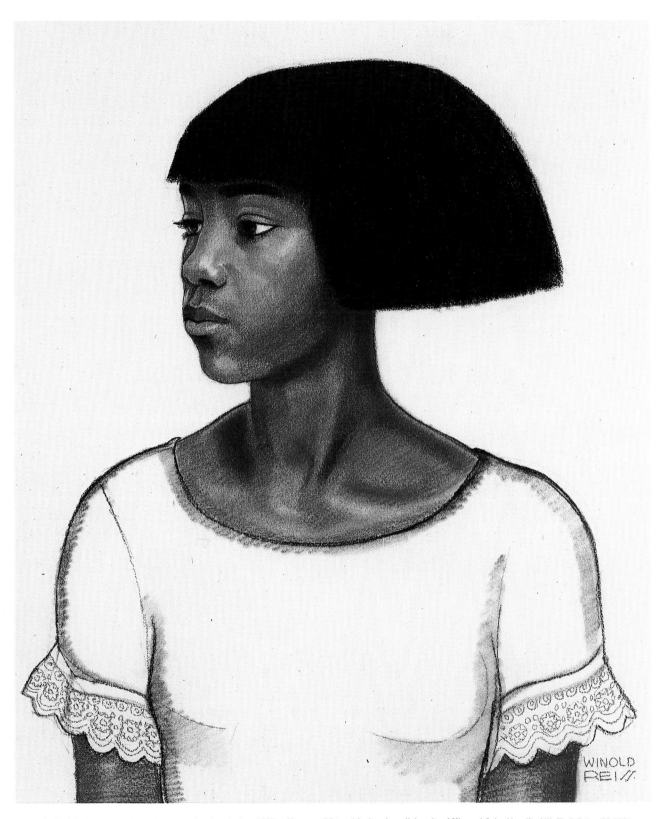

HARLEM GIRL I Pencil, charcoal, and pastel on board, circa 1925 Museum of Art and Archaeology, University of Missouri-Columbia; gift of W. Tjark Reiss (78.183)

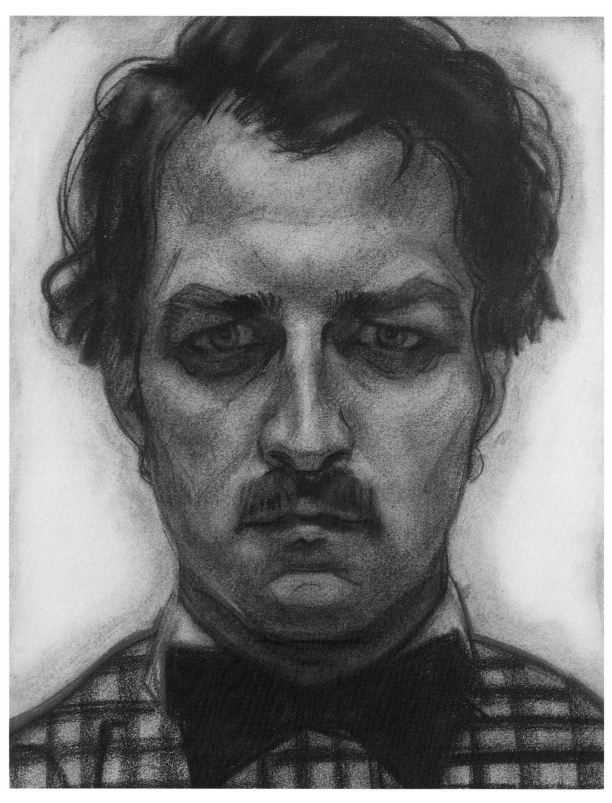

SELF-PORTRAIT IN CHECKERED SHIRT Pastel and conté crayon on paper, circa 1920 Mr. and Mrs. Oscar S. Pollock

TO COLOR AMERICA

PORTRAITS BY

WINOLD REISS

by
Jeffrey C. Stewart

with an essay by
John C. Ewers

Published by the Smithsonian Institution Press
for the National Portrait Gallery
Washington City
1989

An exhibition at the National Portrait Gallery
October 27, 1989, to April 1, 1990

This catalogue and the exhibition
have been made possible
in part by
The Anschutz Foundation,
The Burlington Northern Foundation,
and the
Smithsonian Institution Special Exhibition Fund.

Cover illustration:
Harlem Girl with Blanket (detail)
Pastel and conté crayon on board, circa 1925
Mr. and Mrs. W. Tjark Reiss

C O N T E N T S

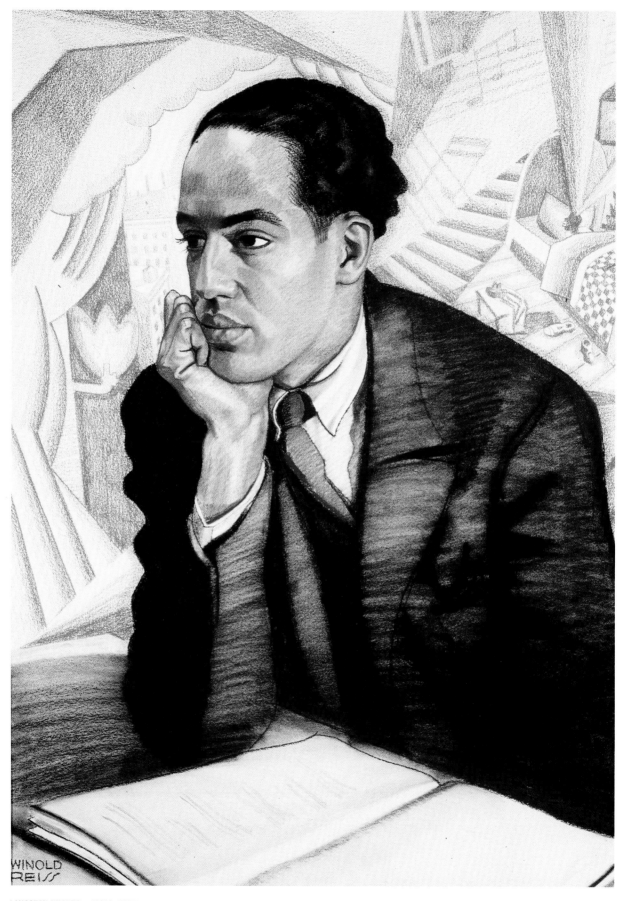

LANGSTON HUGHES (1902–1967) Pastel on board, 1925 National Portrait Gallery, Smithsonian Institution; gift of Tjark Reiss in memory of his father, Winold Reiss

FOREWORD

For many visitors to the National Portrait Gallery, the most lasting impression they carry away of the writers, artists, and educators of the period of the Harlem Renaissance has been transmitted to them by a group of sensitive pastel drawings—directly seen, powerful portraits of such notables as Langston Hughes, W. E. B. Du Bois, and Alain Locke in a style strikingly different from most of the other portraits in our collection. This style will be familiar to those who are acquainted with twentieth-century Native Americans primarily through the portraits reproduced in the advertisements and paintings commissioned by the Great Northern Railway before the Second World War, and reproduced on calendars or displayed in western hotels. The portraits in both groups bear the signature of Winold Reiss, and for most of us this has been all that we knew of their creator.

Historian Jeffrey Stewart has undertaken a task that should have been attended to long since; he has prepared the first extended biography of Mr. Reiss, he has explored the development of Reiss's style and skill as an artist, and he has restored to the portraits something of the context in which they originally existed. As it turns out, many of us were more familiar with the artist than we had imagined. Reiss brought the advanced artistic thinking of his native Germany with him when he immigrated to America early in this century, and exercised his talents on a number of notable projects. Anyone who has passed through Cincinnati's Union Station, for example, or eaten in the Longchamps restaurants in New York City will have seen his work as muralist and architectural interior designer. He was a significant designer

of publications and advertising, and he was a teacher of many artists who went on to important careers of their own.

But Reiss's unique achievement remains his record of his contemporaries from diverse ethnic backgrounds. He devoted much of his energy to portraits of American Indians, African Americans, Asian Americans, and Mexicans, depicting both prominent people and ordinary men and women of these various racial groups. Whether his viewpoint as an observer from another land freed him from the burden of stereotypes too often carried by American-born artists, or whether he was endowed with a special sensitivity to the dignity of individual human beings, he managed to transcend what might have seemed to others the "exotic" aspects presented by these various ethnic groups and—in his best work—to present us with portraits of men and women seen as fascinating individuals, full of personality.

All of Jeffrey Stewart's talents as a historian could not have brought this study off successfully without the support and cooperation of many people and organizations. While they are acknowledged elsewhere, I want to express the Gallery's particular gratitude to the artist's son, Tjark Reiss, who has been unstintingly generous in sharing family papers, art work, and personal reminiscences with Dr. Stewart and with the rest of us involved in this book and in the exhibition that accompanies it. Our Smithsonian colleague, Dr. John Ewers, has been very helpful in sharing both his personal knowledge of the artist and his extensive experience with the Blackfeet people. And I gratefully acknowledge the substantial grants

received by the Gallery from The Burlington Northern Foundation, The Anschutz Foundation, and the Smithsonian Special Exhibition Fund, without which our book and exhibition would never have come into being.

As we confront this fascinating body of portraiture, we are brought face to face with a number of burning issues that are as relevant today as they were fifty years ago, when many of these portraits were made. Can the arts transcend the boundaries of race? Can people of one group really understand the people of another? Questions of trust, regard, and responsibility were debated then and are still debated today. I hope that the presentation of the life and the work of a remarkable artist, who devoted much of his career to the celebration of ethnic individuality, will add a new dimension to our understanding of how we can comprehend and respect one another, transcending our personal origins. Whether or not this higher goal ever can be reached, at least in the portraits left to us by Winold Reiss we are privileged to get to know a remarkable and diverse group of sitters, including some of the intellectual leaders of our age.

ALAN FERN
Director
National Portrait Gallery

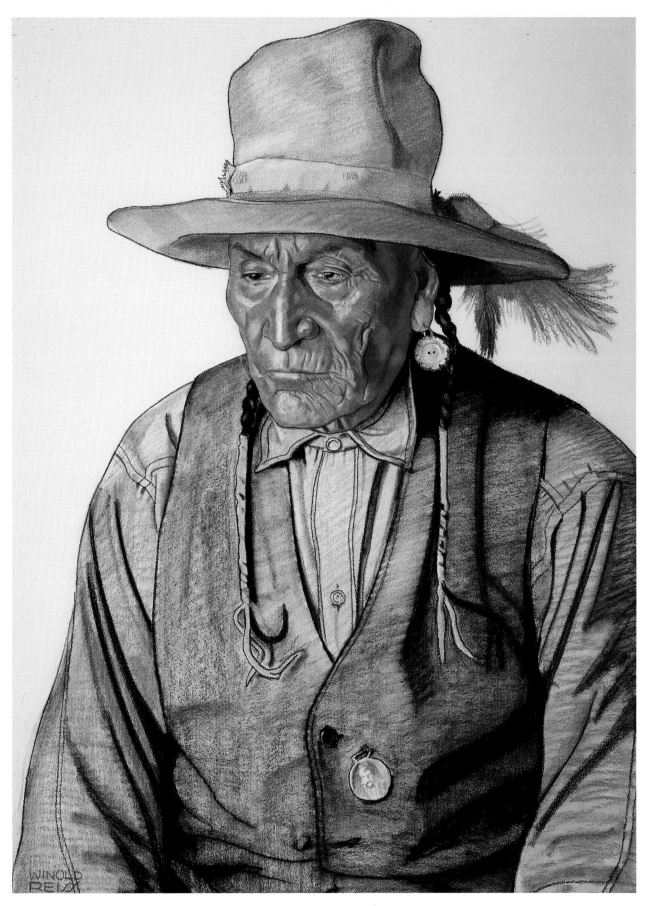

LAZY BOY Pastel on board, 1927 Private collection

ACKNOWLEDGMENTS

Over the last three years of research for this catalogue and exhibition, I have incurred debts too numerous to acknowledge within the space available here. I do wish to thank all the owners of Reiss's portraits, the staffs of museums, libraries, and historical societies, and the scholars and Reiss enthusiasts who have generously answered letters, provided information, and cheerfully returned telephone calls in the midst of their own pressing projects.

Special thanks must go, however, to Tjark Reiss, Winold Reiss's son, and to his wife, Renate. They allowed me access to the extensive Winold Reiss correspondence, hunted down references to portraits, and opened their home to me when I most needed to consult their files. Moreover, their good humor and encouragement made it a joy to work with them. I dedicate this catalogue to them. I am also indebted to John Ewers and Joallyn Archambault of the National Museum of Natural History for answering questions, providing leads, and reading drafts of the catalogue. I particularly want to thank Rex Rieke, who took me around in Montana and introduced me to three of Winold Reiss's Blackfeet sitters— William S. (Billy) Big Spring, Calvin Last Star, and Floyd Middle Rider. That trip was a turning point in my understanding of Reiss's relationship to the Blackfeet and to the Great Northern Railroad, and I am indebted to these Blackfeet men (and to Babe Much, with whom Dolores Fisher-Pepion, of the Museum of the Plains Indian, put me in contact) for broadening my understanding. Ms. Fisher-Pepion was also very helpful in providing information on Reiss's other sitters, as was Vanessa Thaxton of the Penn Center. I also want to thank Gordon Belcourt, president of the Blackfeet Community College, for helping to identify sitters for Reiss's portraits.

In my research, I am thankful to Fred Brauen and Paul Raczka for their excellent work on Reiss, and to Marion Deshmukh of the George Mason University history department for reading drafts of the catalogue and giving me the benefit of her extensive knowledge of German cultural history. I am deeply indebted to my fine research assistants—Kathi Ann Brown, whose library research, organization of the office, and setup of the database were crucial to the early progress of the project; Laurie Jackson, who gave interim support; and Carla Hurt, whose hard work and computer-friendly attitude were crucial to the catalogue and exhibition. I am very grateful to Rayna Green, Christaud Geary, James Glenn, Ivan Karp, Robert Kashey, Richard Powell, Fath Davis Ruffins, and John Tchen for conversations on Reiss, art history, and the politics of minority group representation. I am especially indebted to Marta Reid, who, in addition to being supportive, took time to look at photographs, to share her impressions, and to give me the benefit of her knowledge of art history.

I also want to thank Ms. Brown and Ms. Hurt for their fine work on the illustrated checklist of Winold Reiss's portraits, which will be published in January of 1990.

At the National Portrait Gallery, I must thank Marc Pachter, who was enthusiastic about the project when it was just an idea, and Alan Fern, who not only encouraged me, but also took time from his busy schedule to read drafts and to make needed criticisms and suggestions. I received valued suggestions from Carolyn Carr and superb editorial guidance from Frances Stevenson and Dru Dowdy, as well as outside

editor Sheila Schwartz. I am thankful to Rolland White for his wonderful photographs and reproductions, and to Harry Jackson and Phyllis Cunningham for their support and encouragement. But I must single out for special commendation Beverly Cox, who, along with her assistant Claire Kelly, accepted the challenge of this exhibition and catalogue. Beverly housed the research project in her offices when other space was not available, traveled to sites to review works of art, wrote grant proposals, gave judicious advice, and steered the project through many administrative difficulties. She deserves my special thanks.

I am grateful to The Anschutz Foundation and The Burlington Northern Railway Foundation for supporting this exhibition and catalogue. But particular acknowledgment must be extended to the Special Exhibition Fund of the Smithsonian Institution, and particularly to Barbara Schneider, who not only provided research support, but also encouragement and understanding.

JEFFREY C. STEWART

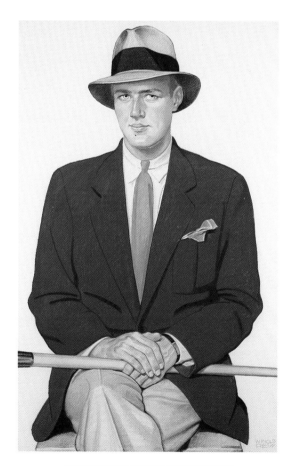

PORTRAIT OF THE ARTIST'S SON IN NEW YORK
(W. TJARK REISS) **(born 1913)** **Pastel on board, 1938** **Renate Reiss**

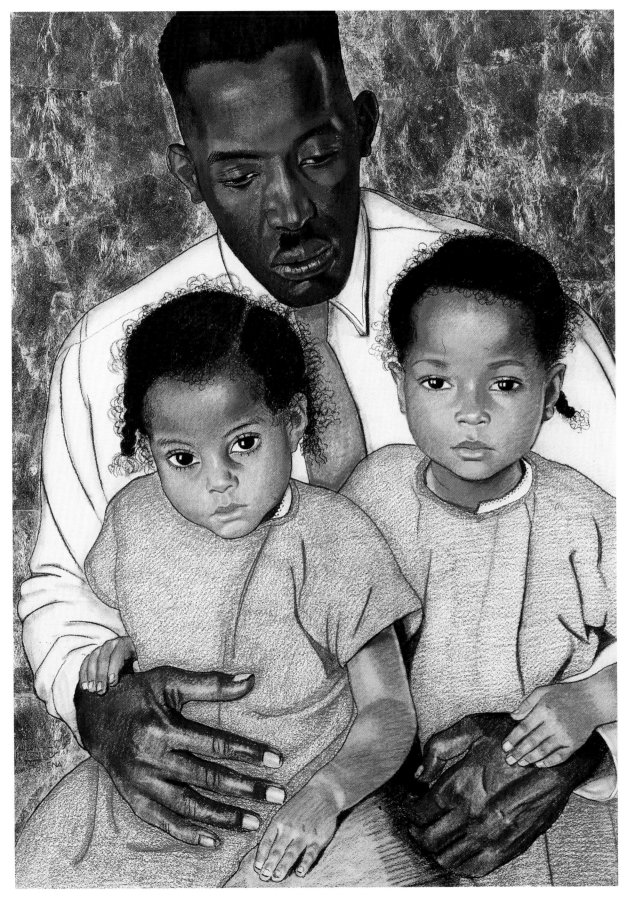

FATHER (FRED FRIPP) WITH TWO CHILDREN Pastel on board, 1927 Fisk University Museum of Art

LENDERS TO THE EXHIBITION

The Anschutz Collection

Artery/U.S. Art, Inc., New York, New York

J. N. Bartfield Galleries, New York, New York

Paul and Pamela Belli

Mr. and Mrs. Neville Blakemore, Jr.

Bradford Brinton Memorial Museum and Historical Ranch, Big Horn, Wyoming

Burlington Northern Railroad, Fort Worth, Texas

Denver Art Museum, Colorado

Laura Lee Brown Deters

Beth and James DeWoody

Fisk University Museum of Art, Nashville, Tennessee

Hampton University Museum, Hampton, Virginia

Carl and Gayle Heishman

Howard University, Washington, D.C.

Library of Congress, Washington, D.C.

National Museum of Natural History, Smithsonian Institution, Washington, D.C.

National Portrait Gallery, Smithsonian Institution, Washington, D.C.

Mr. and Mrs. Oscar S. Pollock

Private collections

Mr. and Mrs. W. Tjark Reiss

Mr. and Mrs. Rex Rieke

C. M. Russell Museum, Great Falls, Montana

Social Welfare History Archives, University of Minnesota, Minneapolis

State Historical Society of Wisconsin, Madison

University of Missouri, Museum of Art and Archaeology, Columbia

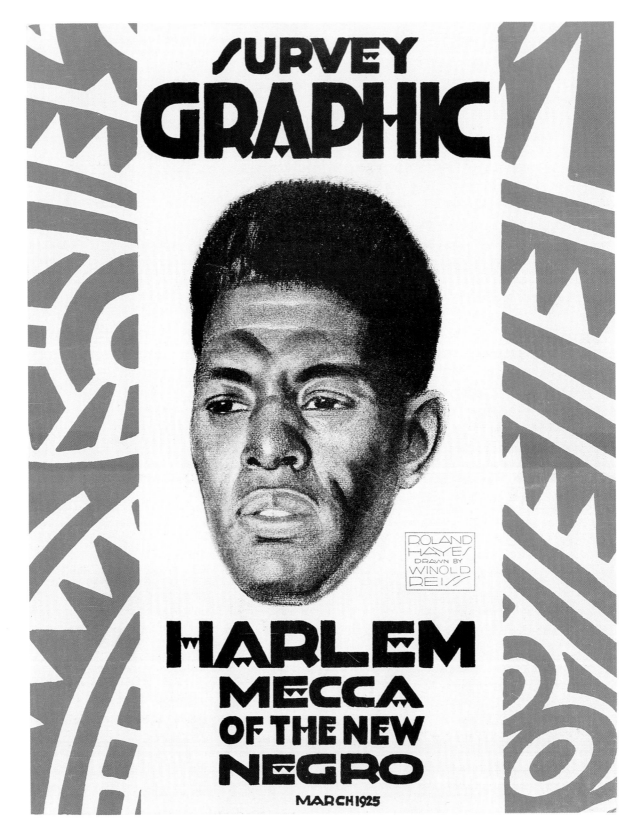

Cover of "Harlem: Mecca of the New Negro," *Survey Graphic*, March 1, 1925. Private collection

INTRODUCTION

On March 1, 1925, *Survey Graphic*, a social welfare journal, published a special issue entitled "Harlem: Mecca of the New Negro." It contained poems, essays, short stories, and social analysis by a younger generation of Black* writers and intellectuals of what would later be known as the Harlem Renaissance of the 1920s. In fact, the issue, which sold more than five thousand copies, helped to launch this Black literary arts movement. "Harlem: Mecca of the New Negro" also included abstracted, stylized designs representing Harlem life; illustrations; and sensitive full-page portraits of Roland Hayes, Paul Robeson, and other African Americans. Remarkably, the artist was a German American named Winold Reiss. That same month, his collection of thirty-seven portraits of Black leaders and Harlem residents was exhibited at the 135th Street branch of the New York Public Library, the first major showing of Black portraits in New York City. Later that year, Reiss's full-color pastel portraits of W. E. B. Du Bois, James Weldon Johnson, and Zora Neale Hurston were chosen by Alain Locke, the African American editor of the *Survey Graphic* issue, for the book-length version entitled *The New Negro: An Interpretation*, which became the most important anthology of the Harlem Renaissance.

By 1925 Reiss already enjoyed a modest reputation in American art circles for his portraits of Indians, Mexicans, and European peasants; like his Harlem portraits, these works exhibited a concern for a detailed and accurate rendering of each subject. The range of Reiss's artistic expression, however, was not limited to precise portraiture. As his illustrations and decorative pages in *Survey Graphic* reveal, he was an accomplished Art Deco designer. Indeed, he was well known in Art Deco circles as one of the first to incorporate this bold new aesthetic into the design of hotel and restaurant interiors. But before 1925 Reiss's name was not yet familiar to the public. His contributions to *Survey Graphic* and concurrent portrait exhibition thrust him into the center of Black America's most vital early twentieth-century movement because his images captured the mood of racial pride that Locke and other Black intellectuals wished to project.

A German immigrant had ironically stumbled onto a Black American community suddenly brimming with racial consciousness and a desire for dignified self-representation. Yet this meeting was more than fortuitous, for Reiss had always been interested in documenting racial types as a means to illuminate the distinctions and integrity of different ethnic groups. His restrained, objective renderings became mirrors that reflected both individuals and the culture they embodied. What Alain Locke said of Reiss's portraits of Black Americans holds as well for all of the artist's work. He called Reiss *a folk-lorist of brush and palette, seeking always the folk character back of the individual, the psychology behind the physiognomy. In design also he looks not merely for the decorative elements, but for the pattern of the culture from which it sprang. Without loss of naturalistic*

*Over the course of two hundred years, African Americans have at various times articulated different names for themselves as an ethnic group, ranging from Negro to Colored to African American. Black is a term of self-designation that arose in the course of African Americans defining themselves in the 1960s. It is capitalized here because it represents a distinctive ethnic group in America. By contrast, white is not capitalized because it does not define an American ethnic group.

accuracy and individuality, he somehow subtly expresses the type, and without being any the less human, captures the racial and the local.[1]

Reiss had a knack for showing up in communities where dramatic social changes were under way. He traveled to Mexico in 1921 and drew the heirs of the Aztecs, as well as the indelible faces of the Mexican revolutionaries. Almost yearly he trekked to Browning, Montana, to record not only the last survivors of the intertribal wars of the nineteenth century, but also the emerging generation of Blackfeet men and women who worked as ranchers and farmers in the reservation days. In his adopted home, New York City, Reiss drew portraits of the young Asian American artists, dancers, and students who were fusing ancient and modern sensibilities into a new Asian American identity. And when he made his last trip to Germany in 1922, he documented his nation's ongoing traditions and postwar changes. Motivated by a sense that ethnic traditions were dying out in the twentieth century, Reiss wanted his art to testify to the persistence of culture under modernization.

What makes Reiss interesting is that he usually chose non-whites as his subjects. He portrayed racial diversity, in part responding to the nineteenth-century belief that the world was divided into distinct races or types, each of which possessed special cultural attributes. Yet Reiss's portraits are more than mere renderings of types. The individualities of his subjects burst through any possible confinement to category. Even more important, Reiss's penetrating delineation of faces uncovers the universal in the particular, the archetypal in the various, and the spiritual in the physical. With each physiognomy, he searched for the ideal man or woman to represent both the race and the individual. Thus his portraits, detailed though they are, go beyond simple realism. They embody his faith in the dignity, honor, beauty, and worthiness of the excluded as part of what Johann Wolfgang von Goethe called the "unity of all creation." Ironically, Reiss believed that by documenting the variety and diversity of humanity he could promote harmony among peoples. His work resonates with the idealistic notion that art can transform the world, by showing the beauty and dignity that exists in all people.

Cover of exhibition announcement featuring Reiss portraits at the 135th Street branch of the New York Public Library, March 15, 1925.
Alain Locke Papers, Moorland-Spingarn Research Center, Howard University

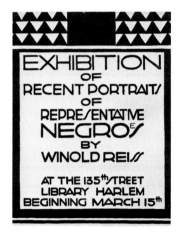

1. [Alain Locke], "Harlem Types: Portraits of Winold Reiss," *Survey Graphic* 53 (March 1, 1925): 653.

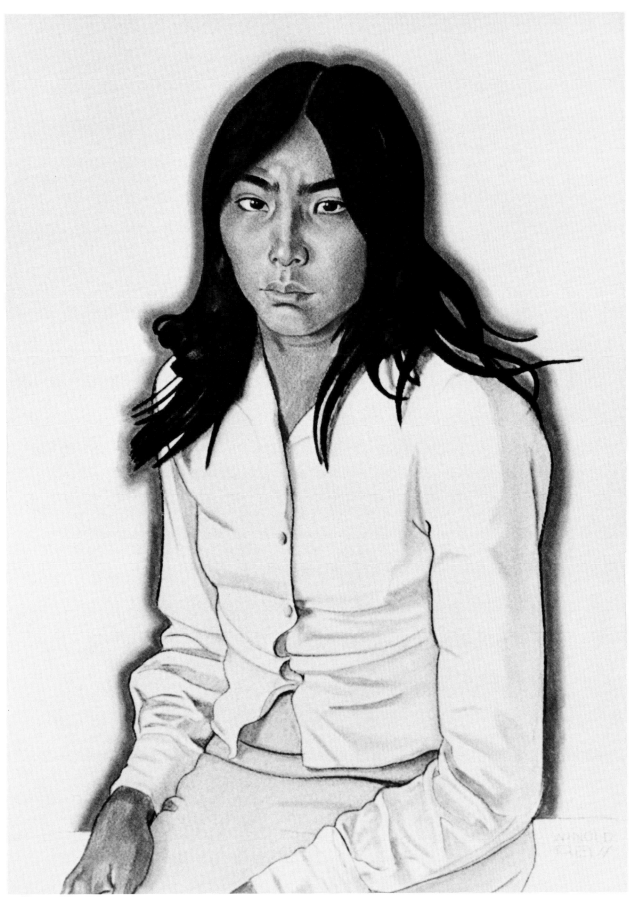

TALE WOMAN Pastel on board, date unknown Mr. and Mrs. Rex Rieke

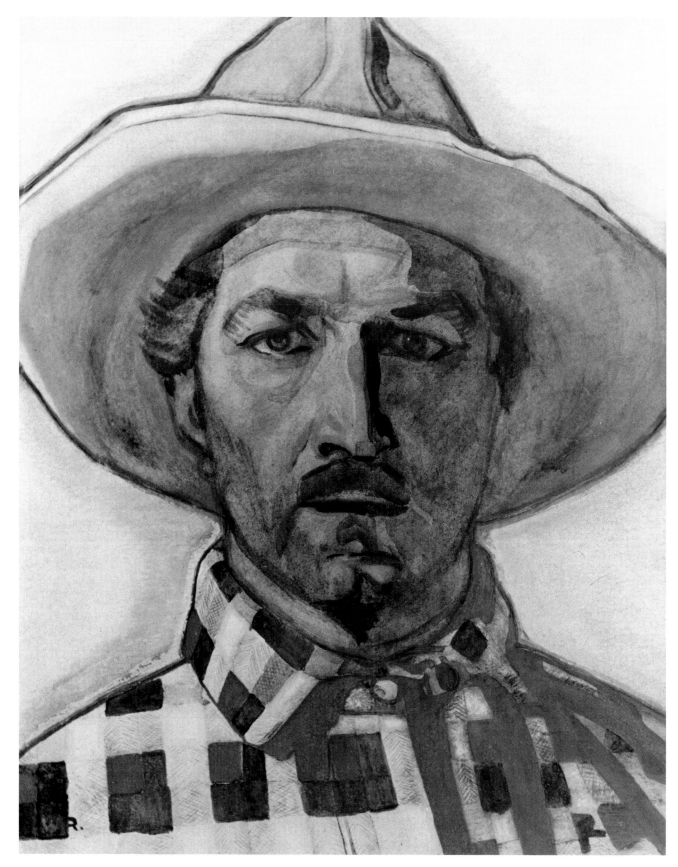

SELF-PORTRAIT Watercolor on paper, 1919 Bradford Brinton Memorial Museum

I n 1913 Winold Reiss left Munich, where he had been studying art for two years, and set out for the United States, wanting nothing more than to see and depict the Indians of the American West. His arrival in October marked the end of a long journey that had taken him not only from Germany to America, but from the romanticized fictions of his boyhood to the reality of American life. Between these two poles we can track the artistic and cultural milestones that brought Reiss to these shores.

Born on September 16, 1886, in Karlsrühe, an eighteenth-century city in southern Germany, Winold Reiss was the son of Fritz Mahler Reiss (1857-1914), a respected artist and his first art teacher. Having studied at the internationally renowned Düsseldorf Academy, Fritz Reiss was a superb landscape painter, particularly in his mastery of watercolor technique, and a skilled portraitist who specialized in sensitive studies of German peasants. This theme reflected the glorification of the peasant in later nineteenth-century Germany as the human link to the country's spiritual past. The young Winold learned from his father that the folk, the peasants, and the masses of old Germany were more deserving of artistic study than the Junkers, the traditional elite, or the new Bismarckians.[1]

Fritz Reiss also maintained that the true artist must travel to find his subjects. In the 1890s, he moved his family of six to Kirchzarten, a small medieval village in southern Germany, where he wanted to paint the picturesque peasants who lived outside the town. Such a commitment echoed his notion that truthfulness to subject was the first requirement of good art. At the Düsseldorf Academy, master teachers had led the students into the forests around Düsseldorf to make direct drawings from nature. Consistent with this emphasis on natural history, German landscape and peasant portraiture was distinguished by its accuracy and detail, and Fritz handed that tradition down to his son.[2]

Winold Reiss developed as much passion for painting Indians as his father had for painting German peasants. He had grown up reading the Wild West novels of the German author Karl May (1842-1912), which told how the German cowboy "Old Shatterhand" had traveled to America, tamed its frontier, and gained the devotion of Winnetou, the Noble Indian who, incredibly, could speak German. Winold also read the novels of James Fenimore Cooper, the American author whose stories of the frontier and "the last Mohican" were so popular that the German translation of his works resulted in "Coopermania" in Germany. This obsession with Indians had begun in the late eighteenth century when Jean-Jacques Rousseau's Noble Savage primitivism spread to Germany. By the late nineteenth century medieval romances of kings and queens and mythological heroes, which had been standard reading fare for young European boys, were replaced with stories of the American frontier. The New World was a more appropriate setting for romantic fantasies, since medieval values of honor, chivalry, and individualism seemed outmoded in a rapidly modernizing Europe. In America a wilderness still existed—or so young German boys like Winold were led to believe by May and Cooper—where men could be heroes, upholding traditional values that no longer suited an industrialized Germany.[3]

GIRL WITH BONNET AND VEIL
Pencil on paper by Fritz Reiss,
date unknown
Peter Reiss

OVERSIZED PORTRAIT OF A MAN
Pencil on paper, circa 1911
Private collection
This portrait is similar to those
Reiss had to submit to the Munich
Academy to gain admission.

It was Germany, however, that shaped Reiss's art as much as the romantic perception of the American West. When he went to Munich in 1911 to enroll in that city's famous Academy of Fine Arts, he encountered artistic and intellectual trends that tempered his boyhood experiences. Leaving his father and the tradition of peasant portraiture, Reiss entered the Academy of Fine Arts and came under the influence of modern decorative arts movements such as Jugendstil and such international movements as Fauvism and Cubism. Perhaps at the suggestion of Franz von Stuck, a commercial as well as a fine artist and his teacher at the Munich Academy, Winold later enrolled at the School of Applied Arts, where he studied commercial design and poster art under Julius Diez. Reiss's studies not only gave him a well-rounded preparation in all of the arts, from drawing to interior design, but also encouraged him to explore abstraction and to develop a distinctive portrait style.

It was Franz von Stuck, the Academy's master teacher, who perhaps had the greatest influence on Reiss. Von Stuck, who was one of the founders of the Munich Secession—a movement by younger artists to exhibit work unacceptable to the mainstream Munich Artists' Society— introduced Reiss to Jugendstil (youth style), the German decorative arts movement that had its roots in France's Art Nouveau of the 1890s and England's Arts and Crafts movement. Both of these styles challenged modern artists to close the long-entrenched division between fine and applied art. Although on the wane in avant-garde circles in Munich by 1911, Jugendstil was very much alive in von Stuck's style and in his classes. Exposure to Jugendstil taught Reiss to ignore the traditional rules of perspective and modeling and to concentrate on the composition of elements on, rather than behind, the picture plane. An excellent example of von Stuck's compositional genius is his most famous portrait, *Sin*, which uses exclusively dark and light tones to create a mood no less than a powerful composition.[4] Reiss's later painting *Salomé*, a favorite theme of Jugendstil artists, reflects the Jugendstil emphasis on flatness of surface and its simplification and stylization of portrait forms. Study under von Stuck enabled Reiss to conceive of a picture as a composition of abstract forms and colors as well as of representational objects. And abstraction had an important if subtle effect on Reiss's portraiture, where such formal principles as exaggeration of size and scale, the interplay of lines, angles, and space, and the patterning of motifs resulted in portraits that did more than merely record the sitter's features.

As Helen Appleton Read noted in 1935, Reiss "was the first painter who saw the Indian abstractly as a subject for art, who recognized the classic monumentality in the manner in which he folded his blanket about him and in the proud carriage of his head."[5] Although Read may have overstated Reiss's primacy in recognizing such signs—George Catlin and Karl Bodmer come to mind—he was unequaled in his ability to convey these attributes in completely realized compositions.[6] In *Clumsy Woman*, the draped and colored blanket makes his subject seem larger than life and conveys a sense of her power. Moreover, Reiss used decorative motifs, another characteristic of Jugendstil, to sharpen the tension in the portrait, employing the leaf and teardrop motifs on the tepee wall and the patterns on the blanket to create a layered sense of decorativeness. One of the principal aesthetic attractions Indians had for Reiss was their design and color sense, which he respected and from which he learned a great deal in his later years. And it was as a student in Munich that he first acquired a sensitivity to these compositional elements.

Like other Munich artists of his day, Reiss found in the work of the Fauves a catalyst for his own expressive use of color. During his years in Munich, there were several exhibitions of Fauvist work as well as of Die Brücke, a group of northern German artists influenced by the Fauves,

and Der Bläue Reiter, the Munich wing of German Expressionism. Among the main tenets of Der Bläue Reiter aesthetic, published in an almanac in 1912 by Franz Marc and Wassily Kandinsky, was that color should be used freely to define form. Like these artists, Reiss was willing to use brilliant, almost shocking colors and to design his compositions around these colors, as his portrait of Dan Bull Plume shows. Working with tempera (von Stuck's favorite medium), Reiss achieves some of the same effects as the Fauves.[7]

Kandinsky and other Munich modernists were also attracted to ethnography, which surely stimulated Reiss's own interest. The 1912 Bläue Reiter almanac contained numerous photographs of the art of the Cameroons, Egypt, and Japan, as well as of Russian and Bavarian folk art, a testament to the desire of Munich artists to plumb the depths of ancient and popular art for inspiration and creativity. Around the middle of the nineteenth century, ethnographic museums had been founded in Berlin, Leipzig, Dresden, and—one of the most important—Munich. But the valuation of African and Asian ethnographic artifacts as art came only in the early twentieth century, with the rise of Cubism and the recognition, whether acknowledged or not, that Asian and African art had something to teach European artists.[8]

Reiss may have encountered Cubism and African art together in 1913, when an exhibition of Picasso's African-inspired Cubist paintings opened in Munich. This would explain both his interest in African art and what one critic has called the "cubists' use of mass and volume" in his portraits.[9] Even if he somehow missed the exhibition, Reiss probably visited Munich's ethnographic museum with other artists, viewed the art and artifacts from Africa and Asia, and developed his passion for ethnography.

What distinguished Reiss's (and Germany's) interest in ethnography from that of the Cubists was its focus on exotic peoples as well as on their art. Unlike Kandinsky and Picasso, for whom non-Western art provided a way out of representationalism, Reiss found in the art and faces of non-Western peoples a modern form of Romanticism's ideal man—the Noble Savage of Asia, Africa, or America. Most nineteenth-century thinkers believed that the world was divided into different races, each of which possessed a distinctive culture. In Germany, however, the fascination with the physical variety of humankind was equally intense. German artists not only studied African art, but also read avidly the works of such ethnologists as Leo Frobenius and the travel accounts of Karl von den Steinen and Eduard Pechuel-Loesche.[10] Some German photographers even went to Africa to document racial variety.[11] More broadly, an interest in "type" portraiture of Europeans as well as non-Europeans flourished in this period: photographers such as August Sander recorded the ideal German "types," who fit occupational as well as regional categories. Sander's aim was to produce a photographic record of twentieth-century mankind.[12]

Reiss's mission to record non-Western racial variety through art was thus not exceptional. On the one hand, it embodied the earlier romantic fascination with Indians; on the other, it was a product of the twentieth century, when ethnographic interest in documenting mankind peaked in Germany. Moreover, Reiss's vision was informed by a respect for the material culture of the people he documented because, like other modernists of prewar Europe, he recognized that non-Western art was a viable source for his own aesthetic expression.

Sometime in 1913, it became clear to Reiss that he must, against his father's wishes, leave Germany. Although he was no doubt anxious to begin his artistic campaign with the Indians, there were other reasons behind his decision to embark at that time. On September 12, 1912, he had married

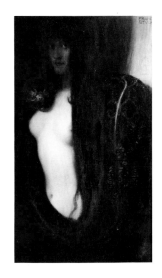

SIN
or DIE SÜNDE
Oil on canvas by Franz von Stuck
(1863-1928), date unknown
Neue Pinakothek Munchen

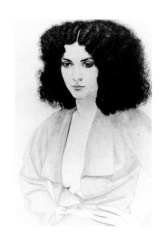

SALOMÉ
or WOMAN IN A RED DRESS
Pastel on board, circa 1926
Unlocated

24

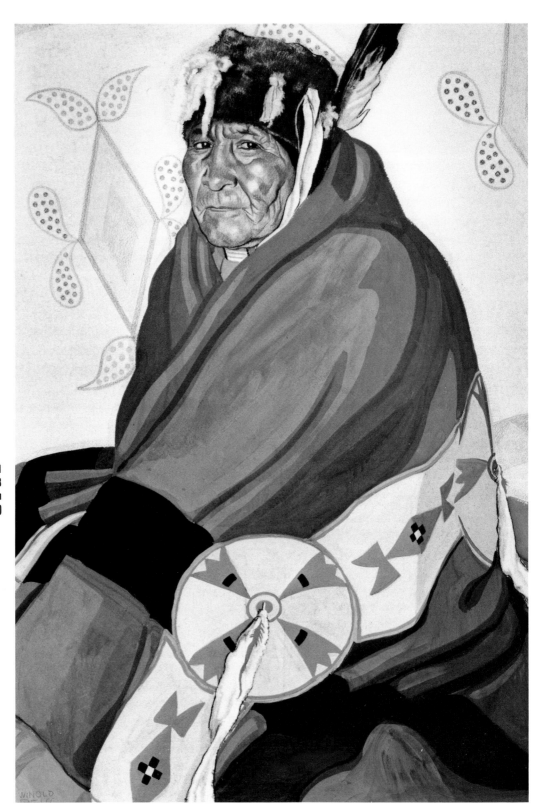

CLUMSY WOMAN
Mixed media, circa 1927–1928
The Anschutz Collection
(color illustration on page 149)

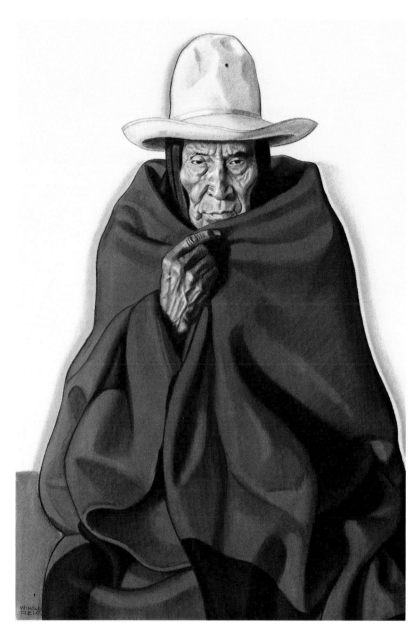

DAN BULL PLUME
(born circa 1876)
Formerly known as Green Grass
Bull
Tempera, pastel, and charcoal on
paper, date unknown
Burlington Northern Railroad

Henrietta Lüthy, a fellow student at the School of Applied Arts, who had been born in England but had studied in Switzerland as well as Germany. In the summer of 1913 she became pregnant, and even though Reiss had a career as a designer in Munich, he believed he could do better in the relatively virgin market of America. His wife, however, recalled that the gathering war clouds in Germany gave him another reason for leaving.[13] By 1913, Kaiser Wilhelm II's *Weltpolitik* had succeeded in making Germany the most feared European power, and this aggressiveness was reflected in an increasingly militant domestic nationalism. Coming from a pacifist family (his brother, Hans, would flee to Sweden in 1914 rather than be drafted into the German army), Reiss did not want to drown in the rising tide of German militarism. Sensitive, idealistic, and socially liberal, he

must have realized that the cosmopolitan, bohemian life of the German artist was disappearing.

Reiss left for America in October, the trip paid for by his wife's dowry, which also sustained him until he could find work. His wife and infant son arrived the following year.[14] By then, war had broken out in Reiss's homeland, and he painted *Decapitated Figures*, one of the first in a series of German Expressionist-style paintings. Created by a man whose portraits show how much he loved the undistorted human head and form, it is a particularly powerful indictment of war. Like other German Expressionist artists who left their native land, Reiss remained profoundly disturbed by the horror visited on his country during World War I.

The Reisses looked upon America as the promised land of great opportunity, especially for Germans, who had been successful in the New World since the 1840s, when millions began to immigrate, escaping famine and political upheaval in Germany. Yet for Winold, the overarching reason for leaving was to draw Indians, even if it meant rebelling against his father. Fulfilling his mission thus resembled the archetypal story of the prodigal son, who must desert family and homeland to realize his dream.

DECAPITATED FIGURES
Gouache on board, circa 1913
Mr. and Mrs. Victor Meyers

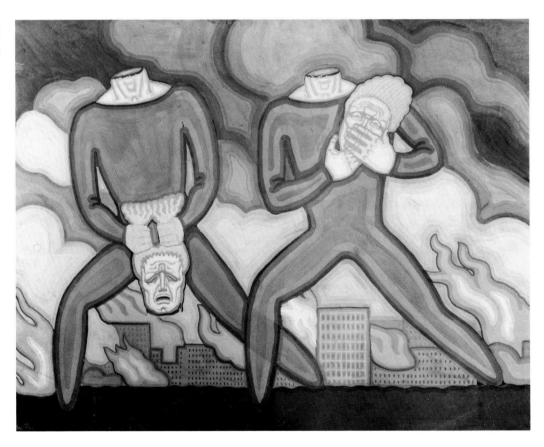

NOTES:

1. Interview with Tjark Reiss, July 25, 1987. For German Romanticism, see Linda Siegel, *Caspar David Friedrich and the Age of German Romanticism* (Boston, 1978) and Arnold Hauser, *The Social History of Art*, vol. 3 (New York, 1958), especially pp. 163-92. For an informative discussion of the relationship between Romanticism and folk ideology in Germany, see George L. Mosse, *The Crisis of German Ideology: Intellectual Origins of the Third Reich* (New York, 1964), pp. 13-30, 52-66.

2. Interview with Tjark Reiss, July 25, 1987. For a discussion of late nineteenth-century German drawing and painting, see Michael Quick's essay in *Munich and American Realism in the 19th Century* (exhibition catalogue, E. B. Crocker Art Gallery, Sacramento, Calif., 1978). For the Düsseldorf Academy see Donelson Hoopes's essay in *The Düsseldorf Academy and the Americans* (exhibition catalogue, High Museum of Art, Atlanta, Ga., 1972).

3. Interview with Tjark Reiss, July 25, 1987. For the German interest in American Indians, see Colin F. Taylor's "The Indian Hobbyist Movement in Europe," in Wilcomb Washburn, ed., *History of Indian-White Relations*, vol. 4 of *The Handbook of North American Indians*, ed. William Sturtevant (Washington, D.C., 1988), pp. 562-69. That volume contains another informative essay on German ideas about American Indians by Christian Feest, "The Indian in Non-English Literature," pp. 582-86. Dr. Washburn graciously permitted me to see these essays in manuscript form. For James Fenimore Cooper's impact in Germany, see Preston A. Barba's "Cooper in Germany," *Indiana University Studies* 2, no. 21 (May 15, 1914): 52-72. Also useful is Ray Allen Billington's *Land of Savagery, Land of Promise: The European Image of the American Frontier* (New York, 1981). The most recent English translation of Karl May's most famous Indian novel, *Winnetou*, is by Michael Shaw (New York, 1977).

4. For the Munich Secession and von Stuck, see *Die Münchner Schule, 1850-1914* (exhibition catalogue, Haus der Kunst, Munich, 1979) and *Die Münchner Secession und ihre Galerie* (Münchner Stadtmuseum, Munich, 1975). For the Jugendstil in general, see Gabriele and Albrecht Banger, *Jugendstil, Art Deco* (Munich, 1980). The most informative discussion of Franz von Stuck's influence as a teacher and of the Jugendstil movement in Munich appears in Peg Weiss's *Kandinsky in Munich: The Formative Jugendstil Years* (Princeton, N.J., 1979), pp. 22-27, 48-53.

5. Helen Appleton Read, "Winold Reiss," in *Blackfeet Indians: Pictures by Winold Reiss. Story by Frank Linderman* (St. Paul, Minn., 1935).

6. For Catlin, see William H. Truettner, *The Natural Man Observed* (Washington, D.C., 1979); for Bodmer, see William H. Goetzmann and William J. Orr, *Karl Bodmer's America*, (Lincoln, Neb., 1984).

7. See *Der Bläue Reiter und sein Kreis* (exhibition catalogue, Leonard Hutton Galleries, New York, 1977) and Kenneth C. Lindsay and Peter Vergo, eds., *Kandinsky: Complete Writings on Art*, vol. 1: *1901-1921* (Boston, 1982), especially pp. 229-73.

8. See Robert Goldwater, *Primitivism in Modern Art* (New York, 1967), for the German ethnographic museums and the changed attitude toward African and Oceanic art by artists in the early twentieth century.

9. Maria Naylor, "Winhold [*sic*] Reiss" in *Portraits of Plains Indians by Winhold [*sic*] Reiss from the Anschutz Collection* (Denver, Colo., 1976), p. 6.

10. Leo Frobenius, *Ethnographische Notizen aus den Jahren, 1905 und 1906* (Stuttgart, 1985-1987); Karl von den Steinen, *Die Marquesaner und ihre Kunst: Studien über die Entwicklung primitiver Sudseeornamentik nach eigenen Reiseergebnissen und dem Material der Museen* (1925; reprint ed., New York, 1969); von den Steinen, *Unten den naturvolkern Zentral-Brasiliens* (Berlin, 1894); Eduard Pechuel-Loesche, *Volkskunde von Loango, von prof. dr. E. Pechuel-Loesche* (Stuttgart, 1907).

11. See Christaud M. Geary, *Images from Bamum: German Colonial Photography at the Court of King Njoya, Cameroon, West Africa, 1902-1915* (Washington, D.C., and London, 1988) and Nicolas Monti, ed., *Africa Then: Photographs, 1840-1918* (New York, 1987).

12. August Sander, *August Sander: Photographs of an Epoch, 1904-1959* (exhibition catalogue, Philadelphia Museum of Art, 1980).

13. Interview with Tjark Reiss, July 25, 1987.

14. *Ibid.*

Despite his passionate commitment, it would be several years before Winold Reiss journeyed to the American Indian tribes of the West. Upon his arrival in New York in 1913, he entered the art scene by encouraging American artists to exploit the possibilities of bold color in commercial design. Within two years his reputation as an authority on German decorative art was such that he was invited to speak on the subject before the Art Students League. Explaining the tradition from which his work had emerged, he gave his American audience insight into the Munich school that had taught him to appreciate color in commercial design. More significantly, he revealed the fundamental tenet of the Arts and Crafts movement in Germany: that the fine and applied arts should not be artificially segregated and that true artists should work in both areas. *Julius Diez is an excellent teacher and a good decorative painter. He designed like his famous master, Franz von Stuck, the well-known Munich exhibition posters; [he made] posters for biscuit factories and piano houses, and made at the same time designs for mural paintings and mosaics. I want to add this, that there isn't a good artist in Germany who wouldn't design a poster. No good artist is ashamed to do something because it is used as a commercial aid.*[1]

In America, where artists were trained to specialize in either fine or commercial art, Reiss would benefit from his ability to contribute to both fields; but his reputation as a fine artist would suffer from the prejudice against artists who also worked in the commercial realm.

As a designer, however, Reiss was highly successful. By 1915 he had become a regular contributor of brightly colored covers for *Scribner's* magazine; had done illustrations for a book, *Mother Goose Rhymes Done in Poster Stamps*; had designed the first modernist interior in New York at Busy Lady Bakery; had co-founded the Society of Modern Art and its magazine, the *Modern Art Collector* (*M.A.C.*), which would spread modern design and color usage in the advertising world; and had opened an art studio and his own art school.[2]

Reiss's rapid success was due to his great versatility. Having been trained in graphics, fabric design, interior decoration, mural and poster art, and landscape and portrait painting, he was able to execute works in diverse areas, whereas most American artists were able to concentrate only in one. He was perhaps the earliest and, in the teens, among the most prolific of the Northern European immigrant artists—Joseph Urban, Bruno Paul, Ilonka Karasz, and Boris Lovet-Lorski—who revolutionized interior design and ushered in the Art Deco movement in America.

Reiss's combination of originality and adaptiveness can be seen in his four covers for *Scribner's* magazine, the first for the September 1915 issue. He also illustrated a short story entitled "A Little Flier in Culture" in the March 1916 issue. The most memorable covers were for Christmas 1915—an abstract triangular design of a tree, in bold blue against a rich green background—and for the April 1916 issue, in Bläue Reiter colors of yellow for the woman's dress, with amethyst birds, against a rich, cobalt-blue background. These covers suggest one reason why Reiss was so successful as an artist in America: unlike some other modernists, who seemed bent on shocking their audiences with abstraction, Reiss was willing to adapt his new designs to his audience. As he said many years

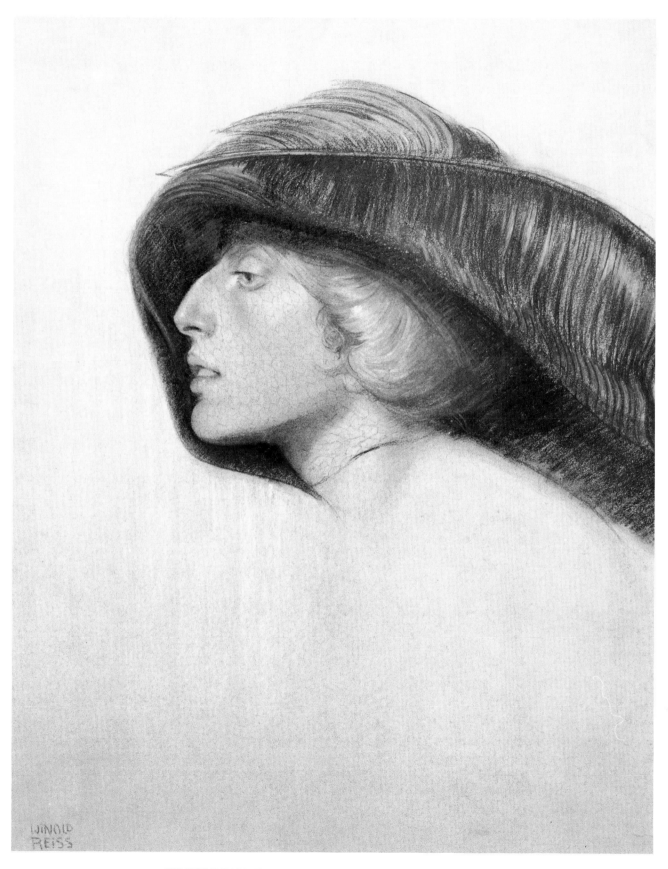

MRS. REISS IN BLACK HAT Pastel on paper, circa 1912 Mr. and Mrs. W. Tjark Reiss

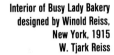

later about mural painting, another area in which he excelled, "It is not the artist's function to be arbitrary. If the owner's ideas are not artistic or in keeping with the space and location of the proposed mural, the painter should try to bring him around to an aesthetic viewpoint by indirection."[3] Rather than rebuke the American audience for its conservative attachment to the older styles, Reiss subtly modernized American taste by reinterpreting romantic themes and familiar subject matter with the bright colors and stylized expressions characteristic of Jugendstil and the European Arts and Crafts movements.

 No better example of this synthetic technique exists than Reiss's 1915 interior decoration of the Busy Lady Bakery on Broadway in New York City. Here he combined stylistic motifs from both the Munich Secession and the Wiener Werkstätte (Viennese Workshop) decorative styles. Like Josef Hoffmann and Koloman Moser, the Vienna designers who founded the workshop in 1903, Reiss wished to create good and beautiful designs with commercial appeal. In the Busy Lady Bakery, moreover, Reiss's interior has the delicacy of the Viennese style: a thin line of dashes border the large expanses of whiteness on the walls and floors, while even the heavier Black Forest themes on the walls and sides of the freestanding cabinets are rendered with a subtle expressiveness of touch. Most important, Reiss's design is perfectly matched to the purpose of the establishment: it is almost as if the motifs are light garnishes sprinkled on cookies, giving the place an air of sweetness and breeziness. Here is a decorative scheme that communicates the unencumbered feeling a "busy lady" would appreciate. Reiss's interior epitomized the "modern

note" in the decorative arts, what critic C. Adolph Glassgold defined in 1928 as the "aesthetically pleasing" design that gives "to the product a form which is expressive of its function."[4]

Unfortunately for Reiss, America did not take to modern interior design, partly because of its high cost and unfamiliar look, but also because upper-middle-class American interior taste remained conservative in the early twentieth century, still wedded to the Victorian traditions of Empire, Rococo, and Renaissance revivals. For Reiss, this meant that the Busy Lady Bakery interior did not lead to additional commissions. Rather, during the teens, his greatest impact continued to be in the print media. His reputation as a modern commercial artist was most effectively established with work for the *Modern Art Collector. M.A.C.* was the inspiration of the German inventor and businessman Oscar W. Wentz, who had immigrated to the United States in 1912 and, with other European immigrants such as Ilonka Karasz and Reiss, founded the Society of Modern Art in 1914.[5]

The organization initially sought to capitalize on the popularity of German poster art in America by producing stunning, brightly colored reproductions of artwork done in the poster art style. Reiss's 1915 lecture at the Art Students League was published, with accompanying photographs, in the first issue of *M.A.C.* The article discussed the larger purpose of the magazine, to introduce modern design in the decorative arts to all aspects of American life. Not only was *M.A.C.* an excellent vehicle for the promotion of modern design, it also served as a launching pad for the careers of later interior designers, such as Ilonka Karasz, whose innovative interiors would become popular at design shows in the 1920s.

M.A.C. provided Reiss with a means to publicize his own work (photographs of his Busy Lady Bakery interior appeared in the first issue), to associate with a like-minded community of artists, and to perfect his tremendous gifts as a colorist and print designer. As Fred Brauen suggests, Wentz practically turned over the production of *M.A.C.* to Reiss, whose work dominates the pages of the magazine as well as the covers, and whose design aesthetic gave focus to each issue.[6] Functioning as a kind of production manager, Reiss not only promoted his work, but also that of other immigrant modern artists. In this way, as he put it, he was able to shape American advertising design: *Before the publication of this magazine, no printing concern here could reproduce bright colors. We were fortunate, however, to secure the help and interest of the Stockinger Photo Engraving Company whose head had just come to America and was trained in fine color printing in Vienna. The first issue, I dare to say, revolutionized American printing.*[7]

An example of Reiss's bold use of color and folk motifs in modern printing can be found in his landscape *Swedish Farmhouse*, published in the first issue of *M.A.C.* Before coming to America, Reiss had purchased a book, *Peasant Art in Sweden, Lapland and Iceland* (London, 1910), which contained numerous photographs of peasants and their houses in Sweden. One of them became the background for his *M.A.C.* Swedish farmhouse. He duplicated the "wonderful block of buildings with the 'low-loft cottage' to the right and the 'high-loft cottage' to the left, and with the 'high house' as the connecting link [which] bears witness to the solid affluence of the South Swedish farmer."[8] At center left, he situated a woman in Swedish costume carrying a basket, whose image had been taken from E. Stenberg's illustration *Sweden — Exterior of a*

SWEDISH FARMHOUSE
Illustration for the magazine *M.A.C.*
Silkscreen on paper, 1915
W. Tjark Reiss

Peasant's Cottage in the same book.[9] But the intense colors that Reiss added enlivened and modernized the scene. Here was the most explicit example of his belief that peasant art and life could be the basis of a modern art.

Although Reiss was acclaimed for his work at *M.A.C.*, the magazine ceased publication in 1917 and is almost unheard of in advertising circles today. The major cause of its demise was the rising tide of anti-German sentiment during World War I. As Brauen suggests, the conservative advertising establishment, which had always resented the modern note of foreign artists, used the anti-German war hysteria to deliver the death blow to the competition. The *Chicago Tribune* announced in March 1918: *The American Association of Commercial Artists has declared war to the hilt upon such German propagandist influence as is manifested in American art utilized in advertising, booklets, posters and other commercial printing. . . . The German school of commercial art has been one of the most effective means of propaganda developed by the Teutons.*[10]

Reiss quickly felt the pinch of "Hun" hating in more direct ways—in the drop-off of students at his art school and in the cancellation of the few commissions he had been able to obtain before the United States entered the war in April 1917. The hatred was such that, as Tjark Reiss recalls, his father sent the "family up to Woodstock, N.Y. . . . and he would go back and forth to the city trying to get commissions to stay alive." Henrietta Reiss, born in England, helped Winold "a great deal by acting as an agent for him, because she spoke English absolutely fluently. If he went around, of course, people would know immediately that he was German. If she took his work around, they wouldn't know what he was or who he was."[11]

With the end of the war, the prejudice subsided somewhat, and Winold Reiss continued his work as a teacher and interior designer. His most important commission of the decade, that for the Crillon restaurant in New York, came shortly after the end of the war. Otto J. Baumgarten, an Austrian-born immigrant, owned the Voisin and the Elysée restaurants in New York and asked Reiss to design his new venture in midtown Manhattan. This was a major commission: in addition to designing the interior, Reiss also had carte blanche to compose the theme for the entire complex, including the exterior, the menus, and even newspaper advertisements. It is extraordinary that in the immediate postwar period Reiss came out with his boldest work yet, almost as if, having been victimized by prejudice while producing tactful, pleasing imagery, he decided now to let the American audience have the full force of his Munich-born Expressionist design sense. And the Crillon designs were a tremendous success: the clientele was pleased and so were newspaper writers and other critics, some of whom hailed the Crillon as the first modern-style restaurant in New York. By the end of this yearlong project, Reiss's reputation as New York's premier interior designer had been reestablished, and he was for the first time able to enjoy a measure of financial security.

Although his first six years in New York were primarily taken up with teaching and design commissions, Reiss never forgot his original reason for coming to America. Initially, he had been disappointed that the Indians—unlike the German peasant folk—did not live in the countryside surrounding the cities, and so he was particularly excited when he discovered a full-blooded Indian in New York. M. D. R. Crawford, who worked for the American Museum of Natural History, recalled that Reiss *applied to me for the use of certain Indian costumes. For he had discovered his first Indian in an elevated train on Manhattan Island. Yellow Elk— such was the worthy's name— a Blackfoot brave recently discharged for good and sufficient reasons from a circus, was not a prepossessing spectacle. He had slept many nights in his clothes; had eaten in a rather haphazard manner. The burden of the white man's civilization was heavy upon him. But he was tall and slender, with a fine aquiline nose, piercing black eyes, and a color of a rusty pot. To Reiss he came as a fulfillment of a prophecy. We dressed him in the war bonnet, the beaded shirt of Flaming Cloud, the not unworthy lieutenant of the great Sitting Bull, once the terror of the plains. The change was instantaneous. Gone was the slouching gait, the hang dog look, the dumb suffering. . . . In his place there stood a man and a warrior, resplendent in color, filling the dim halls of the museum with dignity and poise. Hour after hour, day after day Reiss drew from this model.*[12]

Putting Sioux Indian clothing on a Blackfeet Indian and painting him as an act of preservation was a typical mistake of well-meaning but ill-informed whites whose interest in Indians was more romantic than realistic. That approach to Indian culture froze Indians in time for whites who felt ambivalent about modernization. Fortunately, Reiss grew out of this early naiveté and learned to attend closely to the accuracy of the dress of the Indians he portrayed. Moreover, he learned to draw Indians as they were, as real people in living cultures, many of whom had abandoned traditional dress and adapted the dress of the white man to their own needs. That learning process began in 1919 on a trip to Browning, Montana, home of the Blackfeet Indians, which Reiss financed with the proceeds from his Crillon restaurant commission.

Reiss recalled to an interviewer his first hours in Browning: *I arrived at Browning at three in the morning, in a fierce blizzard. A kind of a "bus" took us to the hotel, which was almost*

dark. Entering I found the clerk asleep in a big chair, and when I requested lodging he said very gruffly there wasn't any. I argued that I could not go back into the storm and that he must let me lay my terribly tired head somewhere. He finally told me I could share the "bunk" of a cowboy upstairs, at the back of the building. I mounted by candle light and entered a loft in which the one bed was already occupied, and the cowboy's Wild West outfit was piled on the only chair. As I crowded in beside him the sleeper only grunted, and I fast joined him and knew no more until broad daylight. When I wakened my bedfellow had gone, and as I felt for my wad of money under our one pillow found it still there. Looking out of the window, I saw eight or ten very tall Indians in Buffalo coats and huge fur caps standing silently in the snowy enclosure before the hotel. I went down at once, intending to make their acquaintance without knowing how, but, acting on impulse, I walked up to the tallest brave and slapped him on the back to his utter astonishment. Another, a half-breed who spoke English, asked what I wanted. I said I had come all the way from Europe to make the acquaintance of my Indian brother. The interpreter's explanation brought a handclasp, smile and nod that passed all down the line.[13]

As Paul Raczka has observed, Reiss was certainly lucky not to have been throttled by the Blackfeet after he greeted them as he and his boyhood friends in Germany had greeted each other while playing cowboys and Indians.[14] It was remarkable that he was not struck dead on the spot by the man whose back he slapped—Turtle, who had wrestled a bear and won and who was one of the most feared younger hunters of the Blackfeet. But luckily for Reiss, Turtle liked him, and as the Blackfeet laughed and made jokes about this naive white man from the East, Reiss made friends. Shortly afterward, the Blackfeet allowed him to begin drawing them.

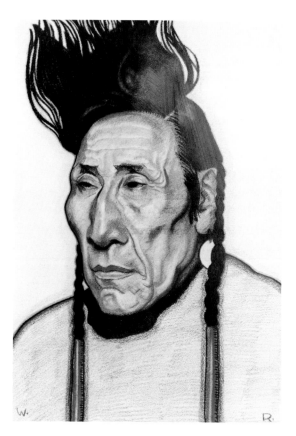

**TURTLE
(born 1877)
Crayon on paper, 1919
Bradford Brinton Memorial Museum**

Sketching quickly with charcoal, crayon, and pastels on heavy drawing paper in his makeshift studio at the Hotel Hagarty, Reiss merely outlined the bodies and clothing of his subjects in order to concentrate his energies on the wonderful faces of the Blackfeet. In his portrait of Turtle, for example, he sought to capture every line on his subject's face and every strand of his Crow hairstyle, while at the same time utilizing mass and volume to create a sculptural, almost three-dimensional presence. Reiss was able to combine a sensitivity to the interplay of forms with a fidelity to the living person that made his portraits bold as well as truthful likenesses.

Of course, some romanticism could be found in these portraits. There was the idealized Indian maiden of *Little Singing Woman,* who at fifteen years old was beautifully garbed in the formal dress she would have worn at a powwow or other special occasion. But there was also the

remarkable realism of *Bad Marriage*, a sixty-year-old man. With his long hair, cloth shirt, bandanna, and reservation hat, he provided an accurate portrait of what an older Blackfeet looked like on the northern plains in the 1910s. Certainly, Bad Marriage had put on his dress beads and elk teeth for the sitting. But Reiss's image remains a much more realistic rendering than those created by white artists working within the romantic tradition of Indian portraiture.

Reiss excelled in producing both endearing portraits of the youngest children and striking documentary portraits of the oldest, most revered members of the Blackfeet aristocracy. In his portrait of Curly Bear, a sixty-eight-year-old man who had lived and fought during the intertribal wars, he began what would later become a trademark of his Indian portraits—detailed treatment of the designs on the sitter's shirts. Like George Catlin, the first white man to draw the Blackfeet, Reiss wanted to document their dress and customs. But unlike Catlin, he also drew upon his design training in Munich, particularly the poster work of Ludwig Hohlwein. In his 1915 Art Students League lecture, Reiss had recalled one poster, for a sporting-goods house, as being especially influential. In *Arrow Top*, a portrait of a Blackfeet cowboy, Reiss flattened and abstracted the designs of the Indian's modern shirt and checkered headband in the manner of Hohlwein's posters. Moreover, the treatment of the curved brim of the hat gives this composition a dynamism and rhythm that transcends realism. Reiss thus added a decorative feel to what would otherwise have been a merely documentary portrait. Put another way, his training in modern decoration sensitized him to the design and color qualities of his subjects' dress.

But most important, as his portrait of Two Guns White Calf shows, Reiss was adept at portraying Indians with dignity by fusing the best of the romantic conceits with the most careful

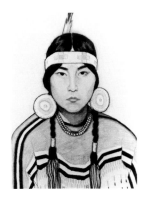

LITTLE SINGING WOMAN
(born 1904)
Crayon on paper, 1919
Bradford Brinton Memorial Museum

BAD MARRIAGE
(born 1859)
Crayon, 1919
Bradford Brinton Memorial Museum

TWO GUNS WHITE CALF
(1871-1934)
Crayon, charcoal, and conté pencil, 1919
Bradford Brinton Memorial Museum

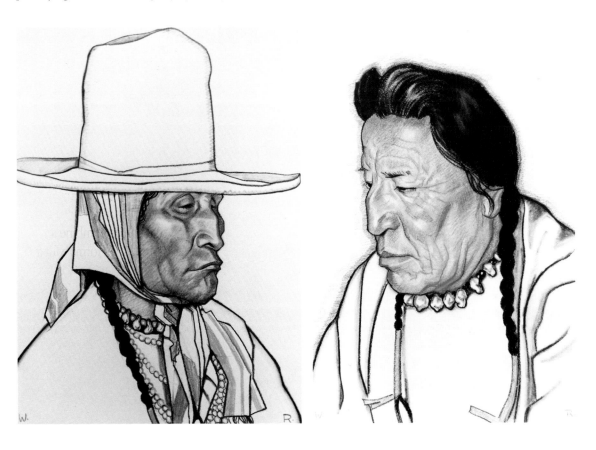

ethnographic precision. When at the end of six weeks he showed the thirty-six portraits he had made to the Blackfeet, he won their approval and admiration, for the works were remarkable for their objectivity and achieved a dignified presentation of the Blackfeet people.

Upon his return to New York early in the spring of 1920, Reiss exhibited the portraits at the gallery of E. F. Hanfstaengl, the Harvard-educated son of a prominent Munich art dealer. Another German immigrant, Reiss's friend Hans Kaltenborn, arranged to have the exhibition reviewed in the *Brooklyn Eagle*, where Kaltenborn was an associate editor. Within three days, the entire collection was purchased by Dr. Philip Cole, a New York doctor from Montana who knew many of the subjects Reiss had drawn.[15]

Reiss's trip to Montana at the height of his triumph as a modern designer not only reflected his desire to depict Indians, but was also consistent with his urge to return to the folk, to the primitive, and the peasant sources of his own creativity. His decision attests to the ancient sources of his modernism, which involved the revival and elaboration of forms derived from peasant and pre-modern sources. As Edwin Park noted years later, *The Austrian [sic] artist, Winold Reiss, whose work is undoubtedly familiar to most people, was the author of the first experiment of this sort in New York City. Seven years ago he decorated the old Crillon restaurant in decidedly modern and thoroughly American taste, using flat surfaces, broad and colorful painted decoration, based on the patterns found in Navajo blankets and Indian pottery.*[16]

As much as Reiss liked commercial design, he was ultimately unsatisfied by it, for he needed the connection to the folk to feel fulfilled as an artist—even if he somewhat mistakenly

ARROW TOP
or PHILLIP ARROW TOP
(born 1887)
Charcoal, conté pencil, and
colored pencil, 1919
Bradford Brinton Memorial Museum

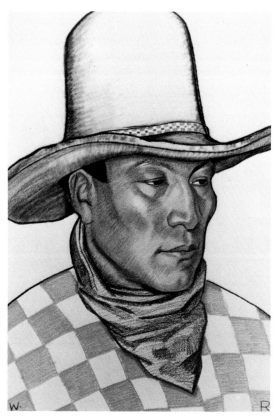

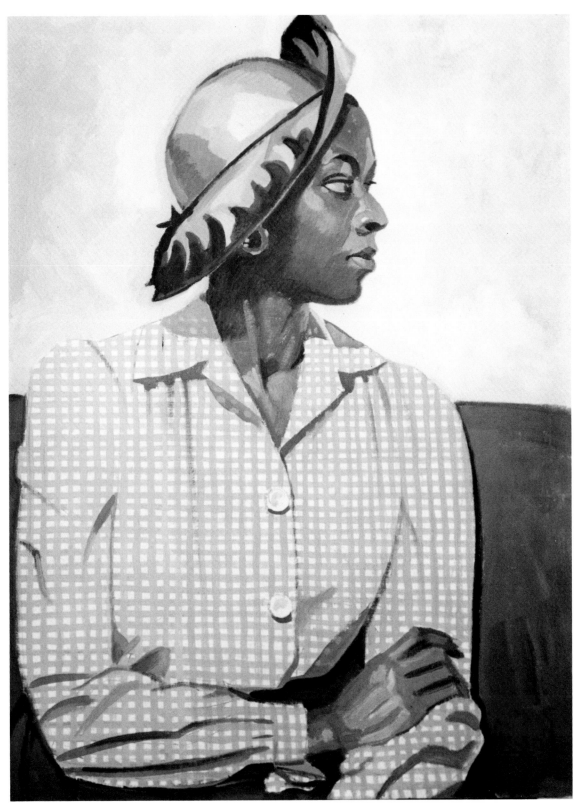

WOMAN IN A GREEN HAT Oil on canvas board, circa 1935 W. Tjark Reiss

considered Native Americans to be folk. For him, folkloric portraiture was a kind of emotional and aesthetic ballast for hyperaggressive modernism. Like the modern American artists who settled in Taos and Santa Fe, New Mexico, in the early part of the century, Reiss discovered a spiritual renewal in the West. As he said in 1926, *How beautiful the West is you people in New York don't realize. Except for my trip to Glacier Park, to Mexico, to the Southwest and California, I have lived in New York; but now I can't stand it any longer; I feel I must break away— get among the Indians again, live with them in their simple way and study and paint them.*[17]

 Reiss found in the folk the inspiration for a more holistic, spiritual engagement with the world through art. He was an artist who fused the twin aspects of early twentieth-century modernism—the effort to break away from Western nineteenth-century tradition and, through primitivism, to reconnect with alternative (folk) traditions that exemplified a more integrative role for art in everyday life. In Montana, Reiss quite simply felt himself to be more of an artist than he was in New York, even though he would reside in that city for the rest of his life.

Winold Reiss and Otto J.
Baumgarten at Reiss's farm in
Columbia County, New York,
date unknown
W. Tjark Reiss

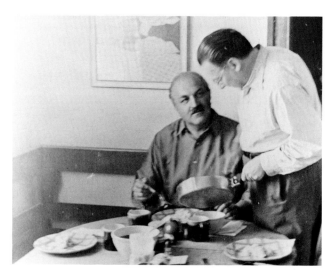

H. V. KALTENBORN
(1878–1965)
Pastel on board, date unknown
H. V. Kaltenborn Collection, Mass
Communications History Center,
State Historical Society
of Wisconsin

NOTES:

1. Synopsis of lecture, "The Modern German Poster," by Winold Reiss before the Art Students League, published in the first issue of *Modern Art Collector* (1915). I am grateful to the Public Library of Cincinnati and Hamilton County for supplying this material to me.

2. I am indebted to Dr. Fred Brauen's unpublished manuscript, "Winold Reiss, 1886-1953: Color and Design in the New American Art" (1980) for many leads on Reiss's activities as an illustrator, an interior designer, and a contributor to the *Modern Art Collector*.

3. "Tact in Art," *Art Digest* 7 (September 1933): 24.

4. C. Adolph Glassgold, "The Modern Note in Decorative Arts, Part I," *Arts* 13 (March 1928): 154. For more information on the Wiener Werkstätte, see Kirk Varnedoe, *Vienna 1900: Art, Architecture & Design* (New York, 1986), pp. 88-90. Winold Reiss's reference to Wiener Werkstätte can be found in his lecture, "The Modern German Poster," reprinted in *Modern Art Collector* (1915).

5. Glassgold, "The Modern Note in Decorative Arts, Part II" *Arts* 13 (April 1928): 225.

6. Brauen, "Winold Reiss," p. 9.

7. Walter L. Creese, "American Architecture from 1918 to 1933, with Special Emphasis on European Influence" (Ph.D. diss., Harvard University, 1950), part 2, pp. 4, 5, and n. 5, cited in Brauen, "Winold Reiss," p. 78.

8. Charles Holme, ed., *Peasant Art in Sweden, Lapland and Iceland* (London, 1910), pp. 4, 30.

9. *Ibid.*, p. 30.

10. *Chicago Daily Tribune*, March 18, 1918. Also quoted in Brauen, "Winold Reiss," p. 15.

11. Interview with Tjark Reiss, July 25, 1987.

12. M. D. R. Crawford, "Draughtsmanship and Racial Types: Mexican Character Studies by Winold Reiss," *Arts and Decoration* 15 (May 1921): 28-29.

13. Quoted in Lillian E. Prussig, "Captured on Canvas: The Spirit of the Races," *Brooklyn Eagle*, July 22, 1928, p. 8. Conflicting accounts exist of Reiss's first trip to Browning, Montana. Fred Brauen ("Winold Reiss," p. 28) and Helen Comstock ("Langdon Kihn, Indian Painter," *International Studio* [October 1925]: 50-55) rely on Langdon Kihn's account that he accompanied Reiss on this first trip. Reiss is recorded by Prussig in 1928 as narrating in detail his solo arrival in Browning in 1919, and his account has been repeated in several other interviews. Reiss's and Kihn's recollections may have been affected by a disagreement following the Mexico trip (which they did take together) and by their professional rivalry that ensued afterward. David Lloyd's brief notice of the 1920 Hanfstaengl exhibition of Reiss's Blackfeet Indian portraits claims that Reiss made his thirty-five Blackfeet portraits (one self-portrait brought the total to thirty-six) in a period of eighteen days in January 1920, a remarkable achievement if it is true (*New York Evening Post*, March 13, 1920). Reiss, however, maintained as early as 1921 that he made the trip in 1919 (see Crawford, "Draughtsmanship and Racial Types," n. 12). I have given preference to Winold Reiss's recollection in the interpretation presented here.

14. Paul Raczka, "Winold Reiss: 'The Holbein of the Humble,'" in *Winold Reiss: Portraits of the Races, "Art Has No Prejudice"* (exhibition catalogue, C. M. Russell Museum, Great Falls, Mont., 1986), p. 12.

15. Interview with Tjark Reiss, July 25, 1987.

16. Edwin Avery Park, *New Backgrounds for a New Age* (New York, 1927), p. 172.

17. Quoted in Olga Kaltenborn, "Interprets Racial Types in Oils," *Brooklyn Eagle*, January 2, 1927.

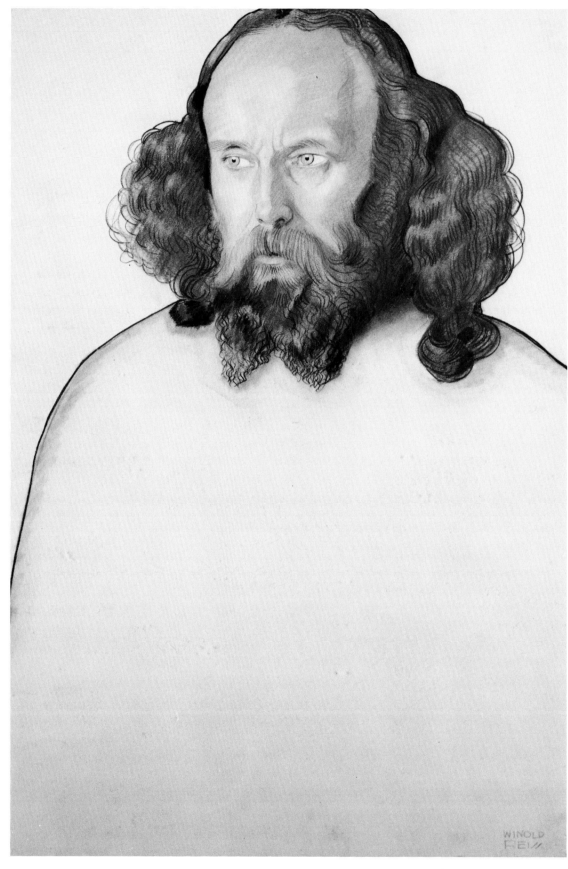

OBERAMMERGAU CHRIST (ANTON LANG) Colored pencil on board, 1922 Renate Reiss

"FOLK-LORIST OF BRUSH AND PALETTE"

Although there had been other artists, such as George Catlin and Karl Bodmer, who had specialized in painting Indians, and others, such as Winslow Homer and Robert Henri, who did genre portrait studies of American Blacks, no other artist in America had made the documentary study of America's non-white races his main artistic production. In doing so, Reiss acted out of a deeply felt humanitarian impulse and in the belief that racial pluralism was a positive good. But though his portraits were studies in the diversity of physical characteristics, they were also records of the distinctive place and history of each minority group within American life. From Mexican revolutionary to Harlem writer to Japanese immigrant, Reiss's portraits told how different minorities and nationalities struggled for self-determination and self-respect on the North American continent. He was certainly a "folk-lorist of brush and palette," as Howard University philosopher and critic Alain Locke labeled him; yet he was also a delineator of those intellectuals, artists, and revolutionaries who were advancing into the mainstream of American consciousness despite racism and political prejudice.

Mexico interested Reiss for several reasons. Having begun to document the Indians of the Northwest, he was anxious to extend his recording into the Southwest and particularly to Mexico, where he could draw the race that had built the great Aztec nation. Moreover, he knew that Mexico had recently undergone a revolution and a new society was in the making. Finally, Reiss wanted to see the remnants of the Aztec and the Mayan civilizations. As one of the originators of American Art Deco, he understood that ancient Mexican architecture had provided modern designers with some of the ideas—such as the step motif of Mayan architecture—that figured so prominently in 1920s skyscrapers. As he later commented to an interviewer, revival of Indian art was a key to a native American art: *In architecture this is already being done. Alfred C. Bossom is using the ancient Maya designs as ornamentation on one of his buildings. The zoning law, which is certainly the outcome of a totally different civilization, has produced structures which go back to the typical aboriginal American expression— the Maya pyramid.*[1] Like his response to the Blackfeet, Reiss's interest in Mexico embodied a search both for the past of a great people and for the sources of a future American aesthetic.

Reiss's opportunity to go to Mexico came in 1920, when his student, W. Langdon Kihn, announced that his father would be willing to finance a study trip to Mexico. Initially, Reiss worried that he might have trouble reentering the United States from Mexico, which was considered a war zone, because he was not yet an American citizen. But he did go, and his fears about reentry were unwarranted.[2] His approach to entering this area in 1920 reveals a great deal about his judgment and character. As his son, Tjark, recalls, *everyone said that he had to take a pistol, but my father didn't believe in violence. He said he would make it with his sketchpad. And he did. Many times he was surrounded by these revolutionaries or outlaws, and he would take out his sketchpad and start sketching them, and before you would know it, they were amenable, and glad to sign the picture. Whereas I am sure that if he had had a gun, reached for it, he would have been a dead duck!*[3]

Reiss produced some remarkable urbanscapes in Mexico, but his main concern was portraiture, as can be seen in his sensitive study of Mexican revolutionaries, *Brothers-in-Arms at Zapata's Headquarters, Cuernavaca, Mexico* (also known as *Zapatista Soldiers*). Also striking was *Aztec Indian from Tepozotlan* [*sic*], Mexico. Reiss appears to have studied Mexican history, even producing a narrative series on the theme of the conquest of Mexico that showed his knowledge of the history of colonization and his anger over the Spanish destruction of Mexico's civilizations. And he was eager to record the specific racial type that had created the great Aztec empire. Katherine Anne Porter was in Mexico at that time, writing articles on the revolution. She met Reiss after he had been there for some months and reported that he invited her to walk to the cathedral of Tepotzotlán with him—a journey of twenty-five miles!—for he wanted to revisit the ancient monastery. "He showed me some remarkable sketches of Indians and told an amazing story: he had tramped the states of Oaxaca, Jalisco, Puebla, and I think, Morelos, though I am not sure, alone, unarmed, carrying enough food to last only from one village to another." Porter later used Reiss's Mexican drawings to illustrate "Where Presidents Have No Friends," her *Century Magazine* article on the Mexican revolution.[4]

LA DOMADORA
Tempera on board, circa 1920
J. N. Bartfield Galleries

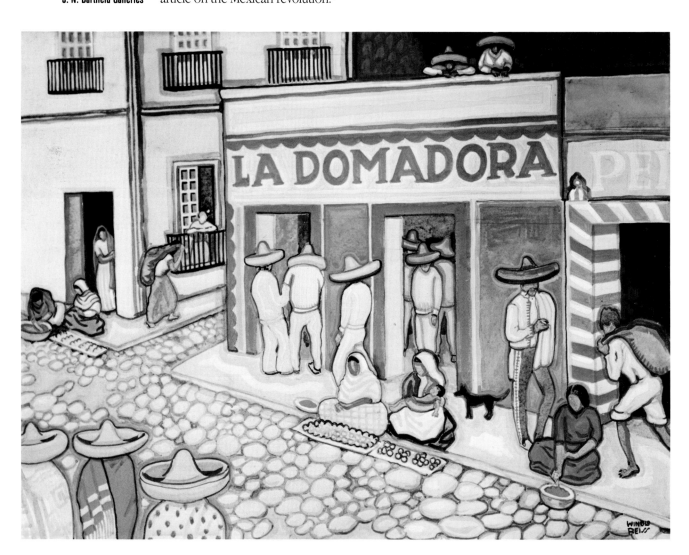

AZTEC INDIAN FROM TEPOZOTLAN, MEXICO
Mixed media on paper, 1920
Private collection
(color illustration on page 1)

CONQUEST OF MEXICO I
Watercolor on paper, 1920
Renate Reiss, courtesy Shepherd
Gallery Associates

BROTHERS-IN-ARMS AT ZAPATA'S HEADQUARTERS, CUERNAVACA, MEXICO
or **ZAPATISTA SOLDIERS**
Pastel on paper, 1920
J. N. Bartfield Galleries
(color illustration on page 147)

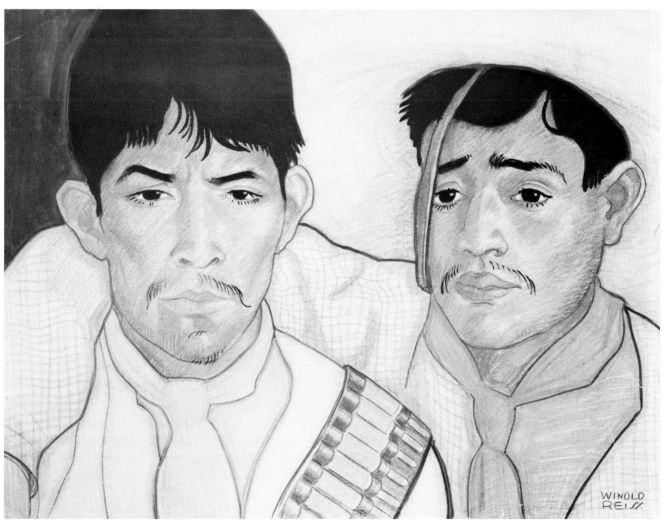

A terrible bout with dysentery cut short Reiss's sojourn in Mexico. Shortly after returning to New York, Reiss made what would be his only trip back to Germany. His father had died in 1914, his brother had fled to Sweden, and his mother was living with her daughter and grandson in Kirchzarten. The trip to Germany in 1922 was important for Reiss in several ways. In addition to visiting his mother, he went to Sweden and encouraged his brother Hans to come live with him in America, which Hans soon did. During his short stay in Sweden, Winold was able to visit Rattvik and Leksands Noret, where he made drawings of the peasants who lived there. Then he returned to Germany for the remainder of his stay.[5]

The most lasting effect of the trip was on Reiss's future artistic development. In Munich and Berlin, he saw that the dominant trend in German painting had switched from the Jugendstil and Expressionism of his student years in Munich to Neue Sachlichkeit (New Objectivity), a form of social realism engendered by the devastation of the war and the economic cruelty of postwar inflation. Otto Dix, George Grosz, Christian Schad, Karl Hubbuch, Rudolf Schlichter, and Max Beckmann had begun to draw modern German life in the cities with a new objectivity that emphasized the outer reality of the subject rather than the inner vision of the artist. Influenced by the Marxist philosophy that man's essence was a product of the material conditions of his work, these artists objectified their subjects by depicting them in their working conditions. Thus they

NIGHTCLUB
Gouache on heavyweight white
wove paper, circa 1929-1930
Mr. Peter Green

WIESBADEN
By Max Beckmann (1884-1950),
1920
Published in *Max Beckmann* by
Von Curt Glasser (1924)

used the trappings of industrial capitalism to indicate social class and to suggest the alienation of modern man. Grosz, in particular, developed a caricatured style to critique the German upper class, while Schlichter, in a style more akin to that of Reiss, produced sparely drawn but sympathetic portraits of urban workers. The Neue Sachlichkeit encouraged Reiss to continue to render his subjects with compassion. On a more subtle level, it gave him confirmation from his German compatriots of the meticulously detailed realism he had pioneered before the war.[6]

The work of Max Beckmann—the paintings Reiss saw and those in a 1924 monograph found in his library—may have shaped Reiss's later renderings of urban decadence. In *Nightclub* the people dance to the music but without eye contact or pleasure, a feeling reinforced by the masklike faces on the left that seem to scream rather than sing to the music. Their alienated, rhythmic reverie in cramped quarters reminds us of Beckmann's work, especially his *Wiesbaden*

(1920) and *Traum* (1921). *Nightclub* tries to capture the rhythm of the urban cabaret, with its commingling of spirits in an atmosphere charged with dissonance and contrapunctuality. Reiss would develop further his ability to record the beat of urban life in the "imaginatives" he produced of Black life in Harlem.

Ultimately, however, Reiss's outlook differed profoundly from the predominantly political one of the Neue Sachlichkeit artists. Nowhere in his work can we find their cynical disparagement of the upper class, although Tjark Reiss reports that several portraits his father did of upper-class American businessmen were refused because the subjects did not like the portrayals.[7] Rather than critique the upper class, Reiss preferred to draw the rural peasants, whom he still believed were harbingers of a spiritual essence that had not been obliterated by modern commercial capitalism. Possibly in homage to his departed father, but surely in keeping with his own encyclopedic program, Reiss spent most of his visit traveling through Germany to draw peasants.

The *Watchman of the Rothenburg Tower* is an excellent example of the peasant portraiture Reiss produced in Germany. In discussing this picture, he drew attention to the Black Forest and its people rather than to the individuality of the man. *In the name itself lies a picture. . . . The* Schwarzwald *is full of deep shadows and it is when the sky hangs full of heavy clouds that drift slowly over the hills that the Black Forest is most beautiful. The people are mostly dark-haired and dark-eyed, which comes from a large admixture of Celtic blood, and some of the mellowness of the atmosphere seems to have attached itself to their temperament. They are a sturdy, hard working race, getting what they can by hard labor out of a stoney [sic] soil. It is wonderful to walk on an early autumn day down the wood-covered mountains and watch the blue smoke curl up from straw-covered roofs of the low peasant houses, and hear the sounds of the cowbells rise as one nears the valley. The war has made these peasants sad and dispirited and it seems an incredible thing that out of these peaceful valleys people should have had to go and fight.*[8]

In *Watchman of the Rothenburg Tower*, Reiss details the deeply lined and gnarled face that, despite years of war, is nonetheless hopeful. In another portrait from the same period, *Woman from Oberammergau*, a village in Bavaria, we again see the combination of strength and character in the face. Here objectivity is put to the more traditional service of showing that rural lives are both hard and sweet. The *Watchman*, however, is remarkable as a portrait because of Reiss's effort to capture the individuality of his subject through the background motif: it shows the view from the tower, an indication that Reiss has subtly adopted the Neue Sachlichkeit strategy of objectifying the individual by using the surroundings to identify social class. But instead of being crushed by war and technology, his subjects are sustained and empowered by their environment.[9]

WOMAN FROM OBERAMMERGAU
Colored pencil on paper, 1922
Renate Reiss

Nowhere is this faith in the spirituality of the rural past more powerfully stated than in Reiss's portraits of the Oberammergau Passion Players. During the Middle Ages, the Oberammergau villagers had been decimated by the plague and had sought divine intervention by enacting the Passion Play of the death of Jesus. When the plague subsided, the peasants believed it to be an act of God and continued to perform the play every ten years. Reiss visited the village and convinced each of the contemporary players to pose for him. Using the heavy-lined technique of his Mexican portraits, he minimized color to create stark, pale images of peasants possessed by their roles in the ritual play. *Oberammergau Christ (Anton Lang)* is a fiery head of hair, perched atop a mass of whiteness, whose form is merely hinted at by a contour line.

It has been suggested that the whiteness of the faces of these Oberammergau portraits

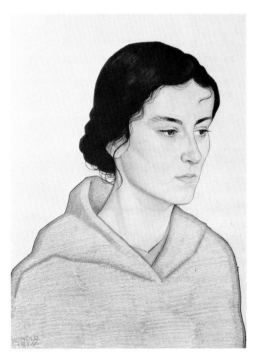

OBERAMMERGAU VIRGIN MARY (MARTA VEIT)
Colored pencil on board, 1922
Renate Reiss, courtesy Shepherd Gallery Associates

reflects Reiss's emerging ethnic consciousness, his way of highlighting the distinctiveness of these German peasants from the more colorful Indian and Mexican subjects.[10] Yet when he was not depicting the Passion Players, his palette could be quite colorful, as in *Woman from Oberammergau*. It thus seems likely that the whiteness of the Passion Player portraits represents Reiss's attempt to communicate the otherworldliness of his subjects, who had apparently been transformed by their roles in the play. In contrast to the *Woman from Oberammergau*, their portraits, especially *Oberammergau Virgin Mary (Marta Veit)* and *Oberammergau Christ*, are dominated by the eyes, which are focused on something beyond human sight. In writing about Anton Lang, who was a potter in the village, Reiss stated as much: *The character of the* Christ *has left its imprint on Anton Lang, mind and body and soul. When I drew him, he seemed like Marta Veit, the* Mary, *to have withdrawn from the things of earth, to have detached himself from his every-day work and his family, and to be living in an inner world of contemplation and prayer. His wife says that it is always so as the time for the play approaches.*[11]

In style, Reiss's portraits of the Passion Players, especially that of Anton Lang, revived some of the expressionism found in his earlier realist works, such as *Oversized Portrait of a Man*. The bare outlines of the body in *Oberammergau Christ* were meant to suggest a man beginning to transcend the ordinary in "one of the few posts in all the world where faith and idealism have successfully withstood materialism and commercial greed."[12]

Reiss was quite taken with the players, who symbolized, perhaps better than the Black Forest and Swedish peasants he also painted on this trip, the German folk heritage he had left behind. Yet the text of the Passion Play was filled with anti-Semitic condemnations, which persist in the performance even today. Despite his reverence for the players, Reiss found that he could not make the German peasant the focus of his life's work as an artist, and after completing the Oberammergau portraits he returned to the United States, never to visit his homeland again.

Shortly after arriving in New York in the fall of 1922, Reiss exhibited 136 portraits at the Anderson Galleries, including those of the Oberammergau players and Black Forest and Swedish peasants, along with his Mexican portraits. Although he continued to work as a designer, adding decorations to the Crillon restaurant, this exhibition of racial types made his reputation. Selections from the group were exhibited in 1923 at the Boston Art Club and at the Memorial Art Gallery in Rochester, New York, and some of the Mexican portraits were chosen by Katherine Anne Porter to illustrate a special Mexican number of *Survey Graphic*, the social welfare journal.

Reiss had brought back from Berlin several books on Egyptian and African art, most notably *Negerplastik* by Carl Einstein, which was illustrated with numerous masks. That book apparently had revived some of his interest in African art, for inside the back cover of the Anderson Galleries catalogue he created a modernist design with an African mask in its center. In retrospect, this was a portent of a more significant involvement with the Black theme. In 1924, Paul Kellogg, editor of

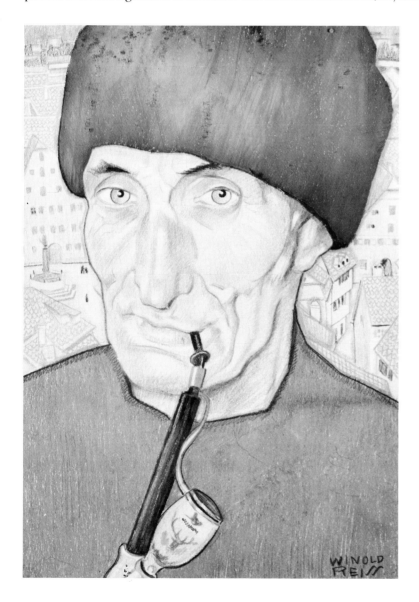

WATCHMAN OF THE ROTHENBURG TOWER (MICHAEL MENT)
Colored pencil on paper, 1922
Renate Reiss

Survey Graphic magazine, asked Reiss to illustrate a special issue that would chronicle a new literary and cultural movement centered in Harlem. Kellogg had recruited Alain Locke, the Black professor of philosophy at Howard University and an emerging literary critic, to guest-edit the special issue. Kellogg gave Reiss total responsibility for producing the artwork for the issue, which included numerous abstract designs based on the Harlem theme. But even more important, Reiss was commissioned to do portraits of Harlem residents and the "New Negroes," the young leaders of the Harlem Renaissance, as the movement would later be called.[13]

Reiss set about his task with enthusiasm, and with the help of his brother Hans, paid

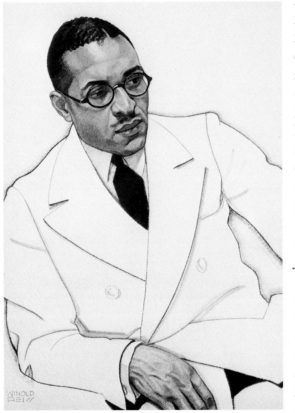

CHARLES SPURGEON JOHNSON
(1893–1956)
Pastel on board, circa 1925
National Portrait Gallery,
Smithsonian Institution; gift of
Lawrence A. Fleischman and
Howard Garfinkle with a matching
grant from the National Endowment
for the Arts

Blacks from the streets of Harlem to pose for him in his studio. Obtaining sittings from prominent Black leaders was more difficult, but Alain Locke, with the assistance of Charles S. Johnson, editor of *Opportunity* magazine, and Elise J. McDougald, an assistant principal in Harlem and a leader in the women's movement, made the necessary introductions. That such portraits would be used to illustrate the racially uplifting Harlem issue was the factor that convinced most to pose. Reiss appreciated the support and wrote to Locke: *Thanks very much for your letter which I received right after the sitting Mr. Roland Hayes was kind enough to give me. I found Mr. Hayes a very interesting man and indeed a true artist. I enjoyed ever so much to draw him. His concert was a tremendous success. I also drew Mr. Jackman, Mrs. McDougald, Mr. Morgan and a few others. On Sunday Mr. Robeson will give me a sitting. I am sure the collection is of a greater interest now and I only await for you to see it and make your choice.*[14]

Locke did make his choice, and on March 1, 1925, *Survey Graphic*'s special issue, "Harlem: Mecca of the New Negro," appeared with Winold Reiss's portrait of concert singer Roland Hayes, embedded in an Expressionist design on the cover. The issue was illustrated throughout with full-page, stunning portraits of African Americans of all shades and all social classes. It also contained a number of imaginative designs that attempted to capture the spirit of Harlem life as well as poems, essays, and short fiction by African American and Euro-American writers. The issue was an immediate sensation, selling out two complete printing runs and becoming the most popular number of *Survey Graphic* published to that date.[15]

Reiss's portraits were easily the most striking feature of the issue. He drew Elise J. McDougald with tact and sympathy, merely outlining her body in charcoal and thereby directing the viewer's attention to her softly shaded face and haunting eyes. He continued to blend his subject's body into the white background, a technique he had developed in the Oberammergau

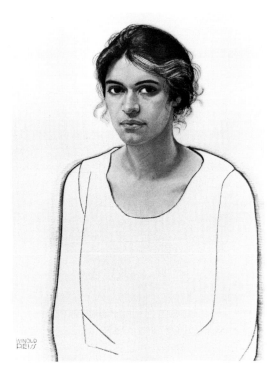 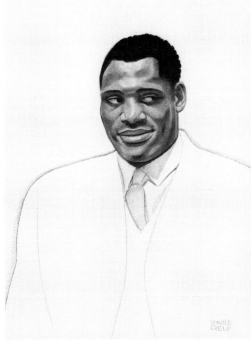

ELISE J. MCDOUGALD
(1885–1971)
Pastel on board, 1924
National Portrait Gallery,
Smithsonian Institution; gift of
Lawrence A. Fleischman and
Howard Garfinkle with a matching
grant from the National Endowment
for the Arts
(color illustration on page 146)

PAUL ROBESON
(1898–1976)
Conté crayon on board, 1924
National Portrait Gallery,
Smithsonian Institution; gift of
Lawrence A. Fleischman and
Howard Garfinkle with a matching
grant from the National Endowment
for the Arts

portraits, but here it produces a bolder, more compelling effect because of the stronger contrast with the sitter's facial color. In the portrait of Paul Robeson, it seems as if Robeson is emerging from whiteness wearing white culture in the form of Western clothing. Reiss also drew Robeson as Emperor Jones, the lead character in Eugene O'Neill's play of the same name, who goes mad on a Caribbean island.[16] All of the ruthlessness and smirking condescension of that character are conveyed in Reiss's portrait. By contrast, in the portrait of Alain Locke, who posed for Reiss after the Harlem issue appeared, the sober mood, attention to facial detail, and soft outlining of his formal coat speak for the pride and dignity of America's Black intellectual class. In a manner reminiscent of Rudolf Schlichter's portraits of Berlin's working class, Reiss presented African Americans as he had presented American Indians in 1919—as dignified individuals deserving of respect from the larger culture.

Reiss's most interesting portraits were of Black urban working-class women. For the *Survey Graphic* issue, Locke selected *Girl in the White Blouse* and included her in a section entitled "Harlem Types." Here Reiss provided a detailed treatment of the face and blouse of an anonymous woman, who appears to belong to the 1920s working poor. Yet he rescued the portrait from anonymity by his tribal treatment of her upstanding hair, reminiscent of his depiction of hair in *Aztec Indian from Tepozotlan* [see page 43]. As in his Mexican portraits, Reiss was concerned here with ancestral heritage, which he evoked as well in *Two Harlem Girls*.

In this latter portrait, the hairstyle of the girl at right may also have been inspired by photographs of small-scale Egyptian sculptures in Hedwig Fechheimer's *Kleinplastik der Ägypter*, which Reiss had in his library and probably purchased in Berlin in 1922.[17] The hair juts out at a perpendicular angle very similar to that of the headdress in an alabaster statuette reproduced as plate 14 in Fechheimer's book. And the grouping of the two figures resembles that of *Anzj-Nefer*

ANZJ-NEFER MIT SEINER FRAU
Published in *Kleinplastik der Ägypter* by Hedwig Fechheimer (1922)

**UNTITLED
(SHOUTING WOMAN)**
By Stuart Davis (1894-1964), 1915
Published in *Art for the Masses* by Rebecca Zurier (1988)
Collection of American Literature, The Beinecke Rare Book and Manuscript Library, Yale University

mit seiner Frau, reproduced as plate 16. The hair of both Harlem women uplifts and frames the faces, especially that of the woman at left, whose powerful features and strong gaze connote a feeling of self-assurance. Reiss may have found in Egyptian sculpture a leitmotif that not only embellished his subjects, but brought out what he believed was the racial heritage traceable to Egyptian Africa.

Reiss's work broke new ground in American portraiture of Blacks. Of course, there had been a nineteenth-century tradition of realist depictions of Blacks, most notably Winslow Homer's historical and genre studies. In addition, such early twentieth-century modernists as Robert Henri and Stuart Davis had occasionally produced sensitive genre treatments of Blacks. But pictures such as Homer's *Dressing for the Carnival* were less accurate portrayals of Black life than Homer's own interpretation of post-Reconstruction Black expectations.[18] Much worse were the modernists: Robert Henri could create dialect jokes and racist cartoons, while Stuart Davis produced stereotyped caricatures for *The Masses*, some of which even his editor, Max Eastman, described as "viciously anti-Negro."[19]

It should be understood, of course, that American modernists such as Davis had little more than the minstrel tradition to turn to in their search for images of the Negro in the early twentieth century. By contrast, Reiss approached the African American subject from the vantage of the European romantic tradition in which Indians (and, in the wake of late nineteenth-century colonialism, Africans and Asians) were Noble Savages who embodied aesthetic traditions that provided alternatives to the dominant European sensibilities. The European tradition was nevertheless as stereotypic as the American. To modernized Europeans, non-Westerners still retained a connection to nature and spiritual forces that they themselves had lost. But in the America of the 1920s, images of the noble African American were an improvement over the prevailing comic and caricatured images of Black plantation mammies and minstrel coons. In addition, because Reiss had been exposed to African art as a student in Munich and during his 1922 trip to Berlin, he conceived of Blacks as bearers of an African tradition that had something to teach the West. Such images of African Americans as his *Harlem Girl I*, *Black Prophet*, or *Harlem Girl with Blanket* thus made a powerful cultural statement: here were Black men and women who were proud of their color, their race, and their heritage.

Reiss was ahead of his time in these bold renderings of largely dark-skinned African Americans, and some Blacks reacted negatively to his portraits, either as seen in *Survey Graphic* or at the exhibition of all thirty-seven portraits at the Harlem Branch of the New York Public Library. Controversy raged around one in particular, that of *Two Public Schoolteachers*. Elise McDougald wrote to Locke from New York that *many interesting episodes have centered around the appearance of the Harlem Issue. . . . One Mr. Williams wondered if the whole art side of the issue were a "piece of subtle propaganda to prejudice the white reader." He told us that "Should he meet those two school teachers in the street, he would be afraid of them." It happened that one of them, Miss Price had come in late with me from another meeting. When an opportune moment arrived, she stood to express her regret that she would frighten him but claimed the portrait as a "pretty good likeness."*[20]

Locke reacted swiftly and publicly to the criticism, which also questioned his choice of a white artist to illustrate an issue on Negro culture. In "To Certain of Our Philistines," in the May 1925 *Opportunity* magazine, he argued that the negative reactions to the art were really reactions to the dark-skinned figures in the portraits, a color prejudice within the Black community that

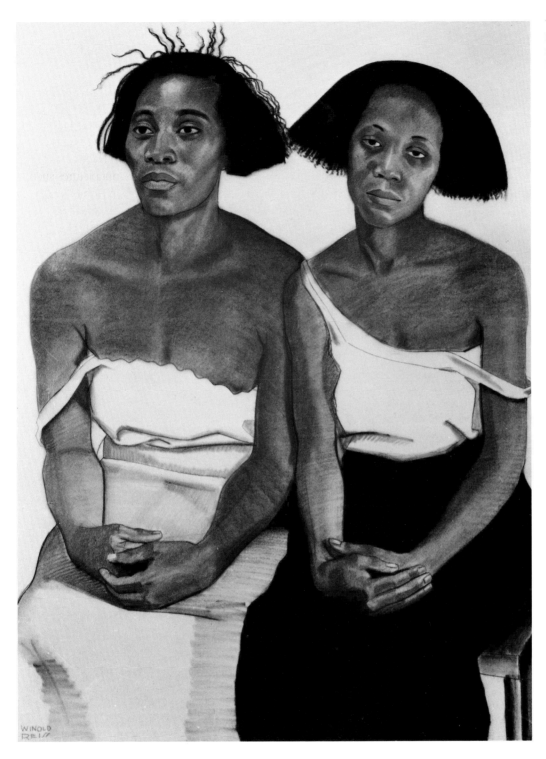

TWO HARLEM GIRLS
Pastel and conté crayon on board,
circa 1924
Mr. and Mrs. W. Tjark Reiss

DAWN IN HARLEM
Ink and wash on paper, circa 1924
Beth and James DeWoody

A COLLEGE LAD
(HAROLD JACKMAN)
Pastel and conté crayon on board,
1924
Collection of the Wolfsonian
Foundation, Miami, Florida

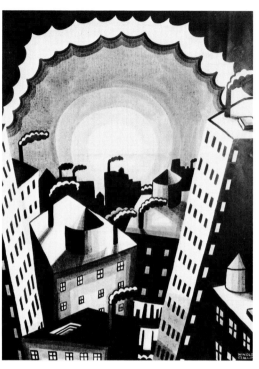 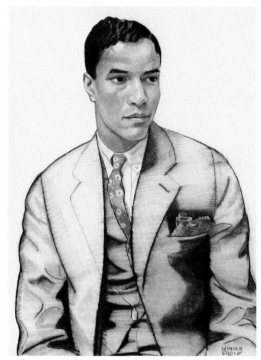

CONGO
or **THE AFRICAN**
Pastel on board, 1925
Fisk University Museum of Art

ALAIN LOCKE
(1885–1954)
Pastel on board, 1925
National Portrait Gallery,
Smithsonian Institution; gift of
Lawrence A. Fleischman and
Howard Garfinkle with a matching
grant from the National Endowment
for the Arts

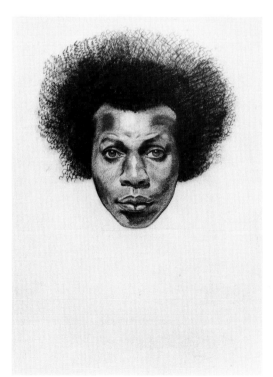 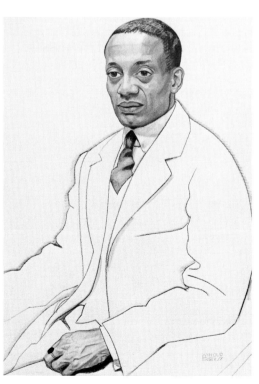

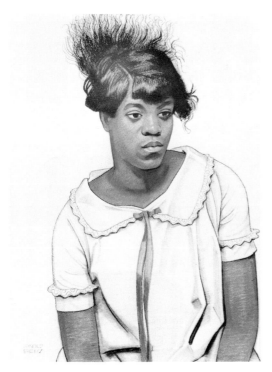

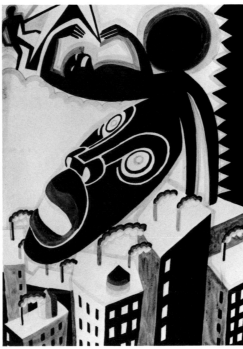

GIRL IN THE WHITE BLOUSE
or HARLEM GIRL III
Pastel, conté crayon, and graphite
on board, circa 1924
Fisk University Museum of Art

MASK OVER CITY
Ink, wash, and graphite on paper,
circa 1924
Private collection, courtesy
Shepherd Gallery Associates

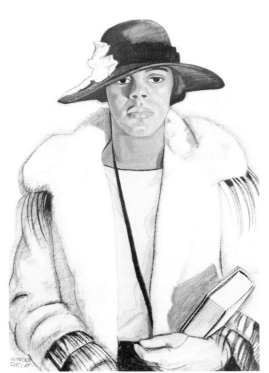

THE LIBRARIAN
Pastel, conté crayon, graphite, and
gouache on board, circa 1924
Fisk University Museum of Art

HARLEM GIRL I
Pencil, charcoal, and pastel on
board, circa 1925
Museum of Art and Archaeology,
University of Missouri-Columbia;
gift of W. Tjark Reiss (78.183)
(color illustration on page 3)

BLACK PROPHET
Pastel and conté crayon on board,
1927
Renate Reiss

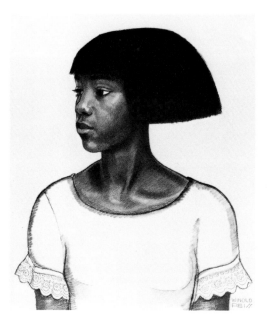

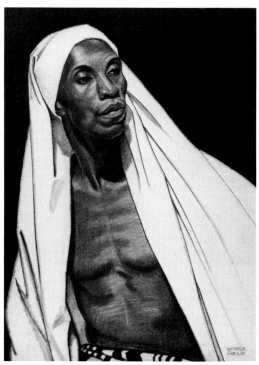

"distorts all true artistic values with the irrelevant social values of 'representative' and 'unrepresentative,' 'favorable' and 'unfavorable'—and threatens a truly racial art with the psychological bleach of 'lily-whitism.' This Philistinism cannot be tolerated." Defending Reiss's work, Locke continued, *Let us take a concrete instance, the much criticized Reiss drawing entitled "Two Public School Teachers." It happens to be my particular choice among a group of thirty more or less divergently mannered sketches; and not for the reason that it is one of the most realistic but for the sheer poetry and intense symbolism back of it. I believe this drawing reflects in addition to good type portraiture of its sort, a professional ideal, that peculiar seriousness, that race redemption spirit, that professional earnestness and even sense of burden which I would be glad to think representative of both my profession and especially its racial aspects.*[21]

Reiss had unwittingly entered into a debate within the Black community about how its image was to be presented to the larger public. The influx of thousands of southern-born, dark-skinned, working-class African Americans to the urban North during World War I had intensified color and class consciousness among some northern-born, lighter-skinned, middle-class Blacks.[22] After years of being stereotyped, caricatured, and misrepresented in the American print media, many educated African Americans believed that too much attention had been focused on the Black lower class, to the detriment of the race as a whole. Some wondered whether it was possible for a white artist to sensitively render the Black image at all. When he labeled as "schoolteachers" two dark-skinned, tired-looking Black women (who were, nevertheless, wearing their Phi Beta Kappa keys), Reiss had challenged the preconceptions of those aggressively assimilated members of the Black bourgeoisie who associated dark skin color and African features with membership in the criminal classes. Moreover, Reiss's style had roots in a folkloric presentation of the working classes of the world, which these Blacks may have perceived as somewhat disrespectful.

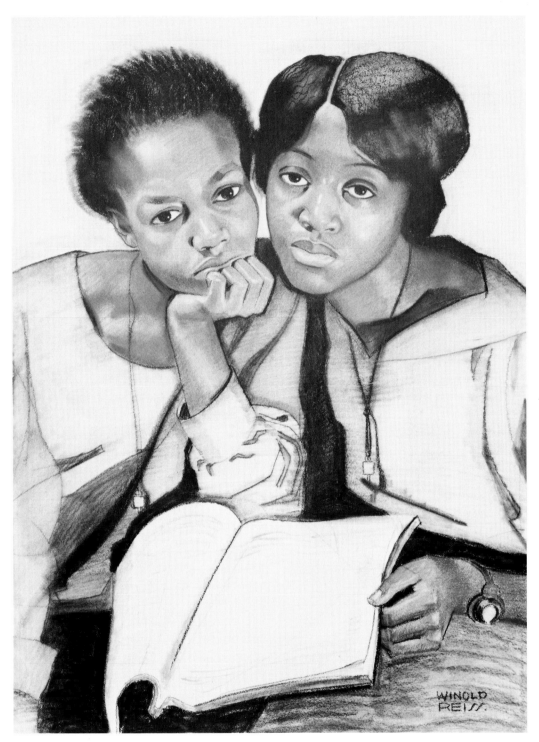

By illustrating the Harlem issue of *Survey Graphic* and later *The New Negro: An Interpretation*, Locke's book-length version of the magazine, Reiss had associated himself with the modernist wing of the Harlem Renaissance, which was challenging the preconceptions of many Blacks about their culture. Those writers who sat for Reiss—Jean Toomer, Countee Cullen, Zora Neale Hurston, Eric Walrond, and Langston Hughes—would themselves be lambasted by critics for the "unrepresentativeness" of their depictions of Black life. Even Dr. W. E. B. Du Bois, who also posed for Reiss, questioned publicly whether Blacks were too often depicted as lower class in the literature of the 1920s. An early supporter of the Black literary renaissance and the editor of *Crisis*, the journal of the National Association for the Advancement of Colored People, Du Bois decried the depiction of Blacks in the tradition of the minstrel and the plantation mammy. He approved, however, of Reiss's work. These portraits were exactly the kind of dignified presentation that the avant-garde of Black intellectuals wanted to see in American art.

Du Bois's portrait, as well as those of several other Black leaders such as Robert Moton and James Weldon Johnson, appeared in *The New Negro: An Interpretation*, published in December 1925. Rather than document the variety of social classes in Harlem, Locke used the book to broaden support for the New Negro movement by including articles from a spectrum of respected Black leaders. More significantly, Reiss's portraits were printed in color! Here was the boldest publication of Reiss's color work since the days of the *M.A.C.* Nowhere was his sensitive rendering of a subject more appropriately blended with the subtle moods of color than in the portrait Locke chose for the frontispiece, *The Brown Madonna*.

Not surprisingly, Reiss's portraiture had an impact on young Black visual artists coming to maturity in the 1920s. Lois Mailou Jones, a former professor of art at Howard University and a renowned Washington Colorist, recalls that as a young Black artist in the 1920s she went through a "Reiss period" on her way toward the development of an independent style.[23] Jones was not alone.

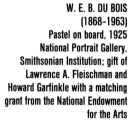

W. E. B. DU BOIS
(1868-1963)
Pastel on board, 1925
National Portrait Gallery,
Smithsonian Institution; gift of
Lawrence A. Fleischman and
Howard Garfinkle with a matching
grant from the National Endowment
for the Arts

JAMES WELDON JOHNSON
(1871-1938)
Pastel on board, circa 1925
National Portrait Gallery,
Smithsonian Institution; gift of
Lawrence A. Fleischman and
Howard Garfinkle with a matching
grant from the National Endowment
for the Arts

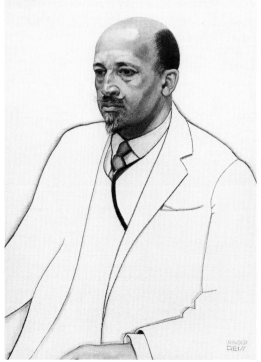
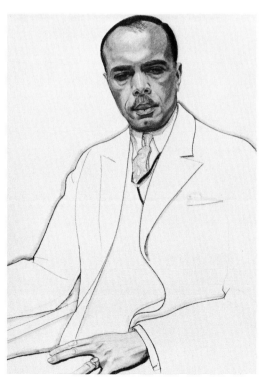

Richmond Barthé, the famous Black sculptor of the Harlem Renaissance, began his career as a painter, and his 1930 portrait of Langston Hughes bears the unmistakable imprint of Reiss's style.

Reiss had the most profound impact on the work of the young African American artist and muralist Aaron Douglas. Douglas was apparently so moved by the cover design of the Harlem issue of *Survey Graphic* that he contacted Reiss, most likely through Alain Locke, and asked to become one of Reiss's students. Douglas credits Reiss with encouraging him to look at African sculpture and develop an African American interpretive design style based on African motifs.[24]

In terms of Reiss's ongoing commitment to render in his art the dignity and distinctiveness of different racial groups, the Harlem work marked a milestone. Reiss came to recognize that the Black experience possessed its own aesthetic, which could be translated into the visual arts. He began that translation in his imaginatives, his name for abstracted compositions produced by free association on a theme or subject. From the angular forms of his Beckmannesque *Dawn in Harlem* to the more evocative *Mask over City*, with its African mask and stylized Black figures, Reiss sought to create designs that captured the rhythm, tension, and expressive form of Black culture and Harlem itself. In such compositions as *Interpretation of Harlem Jazz*, he went beyond primitivism to translate the rhythm and energy of Black dance music into what Richard Powell calls the "blues aesthetic" in the visual arts.[25] Although Reiss alludes to the African origins of this aesthetic with an African mask in the upper-right corner and a banjo between the dancer's legs, his layering of forms, juxtaposition of legs and bodies, and staccato contrasts of black and white convey more directly the swing, the dissonance, and the blues feeling of the African American performance aesthetic. Aaron Douglas, in his own interpretative design of *Emperor Jones*, borrowed the angular posture of the figure in *Interpretation of Harlem Jazz* to suggest another blues mood—a king's indignation with his court. When *The New Negro* appeared, Locke included the African-inspired designs of Aaron Douglas along with those of Reiss.

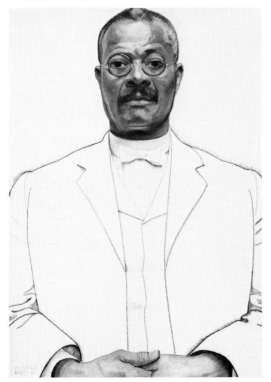

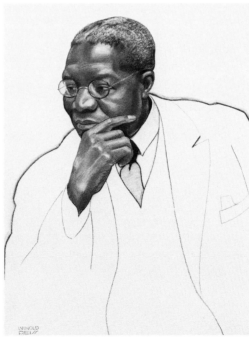

REVEREND W. W. BROWN
Pastel and conté crayon on board, circa 1925
Mr. and Mrs. Neville Blakemore, Jr.

ROBERT MOTON
(1867–1940)
Pastel and charcoal on board, 1925
Hampton University Museum

BROWN MADONNA
Pastel on board, circa 1925
Fisk University Museum of Art

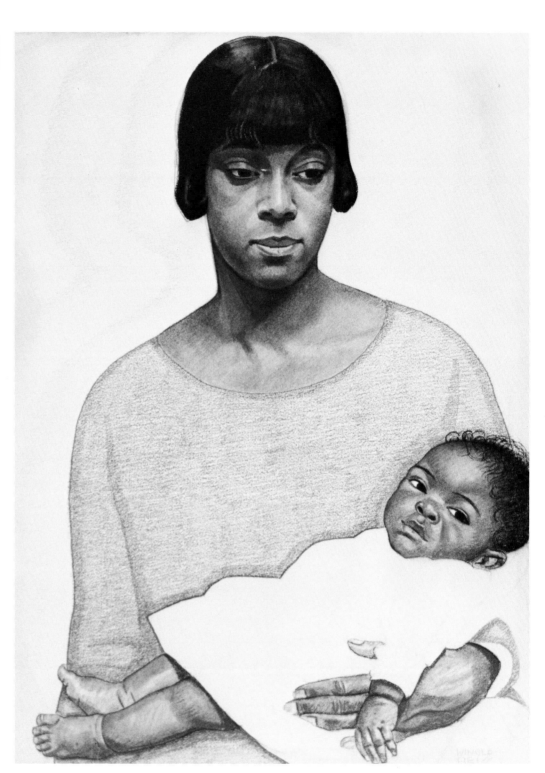

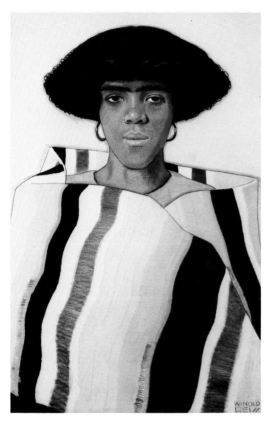

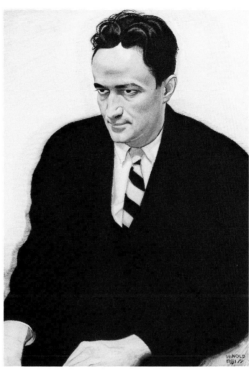

HARLEM GIRL WITH BLANKET
Pastel and conté crayon on board,
circa 1925
Mr. and Mrs. W. Tjark Reiss

JEAN TOOMER
(1894–1967)
Pastel on board, circa 1925
National Portrait Gallery,
Smithsonian Institution; gift of
Lawrence A. Fleischman and
Howard Garfinkle with a matching
grant from the National Endowment
for the Arts

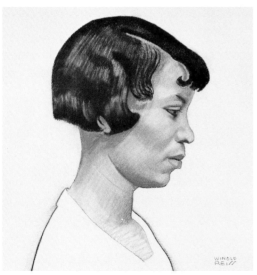

ZORA NEALE HURSTON
(1901?–1960)
Pastel, conté crayon, and graphite
on board, circa 1925
Fisk University Museum of Art

Reiss's influence extended to the entire design aesthetic of the Harlem Renaissance, with adaptations of his style appearing on the covers of small literary magazines, civic club meeting brochures, and literary contest announcements. The reason for this extraordinary enthusiasm was that Reiss's work shared the romantic idea articulated by Alain Locke in *The New Negro*: that the Harlem Renaissance was an aesthetic revival of African forms.[26] More than any specific motif, Reiss taught Aaron Douglas and others that modern American art should be based on a revival of African and other pre-modern, non-Western design forms. Douglas would go on to study Egyptian art but also to employ American Negro spirituals, dance, and folklore as symbolic motifs in his visual designs.

NEGRO COMPOSER
Pastel and conté crayon on paper
by Lois Mailou Jones (born 1905),
1934
Private collection

INTERPRETATION OF HARLEM JAZZ
Ink and watercolor on paper,
circa 1924
Mr. and Mrs. W. Tjark Reiss,
courtesy Shepherd Gallery
Associates

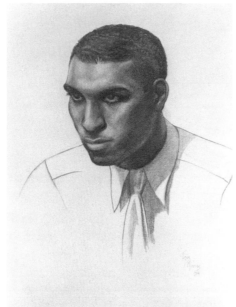

EMPEROR JONES
By Aaron Douglas (1899–1979),
circa 1926
Published in Alain Locke,
"The Negro and the
American Stage,"
Theatre Arts Monthly 10
(February 1926)
James Weldon Johnson Collection,
The Beinecke Rare Book and
Manuscript Library, Yale University

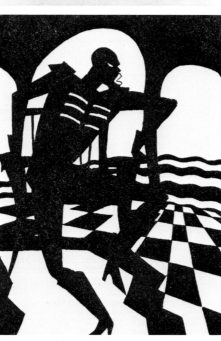

For Reiss, the discovery and development of the Black subject allowed him to achieve a synthesis of modern design and racial motifs that had eluded him in his Indian and other folkloric portraits. Although he had begun to develop a few halting design images based on the theme of Spanish conquest, his African-oriented imaginatives were more numerous and more complete as compositions. Reiss utilized the Black experience on two levels of his art: as portraits and as a fully developed signature design based on Black motifs. The latter was evident in his imaginatives and also in his 1925 interior decoration of the Congo Room, a nightclub in the Hotel Alamac on 70th Street and Broadway, whose murals and furniture were based on African themes.

Reiss's portrait of Langston Hughes, his most complete portrait of the Harlem

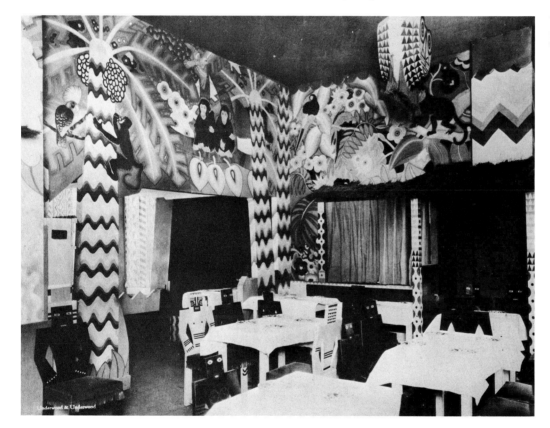

The Congo Room, Hotel Alamac, as designed by Winold Reiss, 1925
W. Tjark Reiss

Renaissance period, embodies this synthesis of African American portraiture and imaginative design. Here Reiss objectified his subject and showed his social role as a poet in the blues imaginative in the background. The background thus conveyed the Black urban experience through design, while the foreground presented the sympathetically drawn man who translated that experience into poetry.

A conflict existed, however, between these primitivist, or blues, aesthetic designs in the background and the realist portraiture of Blacks. Just as primitivism failed to capture the real feelings of African Americans, so too the attempt to reduce their culture to easily recognizable forms forced even Reiss back into the stereotypic tradition. This imagery was difficult to avoid even by non-whites, such as the Mexican artist Miguel Covarrubias, whose *Strut* was one of several stereotypical images he created during the 1920s. Perhaps the exaggeration and simplification of form required to make an abstract design ethnically familiar inevitably brought the artist to the

brink of caricature. As Reiss became friends with the Black intellectuals of the Harlem Renaissance, he, too, perceived that such a presentation of the Black form was offensive. In some of his imaginatives, he moved away from stereotyped lips and faces to a more modernistic rendering of African American features, as in *African Phantasie Sunkiss.* However, it would be left to Aaron Douglas, Reiss's African American prodigy, to evolve a less stereotypical design based on African themes.

One historian has suggested that Reiss took on Douglas as a student because he was tired of working with these themes.[27] But the evidence suggests that Reiss continued to be involved in both Black portraiture and the creation of African-inspired designs after 1925. The January 1926 issue of *Survey Graphic* contained another Reiss portrait, this one of the Gold Coast and Fanti king, Nana Amoah, who was interviewed by Locke while visiting this country. Tjark Reiss recalls that there was quite a stir at his father's studio the day of the sitting, as there was at the arrival of Matthew A. Henson, the Black man who had accompanied Robert Peary on his 1909 attempt to reach the North Pole. In 1929, after a visit to Connie's Inn in Harlem to see "Hot Chocolates," a jazz revue, Reiss was inspired by its production of "Ain't Misbehavin' " to produce another imaginative. When contacted by the Malcolm-Roberts Publishing Company in 1936 about illustrating a book of "Negro types," Reiss replied enthusiastically that he would do the project and "would also suggest some imaginative pages in black and white representing Negro art, dance, etc., similar to those I drew for the 'new Negro.' "[28]

Reiss stated the reason for his continuing commitment in a letter to Alain Locke following *The New Negro*'s publication: *I have to tell you again how much I liked to work with you and I only wish that we will have once an occasion in which we can prove just to all our ideals regardless of commercial people. It would make me very happy if my effort in helping your noble work would really be a small seed in the vast land that still has to be ploughed. Do not forget that you can always find me ready if you need help in your idealistic undertakings.*[29]

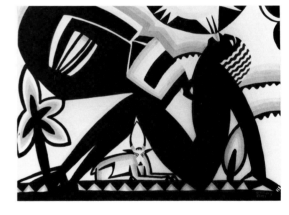

There was not, however, much of a commercial or fine arts market for Reiss's portraits of African Americans. Whereas his 1919 Indian portraits had sold soon after his return to New York, no such offer was made for the Harlem portraits. Tjark remembers that his father had difficulty exhibiting the portraits and that one gallery owner said that he would not exhibit Black portraits because such a show would bring Blacks into the gallery.[30] Racial prejudice and the etiquette of segregation limited the market for Black portraits.

Yet Reiss did find an outlet for his portraits of unpopular racial groups in *Survey Graphic,* and late in 1925 he was again contacted by the *Survey* editor in connection with another special number, this time on Asian Americans. Apparently, the newspaper writer William Allen White had gotten in touch with Kellogg after an article White had written on the Pan-Pacific Conference on International Relations had been rejected by several major magazines. The implication was that in the wake of the passage of the National Origins Act of 1924, which banned further immigration into the United States from Japan and China, fears about the "Yellow Peril"

made any discussion of the positive possibilities for the successful assimilation of Asians into American society unpopular with trade magazines. Kellogg decided to make White's article part of a special issue that would present a rational and progressive view of Asian American assimilation and the benefits to American foreign policy of a more humane view of Asia and its inhabitants. Reiss was asked to do some drawings that, along with sketches by C. Leroy Baldridge and Alexander Calder, would illustrate the issue.[31]

The point of view of this issue was set in the lead article by Robert Park, the University of Chicago sociologist who had a Progressive-era faith in social science as a solution to problems of race relations. In "Behind Our Masks," he argued that "Orientals" (in which category he rather indiscriminately included both Chinese and Japanese) could be absorbed into American society since social conventions could change. But Park still believed that "physical traits, however, do not change. The Oriental in America experiences a profound transfiguration in sentiment and attitude, but he cannot change his physical characteristics. . . . He cannot, much as he may sometimes like to do so, cast aside his racial mask."[32]

The tension in Park's view was reflected in most of the articles in the issue and in Reiss's portraits. His portrait of Mark Ten Sui was a dignified, sympathetic portrait of a man in Western dress, who by his bearing and clean-cut demeanor challenged the prevailing American

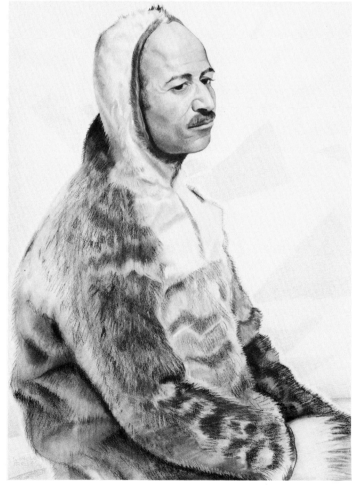

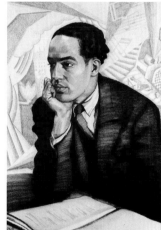

MATTHEW A. HENSON
(1866–1955)
Pastel on board, circa 1927
Fisk University Museum of Art

LANGSTON HUGHES
(1902–1967)
Pastel on board, 1925
National Portrait Gallery,
Smithsonian Institution; gift of
Tjark Reiss in memory of his
father, Winold Reiss
(color illustration on page 8)

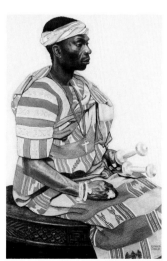

KING AMOAH III, GOLD COAST
AFRICA
Pastel on board, 1925
Private collection

view of Chinese as uncultivated "heathens." The caption to the portrait tells a story of upward mobility from immigrant status: "Mark Ten Sui, a Chinese businessman who came to America in 1872, arriving at San Francisco on the first iron steamboat to cross the Pacific."[33] Mark Ten Sui epitomized the possibilities of acculturation of American conventions by the Chinese. That message was further communicated in a portrait, *Japanese Student*, which did not appear in the magazine but was done at the same time as the others. Here we see a strong, modern Japanese man, whose Western dress is highlighted by the flair of a striped tie. The portrait dignifies its subject, presenting an image that would appeal to the largely liberal, Northeastern audience of *Survey Graphic*, which, despite strong anti-Japanese sentiment in America, might look upon the Japanese as positive models of modernization.

By contrast, *Watanabe* and *Mrs. Tabusa, from Hiroshima, Japan* suggest the retention

JAPANESE STUDENT
Pastel on board, 1926
W. Tjark Reiss

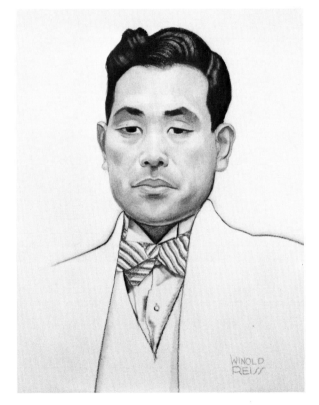

of racial traditions. Unfortunately, we do not know whether the sitters posed with their own kimonos or borrowed them for the portraits. But the visual message emphasizes their connection with traditional Japanese culture and suggests that the Japanese in America had not completely "cast aside the racial mask." Reiss wanted to draw attention to the beauty of traditional culture. Yet, unlike the strong individuality of *Mark Ten Sui* and *Japanese Student*, the decorativeness and overall mood of these two portraits comes close to an ideal image or "Oriental type." Unintentionally, Reiss's portraits here confirmed one of Park's dictums—that the further immigrants move away from their native cultures, the more they are apprehended as individuals rather than types.[34]

Reiss's portrait of a Chinese woman in a headdress was his most successful in combining modernity with respect for ancestral culture, a fact that did not escape Kellogg and the *Survey* staff, who chose it for the cover of the issue. Compared with the stereotypic "Chinese Types" drawn by C. Leroy Baldridge and illustrated elsewhere in the magazine, Reiss's portrait is strikingly naturalistic. The closeness of the subject, the soft and delicate treatment of her features, and the luminous colors in the detailed, ornamental Qing (Ch'ing) Dynasty wedding head-dress and the background all convey a warmth and immediacy designed to make her appealing to almost any viewer. A subtle tension operates here as well: the ornate headdress seems almost to overwhelm the face of this young girl; yet the addition of the colored background gives a lift and a modernity to the composition. In this young woman's wearing of the traditional crown, Reiss found a powerful statement of cultural pluralism: Asian and American cultures can be successfully combined in such a way that Asians can retain attributes of their culture even as they assimilate.

Like Park, Reiss possessed relatively fixed notions of racial types; but he believed that groups should be able to retain their distinctive culture while winning acceptance in America. In that sense, his views were closer to that of Alain Locke. For Reiss's works were testaments to the ability of America's racial groups to honor their ancestral cultures even as they assimilated into mainstream America. Reiss found an ally to disseminate this cultural pluralist perspective in the *Survey Graphic*, which supported his efforts to grapple visually with America's complexities of color and culture.

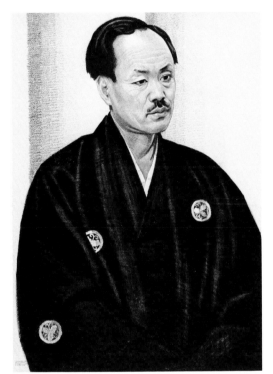 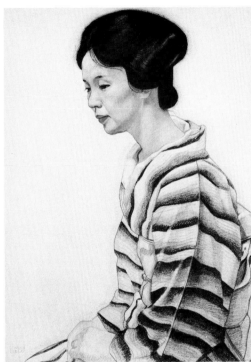

WATANABE, THE PAINTER
Mixed media, 1926
Mr. and Mrs. W. Tjark Reiss

MRS. TABUSA, FROM HIROSHIMA, JAPAN
Pastel on board, 1926
W. Tjark Reiss

CHINESE WOMAN IN HEADDRESS
Pastel on board, 1926
W. Tjark Reiss
(color illustration on page 2)

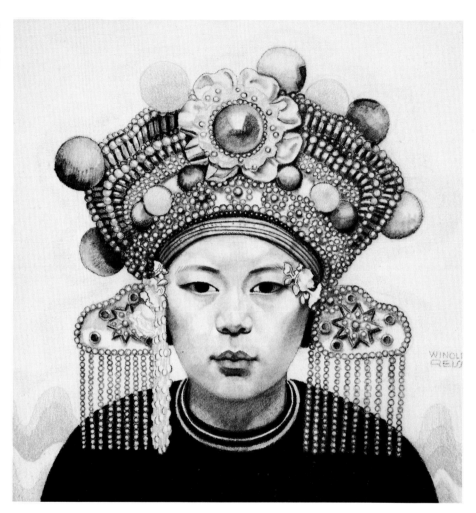

MARK TEN SUI
Pastel on board, 1926
Private collection

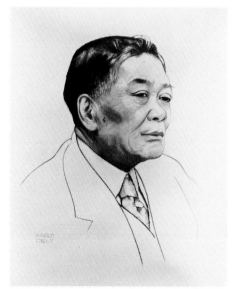

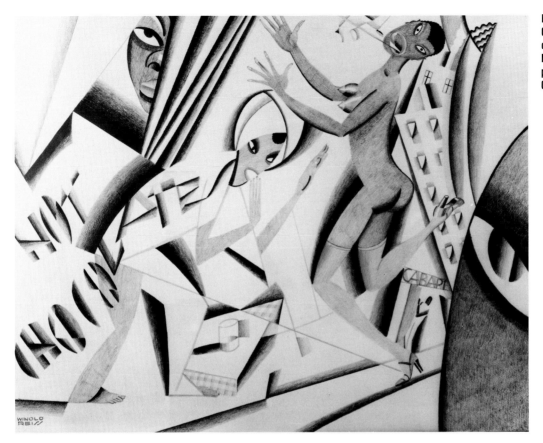

HOT CHOCOLATES
Crayon and pastel on paper,
circa 1929
Mr. and Mrs. W. Tjark Reiss,
photograph courtesy Shepherd
Gallery Associates

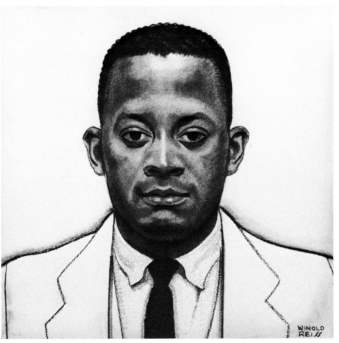

ERIC WALROND
Pastel on board, circa 1925
Fisk University Museum of Art

NOTES:

1. Kaltenborn, "Interprets Racial Types," *Brooklyn Eagle*, January 2, 1927.

2. Reiss to W. H. Holmes, U.S. National Museum, August 14, 1920, Reiss Papers, Reiss estate, private collection.

3. Interview with Tjark Reiss, July 25, 1987.

4. Undated notation by Katherine Anne Porter, Katherine Anne Porter Papers, University of Maryland (permission to publish courtesy of Mrs. Isabel Bayley, literary trustee to the estate of Katherine Anne Porter). I am grateful to Professor Thomas Walsh for leading me to this note. Reiss did go to Morelos, since he produced several urbanscapes of Cuernavaca. Porter's "Where Presidents Have No Friends" appeared in *Century Magazine* 104 (July 1922): 373-84. Reiss's Mexican illustrations also appeared in the special Mexican number of the *Survey Graphic* (May 1924), guest-edited by Porter.

5. Interview with Tjark Reiss, July 25, 1987.

6. Wieland Schmied, "Neue Sachlichkeit and German Realism of the Twenties," in *German Realism of the Twenties: The Artist as Social Critic* (exhibition catalogue, Minneapolis Institute of Arts, 1980), pp. 41-49.

7. Interview with Tjark Reiss, July 25, 1987.

8. Winold Reiss, "The Black Forest," in *The Passion Players of Oberammergau, Drawings by Winold Reiss, Also Drawings of Sweden, Blackforest, Mexico, and Portraits, Woodcuts, and Decorations* (exhibition catalogue, The Anderson Galleries, Inc., New York, 1923).

9. See Robert Jensen's essay, "Portraiture," in *German Realism of the Twenties*, p. 79.

10. Brooks Adams, "Winold Reiss at Shepherd," *Art in America* 75 (April 1987): 225.

11. Winold Reiss, "The Oberammergau Players," *Century Magazine* article reprinted in Anderson Galleries catalogue.

12. *Ibid.*

13. Carl Einstein, *Negerplastik* (Munich, 1920), especially plates 52 and 91. For "Harlem: Mecca of the New Negro," *Survey Graphic* 53, see Jeffrey C. Stewart, ed., *The Critical Temper of Alain Locke* (New York, 1983), introduction and headnote to "Renaissance Apologetics."

14. Winold Reiss to Alain Locke, December 3, 1924, Alain Locke Papers, Moorland-Spingarn Research Center, Howard University.

15. Paul Kellogg to Alain Locke, March 20, 1925, Box 710, Paul Kellogg Papers, Social Welfare Archives, University of Minnesota.

16. The full title of the Robeson portrait is given in *The New Negro: An Interpretation* (New York, 1925), p. xvii, as *Study: Paul Robeson as "Emperor Jones."*

17. Hedwig Fechheimer, *Kleinplastik der Ägypter* (Berlin, 1922).

18. Richard Powell, introduction in Peter Wood and Karen Dalton, *Winslow Homer's Images of Blacks: The Civil War and Reconstruction* (Austin, Tex., 1988).

19. William O'Neill, *The Last Romantic: A Life of Max Eastman* (New York, 1978), p. 37, quoted in Rebecca Zurier's *Art for the Masses: A Radical Magazine and Its Graphics, 1911-1917* (Philadelphia, Pa., 1988), p. 148.

20. Elise McDougald to Alain Locke, undated, *Survey Graphic* Box, Locke Papers, Howard University.

21. Alain Locke, "To Certain of Our Philistines," *Opportunity* 3 (May 1925): 155, 156, reprinted in Stewart, *Critical Temper*, pp. 161, 162.

22. Spencer Crew, *Field to Factory: Afro-American Migration, 1915-1940* (Washington, D.C., 1987), pp. 40-41; Allen B. Ballard, *One More Day's Journey: The Making of Black Philadelphia* (Philadelphia, Pa., 1987), pp. 7-8, 10, 14, 27-29, 50-51, 166-67. Several novels written during the Harlem Renaissance, most notably Claude McKay's *Home to Harlem* (New York, 1928) and Rudolph Fisher's *The Walls of Jericho* (New York, 1928), deal with the social conflict between upper- and lower-class Blacks, which sometimes manifested itself in color consciousness.

23. Interview with Dr. Lois Jones, June 16, 1988, and March 14, 1989.

24. Aaron Douglas to Winold Reiss, January 9, 1952, Reiss Papers, private collection. Douglas recalls his difficulty in taking Reiss's advice to develop a style based on the African theme: *I clearly recall his impatience as he sought to urge me*

beyond my doubts and fears that seemed to loom so large in the presence of the terrifying spectres moving beneath the surface of every African masque and fetish. At last, I began little by little to get the point and to take a few halting, timorous steps toward the unknown. I shall not attempt to describe my feelings as I first tried to objectify with paint and brush what I thought to be the visual emanations or expressions that came into view with the sounds produced by the old black song makers of antebellum days when they first began to put together snatches and bits from Protestant hymns, along with half remembered tribal chants, lullabies and work songs. See "Aaron Douglass [*sic*], Topeka Boy and Former Lincoln High Teacher Here, Wins Fame in New York as Artist," *Kansas City Call*, November 4, 1927, Harmon Foundation Papers, Manuscript Division, Library of Congress; quoted in Richard Powell, "The Blues Aesthetic: Afro-American Culture as an Instrument of Style in Modern American Painting" (M.A. thesis, Yale University, 1982), p. 23. I am indebted to Dr. Richard Powell for bringing this quotation to my attention.

25. Powell, "The Blues Aesthetic," *passim.*

26. Alain Locke, "The Legacy of the Ancestral Arts," *The New Negro* (New York, 1925), pp. 254-67.

27. David Levering Lewis, *When Harlem Was in Vogue* (New York, 1981), p. 97.

28. Reiss to R. W. O'Brien, Malcolm-Roberts Publishing Company, February 5, 1936, Reiss Papers, private collection.

29. Reiss to Alain Locke, December 31, 1925, Locke Papers, Howard University.

30. Interview with Tjark Reiss, July 25, 1987.

31. "About Ourselves," *Survey Graphic* 54 (May 1, 1926): 130.

32. Robert E. Park, "Behind Our Masks," *Survey Graphic* 54 (May 1, 1926): 138. For an excellent discussion of Robert Park's sociology as related to Asian assimilation, see John Tchen's introduction to Paul Siu, *The Chinese Laundryman: A Study of Social Isolation* (New York, 1987). I am indebted to John Tchen for his comments on this issue.

33. "Five Portraits of Orientals in America," *Survey Graphic* 54 (May 1, 1926): 159.

34. Park, "Behind Our Masks," p. 137.

The variety of Reiss's portraiture of racial types was reflected in the eight works he submitted to the Brooklyn Museum's "Exhibition of Water Color Paintings, Pastels, and Drawings by American and European Artists," held from January to February 1927. Among them were the portrait of Roland Hayes from the Harlem series, those of a Miché Indian from Mexico and a Zapoteca Indian from New Mexico, and *Salomé*, a portrait of a Jewish American woman done as a type study.[1] As Helen Appleton Read noted, Reiss was gaining a well-deserved reputation for his portrait painting because of its "combination of decoration and meticulously observed fact."[2] Moreover, he had become a very successful interior designer, in part because of the suitability of his style to the architectural and decorative innovations of the 1920s. By 1926, he had added decorations to the Crillon restaurant and had pioneered in the designing of restaurants around a theme—the famous Congo Room at the Hotel Alamac. His designs were exhibited frequently in the middle twenties with those of such well known modern designers as Joseph Urban, Walter Gropius, Paul Frankl, and Ilonka Karasz.[3]

Yet Winold Reiss was itching to go West: *It has always been my ambition to spend years out West painting the American Indian. What finer thing could one do for these brave fine people, who are so rapidly disappearing, than to go out to their reservations, live with them, study them and preserve their wonderful features and types? Some time soon I will make the rounds of all the reservations, spend several years and draw and paint the most characteristic representatives of all the chief tribes.*[4]

Unfortunately, Reiss would never have the chance to produce such a comprehensive body of portraiture of American Indians. But he did find a way to return to Montana. His brother Hans had spent the summer of 1925 in Glacier Park, Montana, and had gone rock climbing with Louis W. Hill, president of the Great Northern Railway, which operated several hotels in the park. In January 1926 Hans wrote to Hill, suggesting that he invite Winold to the park to paint Indians. Hill had already brought out W. Langdon Kihn, Reiss's student, and several others for that purpose.[5] In response to Hans's letter and the enclosed catalogue and photographs of Winold's portraits, Hill instructed W. R. Mills, manager of the advertising department of Great Northern, to extend the invitation. "Note on back of the catalogue statement," Hill remarked to Mills, *that he furnished decorations for the interior of the Restaurant Crillon. . . . We might . . . suggest the idea of his furnishing us something in the way of decorative pictures or panels for exhibition purposes, and for the summer season to be hung in one or two of our big hotels. I think this man is one of the best prospects we have had in the way of artists painting Indian pictures, which are our strongest feature, and it takes a good artist to make them.*[6]

Louis Hill was the son of James J. Hill, the Canadian-born venture capitalist who had founded the Great Northern Railway, one of the last and most profitable transcontinental railroads. In 1910 Hill, along with others, had lobbied Congress to establish Glacier Park under the National Park Service, and then he built Glacier Station, a stop on the Great Northern Railway, and several hotels near the park to encourage passenger travel on the railroad. In this endeavor, Hill—who

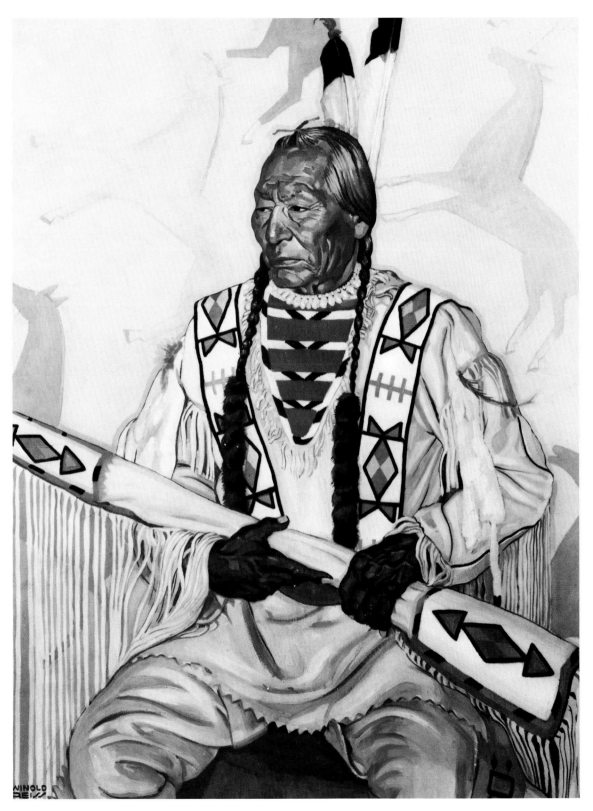

PETE AFTER BUFFALO (born 1859) Oil on canvas, 1927 The Anschutz Collection

invented the phrase "See America First"—was following the lead of the Santa Fe Railroad, which had already appropriated the Indian motif to attract tourists. But he also realized that the railroad had a responsibility to the Blackfeet people whose land it traversed. Believing that a misdirected American reservation policy had failed to provide a means for the American Indian to survive in the world of the white man, Hill employed the Blackfeet to entertain tourists at East Glacier, the major hotel run by the railroad at Glacier Station. Although the hotels were modeled after Swiss lodges and the waitresses were dressed in Swiss peasant outfits (evidently to plant another idea in tourists' minds, that the Rocky Mountains were America's Alps), the entertainment at East Glacier revolved around the theme of Indian culture in the Northwest—especially that of the Blackfeet. Indians lived in tepees provided by Great Northern, greeted tourists at the train depot wearing formal dress outfits, posed for photographs, and danced in powwows at the hotels.[7]

Calvin Last Star, a dancer at the East Glacier Hotel, recalls what it was like for the Indians. *I danced up there from when I was two years old. They had a little program for the tourists at 8 o'clock every night. I'd fancy dance; they had an owl dance—men and women would dance to that—and a rabbit dance, and a round dance to get all the tourists to dance, a circle dance. My dad and the chiefs would pass around the drum to the tourists and they would give me so much a month.... The older people ... would meet the trains at noontime and welcome the tourists.... The tourists mostly would ask you to take pictures with them.... I think my father and the other people enjoyed it. It didn't have nothing to do with the money. My dad had cattle and horses. And some of the other people who stayed up there had cattle and horses. It was just something to do that was enjoyable during the summer.*[8]

Several Blackfeet even represented the railroad at official celebrations. For example, Two Guns White Calf and Wades in the Water led the congregation of Blackfeet that Hill brought to Baltimore in 1927 to celebrate the centenary of the railroad. On that same trip they and other Blackfeet were received by President Calvin Coolidge at the White House. Some Blackfeet were

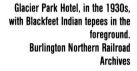

Glacier Park Hotel, in the 1930s, with Blackfeet Indian tepees in the foreground. Burlington Northern Railroad Archives

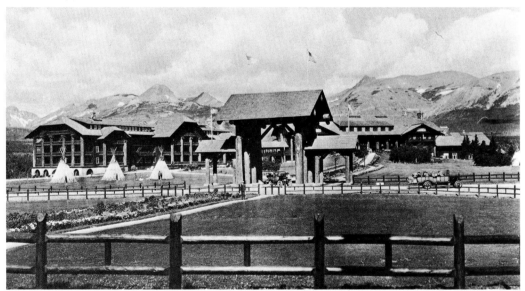

especially skillful at playing the Indian and manipulating the politics of romantic portraiture to serve their own ends. Two Guns, for example, captivated white tourists at Glacier Park by claiming, falsely, that he was the Indian on the buffalo nickel. He charged them accordingly when posing for photographs.[9]

Other Blackfeet Indians, however, resented the hotel and those who worked there. William S. (Billy) Big Spring, who posed for Reiss, recalled that his father refused to participate in Great Northern's programs: "They came to ask my dad to do it, but he never did . . . he felt it was very degrading. He said it was more like . . . well, he called them monkeys. He said they were performing for little or nothing and he had a ranch to run."[10] Some Indians were disturbed that those with little standing in the Blackfeet nation were called "chiefs" at the park and given royal treatment. Other internal tensions and jealousies within the Blackfeet community were generated by the railroad's policy of hiring only full-blooded Blackfeet, thereby excluding the numerous mixed-bloods. Moreover, most Blackfeet families were quite poor and did not own the expensive formal garments required for the greetings and entertainment. In the end, the railroad only employed a small fraction (less than 1 percent) of the Blackfeet population. Although Louis Hill's intentions were noble, his experiment did not actually provide a way for the majority of the Blackfeet to live independent lives in the twentieth century.[11]

In some respects, Winold Reiss and Louis Hill were a natural match. Both had grown up reading romantic novels of the West and regarded the Indians as noble, friendly, and honorable. Both were also Indian enthusiasts, amateur anthropologists, and collectors. And if they seemed to enshrine the modern Indian as the embodiment of a romantic tradition that had little to do with contemporary reality, it was because they realized that the only way Indians could appeal to the broad American public was in the guise of the Noble Redman.

The arrangements for Reiss's trip and negotiations with Great Northern seem to have taken longer than expected, so that Reiss did not set out until the summer of 1927. Great Northern agreed to pay for all his transportation and living expenses for three months, during which he would draw whatever Blackfeet or Blood Indians he might find. The railroad made available a studio at East Glacier Hotel for his entire stay. In return, Great Northern would be able to select and hold copyright on those portraits it wished to use on its calendars, but could not grant secondary rights to any other company. Great Northern or Hill himself would have the right to purchase any or all of the portraits at a reduced price. If the arrangement worked to everyone's satisfaction, there was the possibility that the Reisses' residency could be renewed each year.[12]

Reiss and his son, Tjark, arrived in St. Paul, Minnesota, on June 8 or 9. W. R. Mills, who handled the arrangements, had asked Reiss to stop a day in St. Paul to look over some photographs of Blood Indians on a Canadian reservation. Great Northern was about to open its new Prince of Wales Hotel on Waterton Lakes and wanted some portraits to advertise the resort. After St. Paul, Reiss hurried on to Glacier Park.[13] His accommodations at the East Glacier Hotel were a far cry from the crowded bunk he had shared in a Browning hotel room eight years before. After setting up his studio, Reiss and his son surveyed the grounds and the facilities.

East Glacier was one of a series of hotels located near the train station that accepted tourists arriving between June 15 and September 15. Nevertheless, it was not the ideal location for painting large numbers of Blackfeet. The park employed only a handful of Indians. The majority of the Blackfeet lived far from the park, and because Reiss did not have an automobile, it was impossible for him to travel to their farms and ranches. He hit upon a solution in late June, when

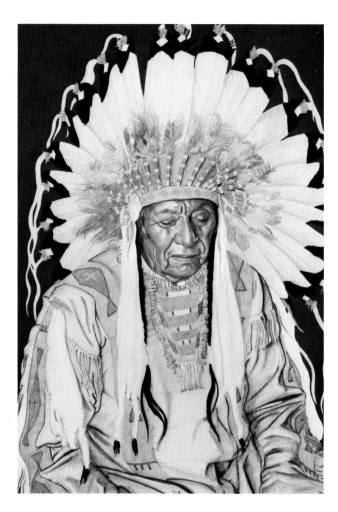

HOME GUN
(born 1860)
Mixed media, 1927
The Anschutz Collection

he learned that a sun dance, the major religious ceremony of the Blackfeet, was to be held that July 4 in Browning. He rented a room in Browning's Hotel Hagarty and turned it into a studio. Browning was also the site of the Blackfeet Agency, which was providing rations and supplies for Indians on the reservation, thereby making it an ideal place to meet Blackfeet. The sun dance of 1927 thus enabled Reiss to draw a cross section of the old generation of buffalo days warriors, men like Pete After Buffalo, Home Gun, and Lazy Boy.[14]

The sun dance was the most sacred of Blackfeet religious rites. Generally, a woman who had made a vow to the sun, seeking, for instance, to spare the life of a family member, hosted the sun dance in a particular year. She fasted for several days and participated in a complex ritual of purification before supervising the raising of the medicine lodge. Such lodges consisted of several posts in a circle tied together by stringers to a sacred center pole. Warriors hung offerings to the sun on this pole, recounted their war successes, and danced to the accompaniment of old men singing and beating on buffalo hide drums. Dancers often faced the sun and blew eagle bone whistles while wearing nothing but breechcloths and moccasins, although shirts decorated with a dream-inspired design were also worn. Dancing, singing, storytelling, and the ritual consumption of dried buffalo tongue wafers lasted for four days, during which the entire community renewed itself.[15]

Perhaps Reiss's most beautiful portrait of 1927 was that of Home Gun. The artist has clearly moved beyond the simple, strong facial characterizations that dominated his 1919 pictures and provided instead a complete, detailed, and decorative portrait of the man and his dress. In those earlier portraits Reiss had paid less attention to what his sitters were wearing. Now, perhaps with a greater anthropological appreciation for the valuable detail of Blackfeet dress, he supplemented facial characterizations with a strong decorative treatment of the entire sitter. Indeed, in his portrait of Home Gun, with its striking cobalt blue background, elaborately detailed dress shirt, and luminous Sioux headdress, which the Blackfeet had adopted in the late nineteenth century, Reiss provided a complete picture of the Blackfeet in nineteenth-century formal garb. The portrait exudes the love and respect he felt for the Blackfeet heritage and attests to his artistic mission to recapture that former glory of a Blackfeet warrior who could still remember the days of intertribal warfare before the buffalo were gone.

Reiss rendered the radiant colors of Blackfeet formal dress by supplementing the pastels he used for the face with tempera for the shirt, bonnet, and background. In some cases, he also successfully exploited oil, as in his portrait of Pete After Buffalo, another warrior from the days of intertribal conflict. The intensity of the reds and blues on his shirt and on the elaborate gun case gives this picture an almost electric quality. But Reiss was not only intrigued by the designs and colors of Blackfeet dress. His detailed treatment of the boldly colored shirt and the beautiful fringed gun case cradled in powerful hands reinforces our sense that this is a strong, respected warrior who has

seen and won many battles. As John Ewers has observed, Reiss often adapted traditional Blackfeet painted hides for the designs in the backgrounds of his portraits. In *Pete After Buffalo* he used Blackfeet horse motifs to suggest a painted hide and to convey something of the Blackfeet's renown for stealing enemy horses. As in his earlier *Watchman from Rothenburg* and *Langston Hughes*, the background serves to objectify Reiss's subjects and convey their social importance.

A similar objectification takes place in the background design of *Lazy Boy*. Lazy Boy was a famous warrior, turned medicine man, whom Reiss surely met at the sun dance in Browning. The Indian wears his sun dance shirt, an eagle bone whistle, and fur headdress. The portrait also reveals the multiple levels of style on which Reiss worked: the hands and face are treated three-dimensionally, the shirt with decorative, flat colors, and the background with abstracted stick-figure symbols.

Reiss's second portrait of Lazy Boy is even more provocative, for it shows the Blackfeet in his everyday, street clothes. Breaking with the traditional image of the ceremonial Indian, Reiss produced a realistic, almost documentary portrait of Lazy Boy as he would have been seen by his friends and family out on the reservation in Browning. There are two Lazy Boys, Reiss is telling us, the formal and the informal Blackfeet, and they are both the same person.

This double imaging recurs in Reiss's two 1927 portraits of Night Shoot. In one portrait, Reiss presents this member of the Brave Dogs Honor society in his traditional formal dress. As in *Pete After Buffalo*, the artist includes the warrior's weapon, which not only adds realism to the narrative message but also creates a diagonal that cuts across and lifts the design. The background again contributes to the subject's history by recounting the exploits of the buffalo hunter through interpretative motifs that improvise on Blackfeet designs. In sharp contrast, however, is the other portrait of Night Shoot, which depicts him in a ten-gallon Blackfeet hat and gives a rather mundane cast to his face. It is almost as if this were a backstage shot, after the performance is over and the actor has changed to street clothes, packed his things, and is ready to go home to wife and family. Reiss also painted Night Shoot's wife, Scalping Woman. In this record of how contemporary Blackfeet women looked on the reservation, Scalping Woman appears in a simple dress, without the kind of heavily beaded outfits more typical of formal nineteenth-century dress.

Reiss thus portrayed not only the ideal Indian, but also the real Blackfeet at a time when most white portrayers of Indians stuck to the more romantic image. By drawing Indians in both formal and everyday garments, Reiss documented the Blackfeet nation's transition from nineteenth- to twentieth-century life-styles. While it was certainly true that his sitters looked more beautiful in formal dress, in reality that dress was worn less and less frequently on the reservation. Indeed, Great Northern may have perpetuated such costumes long after their time by paying Blackfeet to wear them for the benefit of white tourists at Glacier Park. By producing both kinds of portraits, Reiss satisfied the railroad's desire for traditional Indian images for its advertising calendars, but also introduced through these calendars a more accurate image of how Blackfeet Indians looked in Montana in the late 1920s.

Shortly after July 7, Reiss returned to his studio at East Glacier Hotel, bringing with him several Indians whom he wished to continue drawing.[16] Although the Browning sun dance had served his immediate artistic purpose, it had also disturbed him. Tjark Reiss remembers his father remarking on the stupidity of the Department of Interior's requirement that the Blackfeet hold their sun dance on July 4, while setting no restrictions on the behavior of local whites. The sacredness of the Blackfeet religious celebration was therefore marred by exploding firecrackers and drunken whites who were allowed to drive trucks and automobiles right up to the lodges, to

SCALPING WOMAN
(born 1877)
Mixed media, 1927
The Anschutz Collection

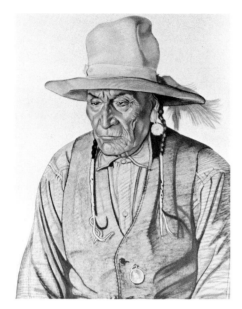

LAZY BOY
Pastel on board, 1927
Private collection
(color illustration on page 11)

LAZY BOY IN HIS MEDICINE ROBES
(1855-1948)
Pastel and tempera on board,
1927
Department of Anthropology,
National Museum of Natural
History, Smithsonian Institution

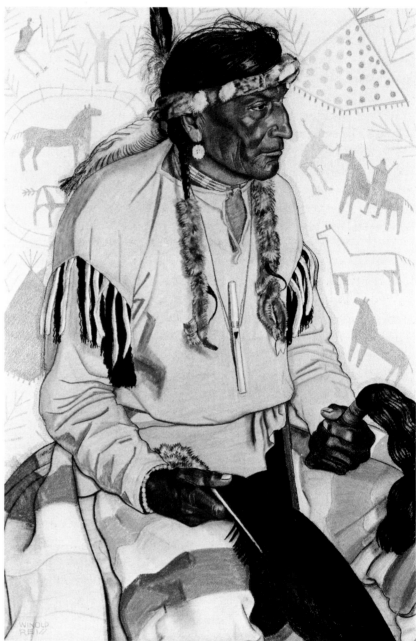

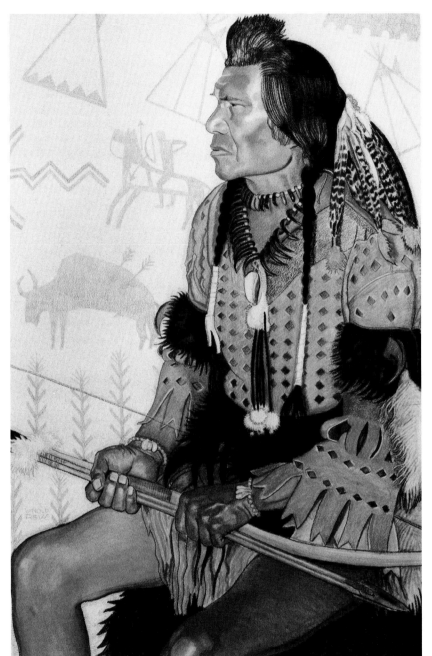

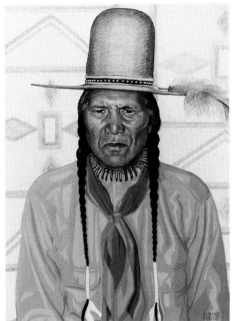

NIGHT SHOOT
Mixed media, 1927
The Anschutz Collection

NIGHT SHOOT—BRAVE SOCIETY
Mixed media, 1927
The Anschutz Collection

blow their car horns, and to yell to one another without any respect for the proceedings. The American practice contrasted dramatically with what Winold and Tjark would find when they traveled to Alberta that summer: the Canadian government allowed the Blackfoot (the modern name of the three related tribes in Canada of the Blood, the North Piegan, and the Siksika Indians) to determine the timing of the sun dance ceremonies. Moreover, the Canadian government required visitors to the Blood Reserve to apply for permits to enter Indian territory.[17]

Reiss went to Alberta in late July, at the urging of W. R. Mills, to draw the Blood Indians. Great Northern helped him transport his materials and arranged for a temporary studio at the headquarters of Mr. Pugh, the superintendent of the Blood Indian Reserve, located approximately seven miles outside of Cardston. On this trip, Reiss produced sixteen of his most documentary portraits of Indians in everyday dress.[18]

The portrait of Heavy Shield is powerful because it leaves behind romantic images of the Indian. His angular, crossed arms are capped with marvelously sculpted, heavily veined hands. This is not the ideal of beauty but rather the ideal of authenticity: Reiss is expressing what he believes is the character of the modern, anguished Indian. By detailing every line and crease of this elderly man's face, hands, and clutched blanket, Reiss made a statement that went beyond his subject's biography. The portrait seems to express Reiss's own developing sense of the suffering endured by the Blackfoot after the white man had come and the buffalo had gone.

By contrast, his two-figure portrait of Double Steel and Two Cutter is less gripping and more composed. Reiss conveys a different message here—that of the affection and mutual regard that seem to exist between these two women. In *Double Steel and Two Cutter* the mood is more hopeful than that of *Heavy Shield*, and the shawl worn by Double Steel gives her a Madonna-like quality.

On this Alberta trip Reiss visited the Blood Indian sun dance and met a man who would be a frequent sitter for later portraits—Shot Both Sides, the Blood Indian chief. The Canadian government allowed the Blood Indians to keep their chiefs, whereas the United States government forbade it, another example of the onerous American policy toward the Blackfeet.[19] The "chiefs" who adorned the walls of East Glacier had that office imposed on them.

Reiss also produced a portrait of Shot Both Sides's wife, Long Time Pipe Woman, in which he created a tension between the abstract understructure of the tepee lining in the background and the overlay of designs on her beaded dress. The lines of the wall motifs intersect with those on the sitter's back, arms, feather, headband, and shrouded legs to suggest an abstract mosaic overlaid by bold, startling colors. At the same time, this complex composition conveys the dignity of the sitter and the spectacular design sense of the Indians.

After spending August back in Glacier Park, Reiss returned to New York, probably in late September. He had made fifty-two portraits in less than three months. And not only had he been prolific, but he had also rendered the Indians with far greater detail and accuracy of dress than he had in the 1919 portraits. In the intervening eight years, his folkloric studies of Indians, Blacks, and European peasants had sensitized him to the importance of dress. In sum, Reiss had produced some of the best portraits of his career. And in December of 1927 came his financial reward: Louis Hill purchased the entire collection of fifty-two portraits for $10,000.[20]

Reiss returned to Glacier Park in the summers of 1928 and 1929 to make more Indian portraits. Although not as prolific as that first summer, he was able to supply a steady stream of

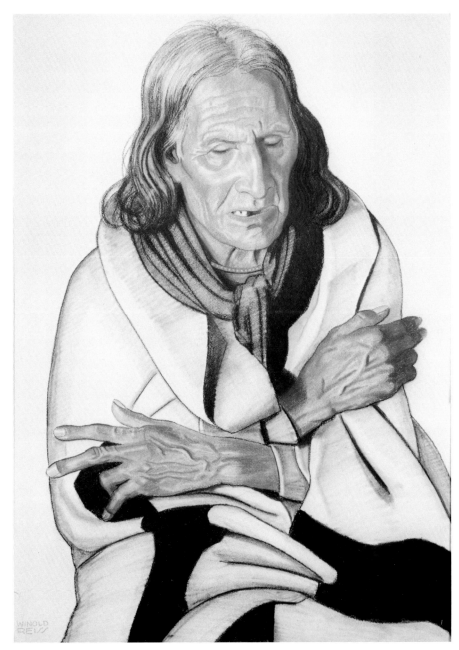

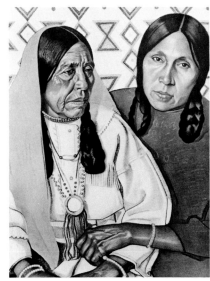

DOUBLE STEEL AND TWO CUTTER
(born 1890) (born 1873)
Pastel, charcoal, chalk, and
gouache on board, 1927
Glenbow Museum; gift of
Mr. L. W. Hill, 1979

HEAVY SHIELD
(born 1848)
Pastel on board, 1927
Renate Reiss

subjects for the Great Northern calendars, which sported a different Indian portrait every month during the 1920s. Great Northern also used Reiss's portraits in other ways. In the summer of 1927, Mills asked Reiss about "the possibility of publishing a book that could be sold at a reasonable price to tourists," which would reproduce some of Reiss's work. That book, *The Blackfeet Indians*, was really a portfolio that was eventually published by the railroad in 1935. Reiss himself made another suggestion: that Great Northern redesign the interior of their train, the Empire Builder, with an Indian motif so that it could, in Reiss's words, "give to its passengers a pleasant suggestion of the traditions of the country through which they travel."[21] What he was offering Great Northern was a multimedia design service.

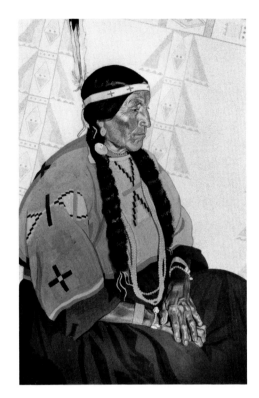

LONG TIME PIPE WOMAN
(circa 1868-1955)
Mixed media, circa 1927-1928
The Anschutz Collection

SHOT BOTH SIDES
(1877-1956)
Pastel on board, 1927
Glenbow Museum

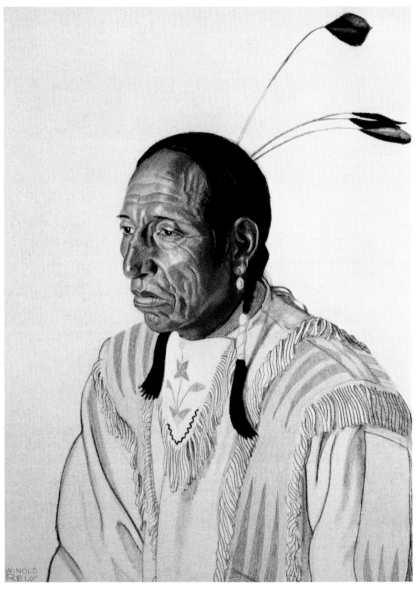

Reiss had entered a new phase in his artistic career. On one level, working for Great Northern solved a long-term dilemma—how to make the portrayal of America's folk pay. But on another, it allowed him to synthesize the folkloric and commercial sides of his artistic personality. Before the Great Northern contract, the two had been rigidly separated, the former often providing the economic means by which the latter could be pursued as an avocation. Now, however, the folkloric portraits paid because they were of use to a commercial enterprise. Reiss had entered a middle ground between folkloric and commercial art, and he would have to tread carefully that thin line between producing what would please his employer and what would please him as an artist. But given the relative freedom Great Northern granted him in selecting his subjects, he successfully manipulated the economics of patronage so as to remain true to his vision of an artistic and documentary portrayal of America's natives.

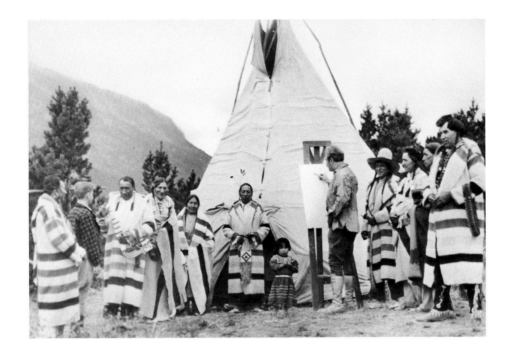

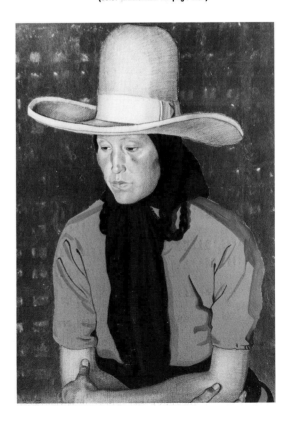

That he was successful is attested by one of his best works of the period, the stunning color portrait of Nenauaki—Mrs. Joe Devine. Reiss depicted her as an up-to-date Blackfeet woman in a ranching dress, employing his most modern style in which color is the key to form. Color not only supplies the tension in the composition, but plays a more important role than line in defining her hat, shirt, and scarf. Reiss's palette recalls the explosive color that André Derain used in his *Femme en Chemise (Lady in a Chemise)*. Applied directly from the tube, Derain's colors create an exaggerated, variegated visual arabesque.

As important as the Great Northern contract was, Reiss had other outlets for his talents in the late 1920s. Upon his return to New York in the fall of 1927, he was invited by *Survey Graphic* to travel down to South Carolina and draw portraits of the Sea Island African Americans. The project was initiated by Rossa Cooley, the white principal of Penn Community School on St. Helena Island. She knew Paul Kellogg, the editor, and wanted to promote the school and gain financial support from the northern social-reform audience. Reiss arrived on October 25, and in ten days produced approximately sixteen portraits. Four articles on the school, illustrated with these works, appeared in *Survey Graphic*, and the school made postcards out of his portraits as well.[22]

For Reiss, the project offered a marvelous opportunity to further his folkloric investigations. He believed that these African Americans were descendants of some of the last

Africans to be brought to America under the slave trade and that in the relative isolation of the Sea Islands they had perpetuated many African traditions. They spoke a Gullah language that fused elements of English and of various African languages; their dress and agricultural techniques showed the persistence of African customs. Reiss captured this persistence in his portrait of Aunt Celia Simmons, whose cloth headpiece recalls West Africa, and in *Young Basketmaker*, where a boy is fabricating what appears to be a rice fanner basket, part of the rice technology his ancestors brought with them from Africa. More broadly, men and women like Uncle Sam and Aunt Sophie Daise represented the tie with the slave past, from which St. Helena residents had survived with their dignity intact.

Although a desire to record the St. Helena community motivated Reiss's work, he was also sensitive to the promotional, nearly commercial, impulse behind this commission. He included among his subjects a number of the younger members of the community because he believed they would have broad appeal to the American public. Certainly, he succeeded admirably in producing endearing portraits of children in *Father with Two Children* [see page 14] and *Ruby and Marie Beginning Their Education in the Primary Grade*. Paul Kellogg later lamented that Reiss had not been able to produce more portraits of the community elders, even though he agreed with Cooley and Reiss that the younger subjects would attract more interest.[23]

While documenting this community, Reiss gave full play to his artistic impulses. By ignoring the effect of body contours on the pattern of Ruby's dress, à la Ludwig Hohlwein, he turned the plaid of her skirt into a flat, mosaiclike design. His portrait of Veronica Smalls [see page 86] uses the contrasts of dark and light masses, highlighted by the chrysanthemums against the rich dark brown of her face, to create a work that recalls Franz von Stuck's compositional genius [see page 23]. At the same time, these aesthetic conceits make the conceptual statement more powerful, reinforcing the image of a strong young woman of the South full of promise. Even in some of his portraits of middle-aged St. Helena professionals, such as *An Island Nurse (Nurse Brisbane)*, Reiss exploited the contrasts of her uniform—nurse's cap, the white collar and straps, and the firmly gripped nurse's bag—to give the work a crisp simplicity of design that lifts it above the merely docu-

ROSSA COOLEY
(1872–1949)
Pastel on board, 1927
Fisk University Museum of Art

mentary [see page 87]. What makes Reiss's St. Helena portraits more remarkable than his Harlem series is that he was able to render what were heavily stereotyped subjects in American culture—Black people of the South—with both honesty and the eyes of the modern designer.

In the St. Helena portraits, Reiss avoided the primitivist design possibilities he had explored in the Harlem issue of *Survey Graphic*. Instead he developed some of the more innovative portrait techniques he had begun at the same time. In his portrait of Dr. York Bailey [see page 88], he uses only the negative space between the head and hands to suggest the doctor's lab coat. The focus of the portrait is on those powerful hands that signify Dr. Bailey's role as a surgeon and healer. In his

portrait of James B. King [see page 88], Reiss elaborated on a technique found in his earlier portrait of Countee Cullen, that of reducing the image to a head, with a shirt, tie, and partial vest to suggest an unseen coat. As in such Harlem portraits as *Roland Hayes* and *Paul Robeson*, Reiss exploits the flat white background to highlight the powerful mass of a head; but here he also integrates remarkable detail, as in the treatment of the hair, with an abstract conception of the portrait, whose sitter seems to peer out of the negative space surrounding him. The result is a stronger portrait than realism alone could have produced.

 For all their aesthetic strength, Reiss's St. Helena portraits remain documentary records of a community looking back to its ancestral heritage while trying to enter modern times. Miss Cooley, who had been trained at Hampton Institute, saw the Penn Community School as a modernizing force that would educate the entire community. As she noted in her article "How We Brought Farms to School," the school promoted modern agricultural techniques, reliance on clocks instead of the sun to tell time, and modern health care.[24] Yet it also tried to make traditional handicrafts commercially viable in the twentieth century. For this purpose, the school gave instruction in the ancient craft of basketweaving, so sensitively portrayed in *Young Basketmaker*. Although ultimately abandoned as a major course in the curriculum, the basketweaving program epitomized the mission of the school—to promote, wherever possible, a synthesis of modern life with community traditions.[25]

 This mix can be seen in some of Reiss's St. Helena portraits. Nurse Brisbane was both a member of the school's community class and a midwife. Her cap recalls African traditions of headwear and healing, while the doctor's bag she holds suggests the modern medicine she dispenses to the community. Dr. York Bailey embodied the school's mission of making science and education serve the community: a Penn Community School graduate who had studied medicine at Howard University, he returned to St. Helena to set up the only medical practice on the island.

 After *Survey Graphic* used the portraits to illustrate Cooley's articles, Reiss exhibited

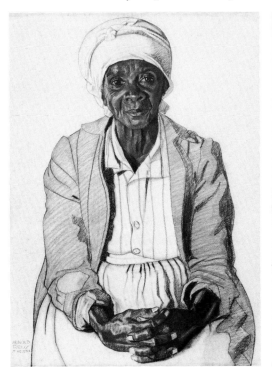

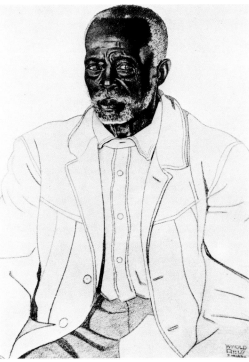

AUNT SOPHIE DAISE
Pastel on board, 1927
Penn Center Historical Collection,
St. Helena Island, South Carolina

UNCLE SAM
Pastel, 1927
Unlocated

RUBY AND MARIE BEGINNING
THEIR EDUCATION IN THE
PRIMARY GRADE
Pastel and conté crayon on board,
1927
Private collection

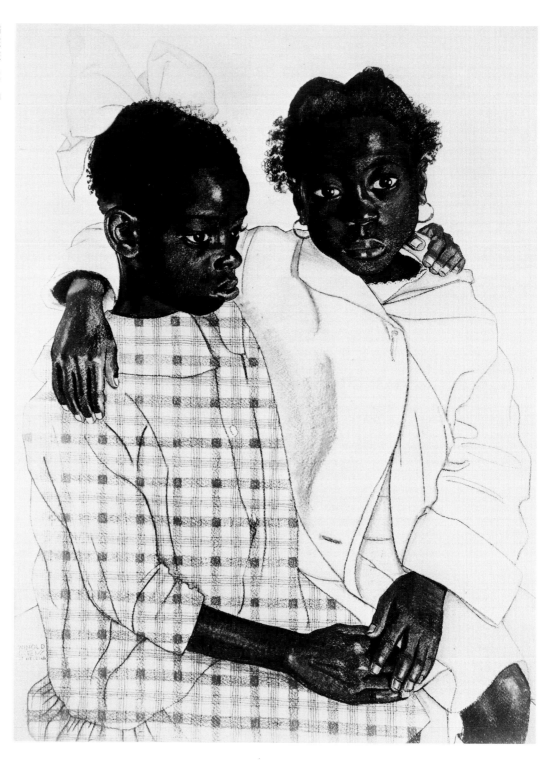

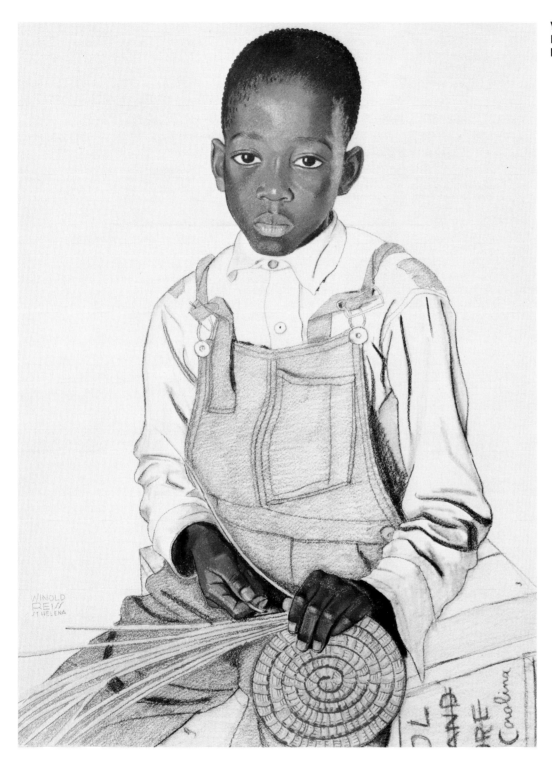

YOUNG BASKETMAKER
Pastel on board, 1927
Fisk University Museum of Art

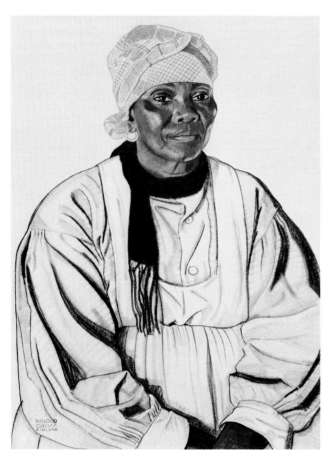 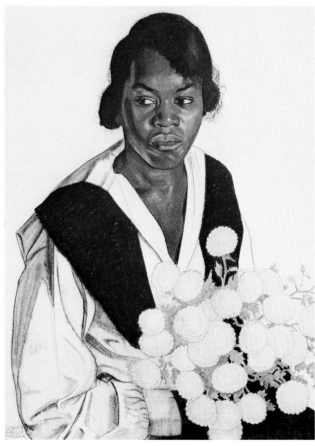

AUNT CELIA SIMMONS
Pastel on board, 1927
Fisk University Museum of Art

VERONICA SMALLS
or TYPE STUDY III
Pastel on board, 1927
Fisk University Museum of Art

Boy from St. Helena, Uncle Sam, and *Aunt Sophie Daise,* along with two Swedish peasant portraits, in an exhibition at the Pennsylvania Academy of the Fine Arts in the winter of 1928. The following year, *Aunt Sophie Daise* and *Uncle Sam* were on exhibition at the Art Institute of Chicago. Interestingly, Reiss seems not to have placed the more artistically adventuresome of his St. Helena portraits on exhibition, although this may not have been a matter of choice: the Penn School appears to have exhibited them in Poughkeepsie, New York, at a fundraiser in 1928; it is also possible that Rossa Cooley held on to some of the portraits until after the publication of her *School Acres: An Adventure in Rural Education* (1930), which was illustrated with Reiss pastels.[26] Whatever the case, the St. Helena commission was artistically successful and strengthened Reiss's relationship with *Survey Graphic,* which published his Blackfeet and Black Forest portraits in 1929.

Although in the late 1920s Reiss enjoyed a modest reputation as a fine portrait artist of folk types, he was still far more influential in the American movement in modern interior design. The phenomenal proliferation of the skyscraper in American cities, the successful Paris "Exposition Internationale des Arts Décoratifs et Industriels" in 1925 (from which the Art Deco style took its name), and the willingness of department stores such as Macy & Company to host related exhibitions—in 1928 Macy's opened its own "Exhibition of Art in Trade"—created a lucrative market for American designers of the modern style.[27] Reiss's commissions increased: from 1926 to

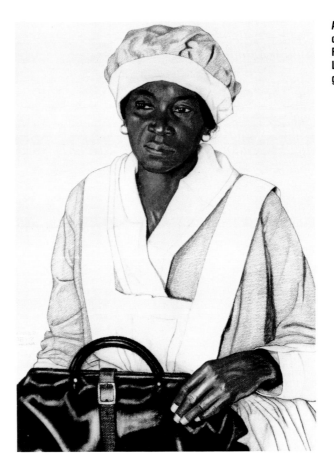

AN ISLAND NURSE
or NURSE BRISBANE
Pastel on paper, 1927
Laura Lee Brown Deters; promised
gift to the J. B. Speed Art Museum

1930, he added decorations to the Crillon restaurant, designed ornate bronze doors for New York's Weicker Apartments, produced Chicago's first modern interior decoration at the Tavern Club, and, the most ambitious project of all, completed an interior design of the rooms and the lobby of Brooklyn's St. George Hotel. For this last commission Reiss invented an organ that reflected lights on the grand ballroom's walls that changed color with the music.

All of these commissions enhanced Reiss's reputation as one of America's foremost interior designers. In 1928, C. Adolph Glassgold declared that Reiss's design of the Baumgarten Confection Shop on East Forty-seventh Street was "another noteworthy addition to contemporary decoration. . . . It is a place distinctly worth seeing for those interested in the development of contemporary American decorative arts."[28] Glassgold also noted that Reiss was "engaged on a project to design a series of rooms and their furnishings for department stores which propose to offer them to the public at inexpensive prices. This certainly is a portent of the future."[29] Reiss designed the first of these, a "daughter's room," for the November 1928 exhibition of the American Designer's Gallery, a consortium of artists and designers he helped to found, along with Paul Frankl, Wolfgang Hoffman, Ilonka Karasz, Herman Rosse, and several others. One critic wrote of the installation: "Winold Reiss's 'daughter's room,' a charming room carried out in yellow, blue and silver, is probably the most successful combination of modernity and liveableness included in the exhibition."[30] Building on his early reputation as a co-founder of the Society of Modern Art and

M.A.C., Reiss became one of the most respected and sought-after designers of the late 1920s, mainly because of his ability to combine boldly original design ideas with a practical sense of his audience's tastes and needs.

Reiss's reputation as an artist was firmly established, for the public and critics alike, through a traveling exhibition of the Louis Hill collection. Shortly after purchasing the collection, Hill gave Reiss permission to arrange a New York exhibition and a subsequent national tour. Reiss got Rodman Wanamaker, the Indian hobbyist and department store owner, to sponsor the show in the Belmaison Galleries of Wanamaker's. Opening on April 14, 1928, the exhibition contained fifty-one portraits (inexplicably, one was dropped from the original fifty-two) and was accompanied by a catalogue, with color reproductions, designed by Reiss and introduced by H. V. Kaltenborn. The show then traveled to the University of Michigan at Ann Arbor. From June to October, twenty-six of the portraits were exhibited at the Brooklyn Museum, along with works by Joseph Stella, Bela Kadar, and Aimee Seyfort. A one-man show in November at the Worcester Art Museum allowed the entire Hill collection to again be seen by the public. The exhibition then moved on to Boston, Chicago, Detroit, and Buffalo, as well as other cities. In July 1929, half of the collection was exhibited at the Glaspalast in Munich, under the auspices of the Munich Association of Artists. This show subsequently traveled to Italy, France, and other sites in Germany before being shipped back to America for an exhibition in Denver.[31]

This first world tour of Reiss's Indian portraits was a critical and popular success. The *New York Times* was ecstatic: *These bright outstanding portraits are noticeable from afar, avowedly*

JAMES B. KING
Pastel on paper, 1927
Laura Lee Brown Deters; promised gift to the J. B. Speed Art Museum
(color illustration on page 148)

DR. YORK BAILEY
(1881–1971)
Pastel and conté crayon on board, 1927
Mr. and Mrs. W. Tjark Reiss, courtesy Shepherd Gallery Associates

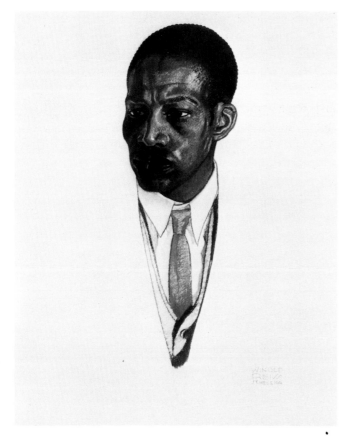

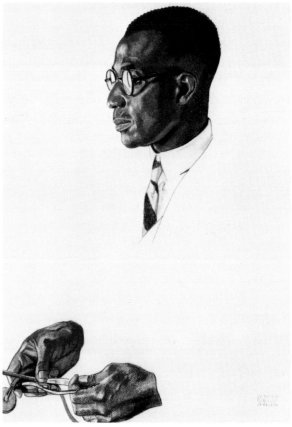

documents of history. . . . Their great virtue is that, in nearly all, the subject is stated without idealization. A rather quaint mixture of realism and decorative intention appears in them, as though the vision of a natural realist had been tampered with by the pictorial tradition of his subject. The review continued: *In portraits such as that of the time-worn Blood Indian, Heavy Shield, he goes further and makes a design of dark and light, of echoing and diverging lines, of accents rhythmically placed, a design that, in the absence of illustrative decoration and symbol, shows Mr. Reiss at his best as an artist.*[32]

The stop at the Worcester Art Museum was just as successful: *Winold Reiss's Indian portraits proved to be the most popular exhibition of the year. The excellence of these drawings and paintings and the appeal of their subjects played a chief part in this, but it is also true that in scale, in number and in the forcefulness of their decorative treatment the portraits formed an unusually fine enrichment for the large gallery in which they were seen.*[33] At the Milwaukee Art Institute, critics noted that the portraits of Indians afford *ample opportunity for expression in pure colors and broad, flat surfaces. He delights in the unusual composition and color arrangements allowed in portraits such as these and extends the primitive spirit of* [the] *picture even to the frame itself, which is left unpainted save for narrow borders of bright reds, blues and yellows.*[34]

Reiss's portraits were appreciated in part because Americans were beginning to value their own art and to search for expressions of American regional themes. "Because he has an intense love of color, Winold Reiss has painted the American Indian of the present time in a way that seems peculiarly appropriate in these days of the American renaissance."[35] Reiss firmly believed in that renaissance of a native American culture; as he commented in an interview in the *Brooklyn Eagle*, "The Indian has a great contribution to make to American life. I believe that the typical American art will find a new expression if the native art is used as a foundation."[36]

But Reiss's access to that native art was curtailed in 1930.[37] The stock market crash of 1929 and the resulting Depression had brought financial crisis to Great Northern: passenger service had dropped off sharply and management questioned the wisdom of continuing to spend large sums on advertising. Just at the point in his career when he was enjoying the most success from the Indian portraits, with numerous offers in America and abroad for more pictures, Reiss's access to living subjects was cut off.

NOTES:

1. *Exhibition of Water Color Paintings, Pastels, and Drawings by American and European Artists* (exhibition catalogue, Brooklyn Museum, New York, 1927).

2. Helen Appleton Read, "Informal Medium in Artistic Expression Is Now the Vogue," *Brooklyn Eagle*, January 30, 1927.

3. See "Art and Industry: Americans' Work in the Line of Decorative Art Shown at the Designer's Gallery," *Brooklyn Eagle*, November 18, 1928.

4. Kaltenborn, "Interprets Racial Types," *Brooklyn Eagle*, January 2, 1927.

5. "Enter, the 'Blackfoot Colony' of Artists," *Art Digest* 1 (December 1, 1926): 10.

6. Hans Reiss to Louis W. Hill, January 7, 1926, Louis W. Hill Papers, James J. Hill Reference Library, St. Paul, Minnesota; telephone interview with Tjark Reiss, December 14, 1988; note from Hill to W. R. Mills, copied onto the bottom of letter from Hill to Hans Reiss, January 20, 1926, Hill Papers, Hill Reference Library.

7. Ann T. Walton, "The Louis W. Hill, Sr., Collection of American Indian Art," in *After the Buffalo Were Gone: The Louis Warren Hill, Sr., Collection of Indian Art* (St. Paul, Minn., 1985), pp. 13-17. For James Hill and the Great Northern Railway, see Timothy Jacobsen, *An American Journey by Rail* (Toronto, 1988), pp. 101-22.

8. Interview with Calvin Last Star, sitter for Reiss's portrait *Dancing Boy*, Browning, Montana, October 16, 1988.

9. *Ibid.*

10. Interview with William S. (Billy) Big Spring, East Glacier, October 16, 1988.

11. I have benefited from conversations with Dr. John C. Ewers, Ethnologist Emeritus, National Museum of Natural History, who conducted field research in Browning, Montana, in the 1940s.

12. W. R. Mills to Reiss, March 10 and May 28, 1927, Reiss Papers, private collection.

13. *Ibid.*; and telephone interview with Tjark Reiss, December 17, 1988.

14. C. B. Griffin to Winold Reiss, Hotel Hagarty, July 5 and 7, 1927, Reiss Papers, private collection.

15. John C. Ewers, *The Blackfeet: Raiders on the Northwestern Plains* (Norman, Okla., 1958), pp. 175-84.

16. C. B. Griffin to Reiss, July 7, 1927, Reiss Papers, private collection.

17. Telephone interview with Tjark Reiss, December 17, 1988.

18. Mills to Reiss, July 12, 1927; Mills to U.S. Customs Officer, Babb, Montana, July 12, 1927; Mills to William Roberts, Customs Excise Enforcement Officer, Carway, Canada, July 12, 1927, Reiss Papers, private collection.

19. Interview with Tjark Reiss, July 25, 1987.

20. Mills to L. W. Hill, December 22, 1927, Hill Papers, Hill Reference Library.

21. Reiss to O. J. McGillis, February 11, 1936, Reiss Papers, private collection.

22. James King to Isabella Curtis, October 25, 1927; Cooley to Margaret (no last name) October 28, 1927; and Kellogg to Rossa Cooley, November 21, 1927, Reel 4, Penn School Papers, Southern Historical Collection, University of North Carolina, Chapel Hill.

23. Kellogg to Cooley, November 21, 1927, Reel 4, Penn School Papers, *ibid.*

24. Rossa Cooley, "How We Brought Farms to School," *Survey Graphic* 59 (February 1, 1928): 572-73, 578.

25. Dale Rosengarten, *Row Upon Row: Sea Grass Baskets of the South Carolina Lowcountry* (Columbia, S.C., 1986), pp. 23-28.

26. Rossa Cooley, *School Acres: An Adventure in Rural Education* (New Haven, Conn., 1930); Paul Kellogg to Rossa Cooley, February 11, 1928, Box 61, *Survey Graphic* Papers, Social Welfare Archives, University of Minnesota.

27. Glassgold, "Modern Note in Decorative Arts: Part II," pp. 221, 225, 227.

28. C. Adolph Glassgold, "Decorative Arts Notes," *The Arts* 13 (May 1928): 301.

29. Glassgold, "Modern Note in Decorative Arts: Part II," p. 232.

30. "Art and Industry," *Brooklyn Eagle*, November 18, 1928.

31. Mills to Hill, December 22, 1927, Hill Papers, Hill Reference Library. On this copy of the letter, an "OK" is scribbled next to Mills's suggestion to allow Reiss to arrange an exhibition. Ivan A. Coppe's letter (on Louis W. Hill stationery) to R. A. Plimpton of the Minneapolis Institute of Art (February 7, 1934, Reiss Papers, private collection) reconstructs the schedule of the Hill traveling exhibition.

32. Elisabeth L. Cary, "Summer Art Activity at Brooklyn Museum," *New York Times*, June 24, 1928.

33. "Exhibitions," *Worcester Art Museum Annual Report* (1929): 14.

34. "American Indian Portraits by Winold Reiss," *Bulletin of the Milwaukee Art Institute* 2 (February 1929): 5.

35. "Mr. Hill Shows His Group of Reiss Indians," *Art Digest* 3 (November 1928): 32.

36. Kaltenborn, "Interprets Racial Types," *Brooklyn Eagle*, January 2, 1927.

37. Reiss to O. J. McGillis, June 20, 1930, Reiss Papers, private collection.

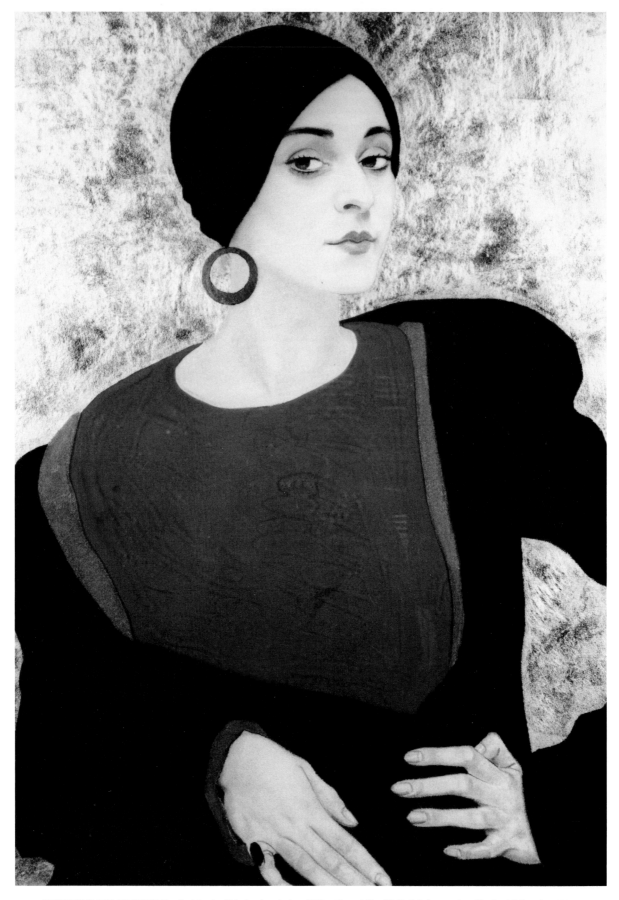

WOMAN WITH GOLD BACKGROUND Pastel and gold leaf on board, circa 1929 Mr. and Mrs. W. Tjark Reiss, courtesy Shepherd Gallery Associates

AN ART FOR THE PEOPLE AND A SCHOOL FOR ARTISTS

Reiss would eventually be able to return to Montana. In the meantime, back in New York he completed a number of projects that would consolidate his reputation in the art world. His broad training and willingness to perform any kind of commercial art, from lettering to interior painting, kept him from having to accept public assistance during the Depression. Rather than retrench, he expanded his activities in the 1930s and benefited from the decade's emphasis on public art, the American Scene, and advertising to create consumer demand. His portraits were included in several international exhibitions, along with the work of Pablo Picasso, Henri Matisse, Stuart Davis, and Rockwell Kent; he was commissioned to design several mural projects for the Cincinnati Railroad Terminal and the New York World's Fair; and he became an assistant professor of mural painting at New York University.

Reiss's art school continued to attract students despite the Depression. Late in 1927, Reiss had moved from 4 Christopher Street to a warehouse at 108 West 16th Street, which he had remodeled with dramatic skylights that provided natural light for the classrooms. His school was also attractive because his brother, Hans, who had himself studied at the Munich Academy, began teaching sculpture at Winold's school shortly after the move. During the 1930s Reiss's studio was a gathering place for artists, dancers, and musicians, who would drop by and dance, paint, and have fun. Some of them became subjects for Reiss's portraits. In these and other works produced shortly after the stock market crash, the effects of the national economic crisis seem not yet to have impressed Reiss. Ailes Gilmour, the sister of artist Isamu Noguchi and a dancer with Martha Graham's troupe, recalls that in 1929 she *used to drop by his studio; he had a record of Indian music and I would dance for him. The artist Marion Greenwood was always there. We had great fun. He, Boykie* [Tjark] *and I would drive up Riverside Drive in a great car he had—I think it was a Cadillac or something—and play tennis. Then we would go eat Chinese food.*[1]

Reiss's portrait of Gilmour, done around 1929, reflects this carefree spirit. He draws Ailes dressed only in a red skirt, a necklace, and a headdress. "I don't remember the pose," Gilmour later remarked, "but I was always dancing around nude at the studio. The headdress I made out of raffia, the necklace I believe was African."[2] Reiss did not draw Ailes as an Asian type. Rather, her portrait reminds us more of Gauguin's exotic Polynesians than Reiss's type portraiture for the 1926 *Survey Graphic* issue. With her regal headdress, Egyptian-style necklace, and posed hands, Ailes Gilmour seems to be a bearer of some unknown ancestral tradition. By contrast, Reiss's portrait of her brother, Isamu Noguchi, probably also done in 1929, presents this emerging sculptor as an acculturated, liberal Oriental. Noguchi's Euro-American suit, his loosened tie, and his relaxed pose suggest a man at ease with Western culture. Moreover, Reiss highlighted his subject's modernity with the abstract background: the portrait broke down the then-predominant stereotype of Asians as unassimilated heathens and delineated a modern Asian American identity. In these portraits of two Japanese Americans, Reiss went beyond type portraiture to present his sitters as artistic individuals rather than as racial types.

AILES GILMOUR
(born 1912)
Pastel on board, circa 1929
Mr. and Mrs. W. Tjark Reiss

ISAMU NOGUCHI
(1906–1988)
Pastel on paper mounted on board,
circa 1929
National Portrait Gallery,
Smithsonian Institution; gift of
Joseph and Rosalyn Newman

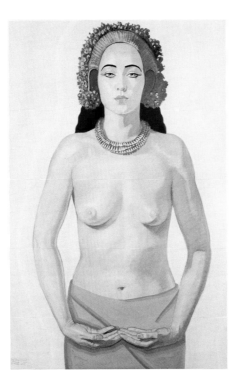 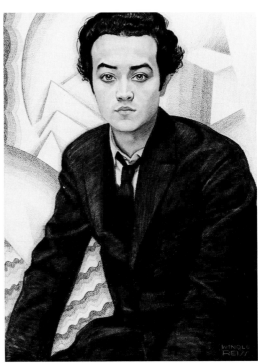

Type portraiture, however, characterizes the full-size, decorative portraits of artists, dancers, and actresses that Reiss produced for the St. George Hotel commission in 1929. He filled the St. George's ballroom with 50 x 30-inch portraits, many representing the actresses and models who frequented his studio. The series showed women in furs and formal dresses, smoking cigarettes in mannered poses. Eleven "American Beauties" constituted another set of type portraits at the hotel, these depicting the wealthy society women of the 1920s in the typical postures they would have assumed as they made their way to a gala party in downtown New York. Such portraits enshrined the devil-may-care attitude associated with the cosmopolitan world in the 1920s and probably also documented the freewheeling café life-style that Reiss enjoyed as a popular personality on the New York art scene.

In 1930, a strikingly different image can be seen in Reiss's decorative portraiture of white Americans. His portrait of Mrs. Harry Woodring (Helen Coolidge)—completed in 1930 and exhibited that November at the Pennsylvania Academy of the Fine Arts—has none of the ironic affect of the "American Beauties" but rather exudes a serious, almost determined mood. Mrs. Woodring is simply dressed, even though she appears to be wealthy, and the contrasts between light and dark masses of color reinforce the sense of solidity and determination. The only decorative play appears in the background, where trees and buildings suggest the world of plenty that lies beyond the present.

Reiss continued that somber mood in *Buy an Apple*. Published in *Survey Graphic* in 1931, it caught the mood of hard times and enabled Reiss to speak to the plight of the unemployed. Here he captured the Depression in an iconographic type that would be widely disseminated by documentary photographers of the thirties. According to *Survey Graphic, the man who brought his box of apples to Winold Reiss' studio and posed for him has been an office man, a construction*

worker, and an insurance salesman who stands now on a windy corner, a shivering and ironical example of one of the ways that American industry "insures" against want the families of its unemployed workers.[3] Reiss's sentiments seemed to be more compassionate than critical. He "donated the original of the picture, roughly three feet by two, to The Survey, to be sold and the proceeds turned over to unemployment work."[4]

 In 1931, Great Northern Railway rescued Reiss from the somberness of the Depression in New York. The railroad approved his proposal to create a portfolio of Indian portraits to be sold to tourists. At the same time, the 1931 Great Northern calendar exhausted the railroad's supply of suitable Reiss images: if the calendars were to continue, Reiss would have to produce some more portraits. Mr. Hubbard, Great Northern's general manager, then asked Reiss if he would be interested in starting an art school at Glacier Park the following summer. Reiss had suggested the idea two years earlier; Great Northern now saw it as a way of defraying the cost of having Reiss spend the summer in Glacier Park.[5]

 Reiss was elated. He wrote to O. J. McGillis, the railroad's advertising manager, "I think it would be a very splendid thing to start a school in the Park, which with the proper advertising and publicity could be worked up to a very profitable enterprise in direct and indirect returns."[6] Unfortunately, there was not enough time to organize the school for the summer of 1931. But the railroad did invite Reiss out to make next year's calendar portraits. This trip, however, he worked within tighter financial restrictions: no longer would the railroad pay for hotel stays in Browning (only at Glacier Park), and it now imposed a limit of $1,500 on the cost of his summer stay. For that amount, the railroad would receive reproduction rights for twelve portraits for its calendar.[7]

 The 1931 portraits are dominated by an artistic impulse rather than an ethnographic one. They are as much meditations on what is essential to portraiture as they are characterizations of his sitters. Reiss suggested what he believed was the essence of portraiture by simplifying many of his 1931 subjects to the barest minimum—the head. In *Buffalo Body*, Reiss leaves behind realism to show a head suspended in space, wearing a buffalo headdress in a way that was almost impossible, considering the weight of these headdresses. Yet by reducing his subject to a head, a two-horned headdress, and braids, Reiss provides a striking image of man as buffalo, and suggests, ironically, that this man is all that is left of the heritage of the buffalo days. In *Red Eagle, Kootenay,*

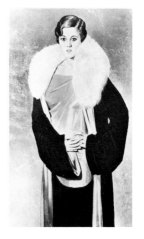

AMERICAN BEAUTY NO. 5
Pastel on board, circa 1929–1930
Unlocated

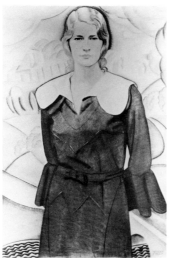

BUY AN APPLE
Published in *Survey Graphic,*
January 1, 1931
Social Welfare History Archives,
University of Minnesota

MRS. HARRY WOODRING
(HELEN COOLIDGE)
Pastel on board, 1930
Unlocated

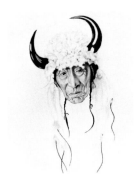

BUFFALO BODY
Tempera and pastel on board, 1931
Mr. and Mrs. Rex Rieke

probably also done this summer, he achieves a sensitive and accurate portrait of the young Indian rancher that is as beautiful as his portraits of Indians in nineteenth-century formal dress.

Great Northern's Depression-induced penury caught up with Reiss a few months after his return to New York. McGillis informed him that he had overspent his budget by $610.59 and was expected to pay back $377.09. After some discussion, the railroad agreed to accept as payment one of the portraits done the previous summer—*Clears Up*, a decorative portrait of a man wearing a beaded floral design vest. Although Reiss was not pleased with Great Northern's penny-pinching, he was not overly concerned.[8] The resumption of his work for the railroad assured him continued access to Indian subjects, even if it was at a slightly higher personal cost.

Moreover, by the spring of 1932, he was thoroughly engrossed in a much larger commercial commission, to design murals for the Cincinnati Railroad Terminal. He had submitted sample drawings in June 1931, on the basis of which the architectural firm of Fellheimer and Wagner asked him to design huge color mosaics for the concourse and rotunda and to assist in creating an Art Deco style throughout the terminal. Apparently, the firm was unhappy with the drawings submitted by the French artist Pierre Bourdelle and had solicited drawings from Reiss, possibly on the recommendation of his friend, designer Paul Philippe Cret, a consultant to Fellheimer and Wagner on the project. When the project had been conceived in 1929, the firm planned to render the building and its interior in a Neoclassical motif. But with the onset of the Depression, the higher material and installation costs of Neoclassical design, and the enthusiasm of Cret for a modern design, Fellheimer and Wagner became dissatisfied with the more conservative style.[9]

The architects were impressed by Reiss's translations of the photographs of Cincinnati industries into brightly colored drawings for the concourse mosaics. They consequently handed over to him responsibility for designing the Art Deco floor and, most important, the wall in the rotunda on which a history of transportation in Cincinnati was to be rendered in mosaic. While there is no written proof that Reiss designed the rotunda, the visual evidence is compelling. The

RED EAGLE, KOOTENAY
Mixed media, circa 1931
The Anschutz Collection

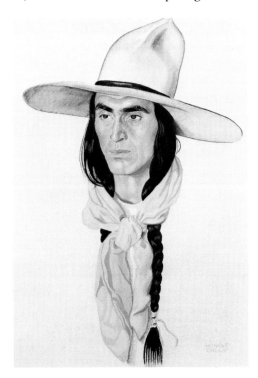

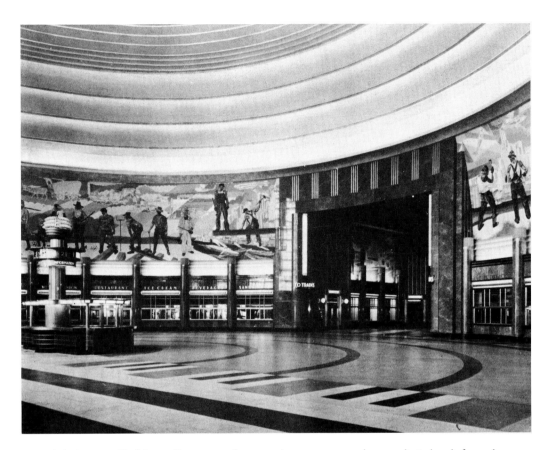

central design motif of the wall presents the narrative account on three stylistic levels from the realistic, monumental foreground figures, to a somewhat stylized middle ground with covered wagons and others forms of transportation on a reduced scale, to a completely abstracted background that evokes the development of transportation from Indian dog travois to the airplane. It was just this kind of stylistic tension within the three regions of pictorial space that Reiss had developed in his 1927 portrait of *Lazy Boy* [see page 76].

The Cincinnati commission for decorating the concourse, floor, and rotunda of the station allowed Reiss to combine all his talents—as a portraitist, a creator of abstract imaginatives, and a designer of Art Deco interiors. Nor did he forget Indian subjects. They not only appeared in their appropriate narrative place, but Indians were rendered in the mosaics he made as samples for the architects of the completed installation. Not surprisingly, Reiss threw himself into this dream-of-a-lifetime project. Tjark Reiss recalls that the *commission started first with sketches, then the sketches got bigger, of course small figure drawings, bigger figure drawings, 30" x 22" board, and then from that the life-size ones. So it was a long, carefully thought-out and planned composition. To save money and also because he thought it looked better, only the figures were in mosaic. The background, the outlines are not full mosaic. Most mosaics you see in antiquity are full mosaics. But he had the idea of doing the main subjects in mosaic and the backgrounds wherever possible in stucco, which would save a lot of money. To further reduce expense, he reduced his fee so that they could apply that to the project.*[10]

The Cincinnati mosaics were a resounding success.[11] Reiss used this ancient artistic medium to make a modern statement that honored American workers and industries, and thereby

anticipated what would become the dominant American Scene genre of the Works Progress Administration murals of the later 1930s. He eulogized industry, but his inclusion of monumental figures projected a world in which men remained masters of their machines. And by celebrating American productivity in the midst of the Depression, Reiss's mosaics extolled the virtues of the American way of life just when that way was most threatened.

The Cincinnati mosaics also catapulted Reiss into national prominence. Articles cited the mosaics as superb examples of the use of the medium in modern design.[12] Probably on the basis of this achievement, in 1933 New York University offered Reiss an assistant professorship in its new program of mural painting. Like his friend and business partner, Albert Schweizer, who had already been hired by the university, Reiss taught the basics of color and design as well as the particular problems encountered when creating art on a giant scale. The NYU experience eventually led to another collaboration with Schweizer, the publication of the book *You Can Design* in 1939.[13]

Reiss also taught tact. In an article published in 1933, which epitomized his entire philosophy of commercial design and perhaps explained his success in turning the Cincinnati terminal into a thoroughly modern design, he preached that muralists must be responsive to the demands of the patrons. *Mural painters should keep in mind that, after all it is the other fellow who owns the wall. Sometimes the owner of the wall has some very definite ideas of what he wants or what he does not want. If the owner's ideas are not artistic or in keeping with the space and location of the proposed mural, the painter should try to bring him around to an aesthetic viewpoint by indirection. Sometimes this can be accomplished in such a manner that the owner will not be aware that his ideas have been changed.*[14]

Such tact was also indispensable to Reiss's working relationship with the Great Northern Railway. By satisfying his patrons' needs for powerful color images, by giving them the form they needed to make a profit, Reiss, as the artist, could control the content. He reasoned that if he provided Great Northern, for example, with Indian images and designs that would attract customers, the railroad would in turn support his mission to document the Indians. Moreover, by working for such powerful companies, Reiss felt he could expose a wider audience to positive images of American Indians and perhaps stimulate a more serious appreciation of Indian art and culture.

All this hinged on Reiss's ability to produce images that satisfied the railroad, which had rejected some of his Indian portraits as unsuitable for the calendars. After the Cincinnati commission, Reiss seems to have pulled together and standardized the ingredients of a Great Northern poster style—a style that had enormous popular appeal and fulfilled the railroad's need for a highly polished, pleasing commercial image.

First Nabor Mateomsemaki, done on Reiss's 1934 trip to Glacier Park, and *Singing For Nothing*, of 1935, render the monumental foreground figures realistically, while the lower backgrounds present a stylized, almost symbolic landscape scene. First Nabor Mateomsemaki is a modern Indian child, wearing overalls like the dockworkers on the Cincinnati wall: his hat is cocked to the left, and a horse's bridle is draped over his left arm, replacing the shovel in the dockworker's hand. The miniature log cabin in the background also reminds us of that in the rotunda mosaics. Perhaps most important, these portraits, like the scenes of Cincinnati's progress, establish a hierarchical relationship between man and his environment: the people are the most important features of life on the plains.

Yet these commercial portraits are less satisfying than Reiss's earlier, more folkloric

works. Gone are the gnarled facial features of the 1919 or 1927 portraits and with them the three-dimensional quality of hands and faces. Despite the ostensible realism, a posterlike flatness pervades the foreground, and the faces possess sweet, almost saccharine, features. Gone too are the Indian designs found in the backgrounds of *Lazy Boy* and *Night Shoot—Brave Society* [see pages 76 and 77], which had lent such authenticity to the renderings. They are now replaced with a stylized landscape that is the pastoral analogy of the Cincinnati river scenes on the rotunda wall.

First Nabor and *Singing For Nothing* were very popular with Great Northern Railway. *First Nabor* appeared as a poster advertising the Winold Reiss Summer School, and McGillis proposed that both portraits be used as images for a double deck of playing cards to be sold to tourists at the park. Reiss's conceit of posing a monumental figure against a landscape motif recurred in several later portraits, most notably in the 1947 portrait of Floyd Middle Rider, one of the artist's most successful renderings of an Indian. Another popular theme was the Blackfeet baby in a carrier. In 1935, Mr. Kenney, president of Great Northern Railway and the man who often made the final selection of portraits, selected *Yellow Bird* as a calendar subject because the baby's portrait had the greatest public appeal of all those Reiss had done that year.[15] Not surprisingly, Reiss was able to anticipate which portraits would be selected by the railroad and, in at least one case, could produce portraits specifically for advertising purposes. In 1937, Kenney approved the first version of *Bullhead*, which Reiss noted he had "made especially for calendar use."[16] However, Reiss's second version of Bullhead captured the individuality of this Blackfeet medicine man in his everyday dress.

This flat, brightly colored, larger-than-life Great Northern style suited the increasingly commercial nature of Reiss's Indian motifs in the middle thirties. In 1935, Longchamps restaurant opened in New York with an interior by Reiss that incorporated Indian designs and Blackfeet portraits he had done in Montana. The restaurant was a tremendous success and a very profitable venture. That same year *Blackfeet Indians* was published by Great Northern, with Reiss's portraits and book design and a text by Frank Linderman. The book, which also contained color photographs of Reiss's portraits from the late twenties, was a commercial triumph, selling four thousand copies of the first edition in one year. This convinced Great Northern that the Indian motif was still viable even in the Depression, and in 1936 the railroad commissioned Reiss to redesign their menu card for the dining car. Reiss then asked McGillis about the possibility of designing the dining and observation car interiors of the Empire Builder train with "the distinguished Indian atmosphere . . . to give its passengers a pleasant suggestion of the traditions of the country through which they travel."[17] Reiss's respect for the Indian nations comes through in this request. Although he was helping to promote the Indian image commercially, he wanted American riders of the Great Northern trains to learn about the people and the culture through which they were riding.

In O. J. McGillis, the company's advertising manager, Reiss found an ally and an advocate. Even though the railroad did not take Reiss up on his suggestion to redesign the interior of the Empire Builder, McGillis recommended that he be commissioned to redesign the Swiss waitress costumes and the cafeteria dishes of the Glacier Park hotels to bring them into line with the Indian theme. Moreover, McGillis sent him confidential memos about company politics and, in one instance, suggested that he renegotiate his contract with Great Northern to thwart internal critics.[18]

The summer art school Reiss had proposed in 1929, and which Great Northern had approved of in

FIRST NABOR MATEOMSEMAKI
Mixed media, 1934
The Anschutz Collection

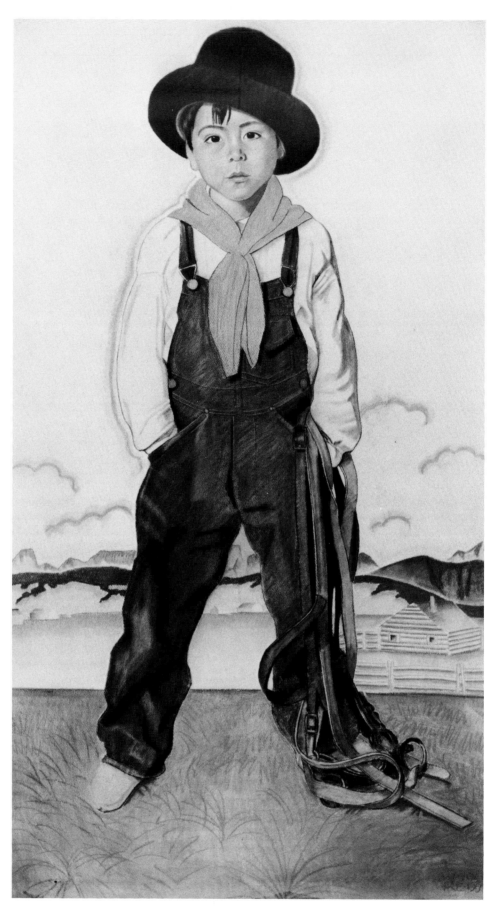

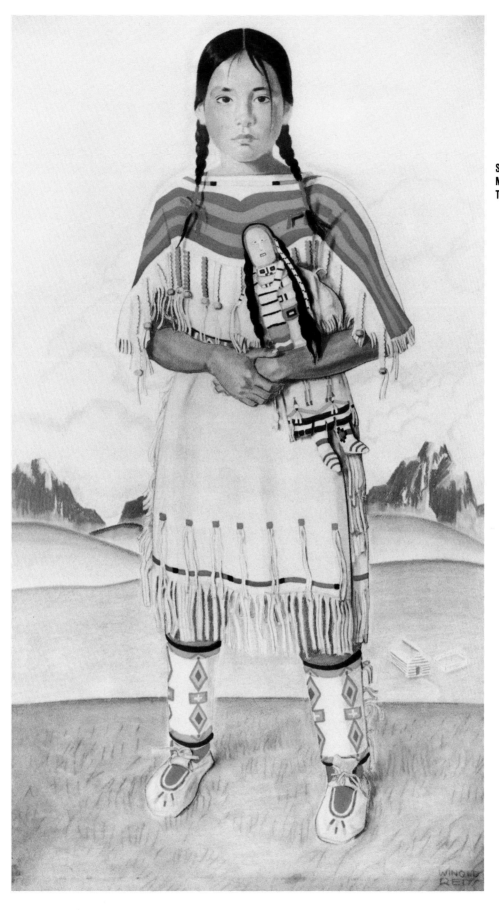

SINGING FOR NOTHING
Mixed media, 1935
The Anschutz Collection

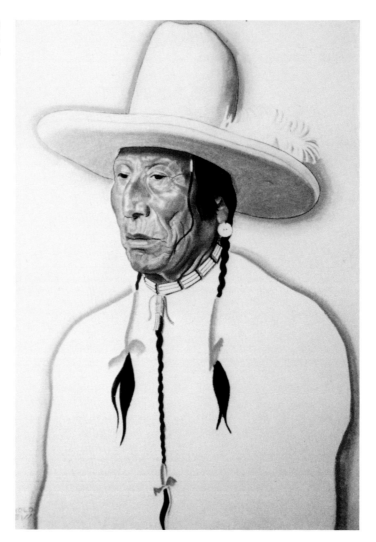

1931, finally opened in 1934. For years he had been taking his New York art school students to Woodstock for summer nature studies; and he had once dreamed of establishing a school in Santa Fe. But both Woodstock and Santa Fe had become fashionable artist colonies and were no longer, in Reiss's opinion, places for serious art study. Always something of a loner, he relished the chance to establish his own school in a national park and to teach students about Indian life.

Through the summer of 1937, Reiss and two instructors (his brother, Hans, who taught sculpture, and Carl Link, another German artist devoted to Indian portraiture) had the use of St. Mary's Chalet Hotel from June 15 to September 15. St. Mary's was several miles away from the main hotel at East Glacier and underutilized in the mid-thirties. The students paid Reiss $45 a month for lessons and the hotel $120 a month (or $300 for the season) for room and board. The hotel provided tepees and rations to the Indians who served as models; they also received 50 cents an hour from students to pose. The railroad's main interest, of course, was access to Reiss's portraits for its calendars. Great Northern was entitled to purchase the reproduction rights of any Reiss images for a fee of $200 each and to purchase the pictures at a reduced rate if it desired.[19]

Tjark Reiss, who accompanied his father during the summers of 1934 and 1935, remembers what it was like. *It was mostly made up of students from his New York school. . . . They*

[Great Northern] *gave us one of their camps which was a very nice place. Log cabins with a main, sort of community center where you ate and lounged, and then there were individual cabins with two or three or four rooms, and one with six to eight rooms which we had the exclusive use of for the studio.*[20]

Tjark served as the school's secretary and coordinated the logistics of camp operation, including transporting Indians to the camp and securing rations. His father *never had any time to do things like that. Dad was generally too busy painting. . . . All the Indians liked to pose for my dad because he treated them properly, paid them well, for that time, provided food, and when they came to stay with us they had a good time. We had three or four tepees right on Lake St. Mary's.*[21]

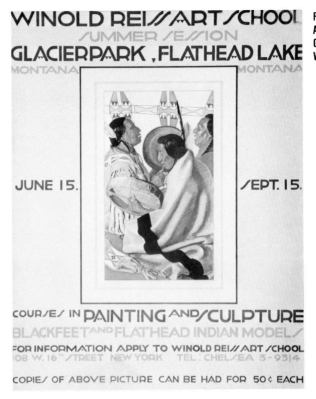

While Reiss had little trouble obtaining sitters for his portraits, it was not always so easy for the students. Claire Sheridan, a cousin of Winston Churchill who studied at the school during the summer of 1937, was advised of the problem when she visited Reiss's New York studio to inquire about summer programs. She was received by Hans Reiss, who *was discouraging. He warned me that it was difficult. The Indians dislike and distrust the Whites. Whether I would successfully get in touch with them depended chiefly on me, on my manner of approach, on my attitude towards them, the type of Indian I fell in with, and also on a certain amount of luck. So much depended, he said, on the interpreter. It was essential to get one who was liked and trusted by the tribe.*[22]

Hans's frankness was designed to dissuade the unserious. Unlike the tourists, the students had to establish personal relationships with the Blackfeet—to learn about and be respectful toward cultural practices. Not the least of the problems was language. Another summer student, Sarah Frijofson, recalls that she and the other students had to compile a dictionary of the Blackfeet language, since many of the models in 1936 and 1937 were Blood Indians from Canada who spoke no English.[23] But even more important was the chemistry that developed between a white student and an Indian. A successful student had to stop thinking of Indians collectively and begin to deal with them as individuals. Some of the Blackfeet were interested in being sitters, and some were not; and some would serve as sitters only if the price was right. Often a student had to survive several rejections before finding a subject. Generally, Indians were silent around whites, causing more feelings of rejection. Some students left the school after a few weeks, perhaps because real Indians did not live up to their romanticized image of picturesque figures just waiting to be drawn by whites.

Hans Reiss seems to have thought that the aristocratic Claire Sheridan was just another

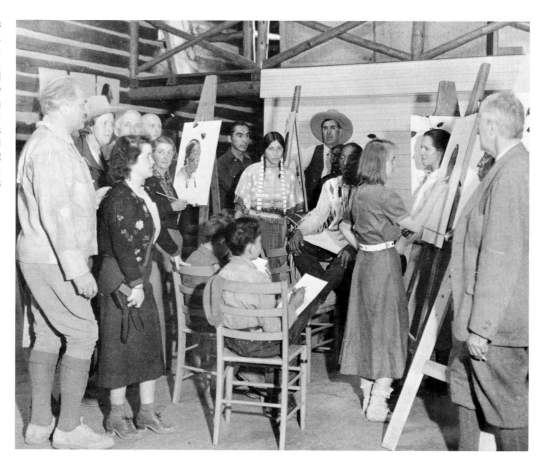

Shot Both Sides posing at Reiss's Glacier Park art school, circa 1937. Reiss is at far left. His student, Sarah Frijofson, is in front of him. Painter Carl Link is directly behind her. Gerald Tailfeathers may be one of the two young Indian students seated in front. Percy Creighton, Reiss's interpreter among the Blood Indians, stands behind Shot Both Sides.
W. Tjark Reiss

thrill-seeker who did not have the mettle to survive a summer among Indians in the West. "He was probably not sure what sort of an artist I was. I talked rather like a journalist in search of adventure."[24] But Hans was mistaken. Sheridan drove across the country to Browning in her English V-8, survived her first, difficult meetings with Indians, and became good friends with such Blackfeet as Little Plume, Last Rider, Bull Plume, and Shot Both Sides. While waiting for the school to open, she lived in the tepee of Lone Wolf and his wife. She was even inducted into the Blackfeet tribe, although this might have been in part arranged because the Blackfeet wanted white friends who would intercede in Washington, "that they might receive the money owed to them by the Government."[25]

In one sense Sheridan remained a romantic: She perceived Indian faces as "imbued with tragic dignity"; believed that "their eyes blazed forth their mystic savagery as they danced and sang"; and that such celebrations linked the Indians "to a past more real than the present."[26] But, like Winold and Hans Reiss, her European romanticism was tempered by a personal openness to the Indians. Real-life contact taught her that the Indians were not dying off as a people, that they were not alienated from their cultural traditions, and that they had just reasons to be strongly critical of their treatment by the American government.

Once the school session began on June 15, the attention of the twenty artists in the colony focused on the rigorous demands of producing art. Seven days a week, from 9:00 to 12:30 and from 2:00 to 4:30, the students worked feverishly. They followed the example of their teachers, Winold, Hans, and Carl Link, who set the pace by drawing, painting, and sculpting incessantly. Frijofson recalls that Winold was a demanding teacher. *He was very particular. We had to draw*

lifesize. He insisted that we go up to the model and measure the features, press the facial bone, with our hands, in order to learn the proportions. He brought all of that German precision to his portraits, and he demanded it of his students.[27]

Carl Link was also demanding. A superb draftsman whose polished portraits of Blackfeet showed Reiss's influence, he was less interested in Indians as culture-bearers than in solving the technical problems of portraiture posed by the Indian head and form. This made him an excellent critic. Once, in 1937, when he threatened to return to Germany, "Winold would not let him go because his criticisms of the students' work rendered him invaluable. Generally the criticism reduced them to tears, but, like the tears of children, they soon dried."[28]

Such rigorous teachers made an impact on the style of their students. Claire Sheridan's sculptures of Turtle, Big Bull, and Shot Both Sides showed the strong modeling of masses combined with remarkable facial detail that characterized Hans's sculptures of the Blackfeet. And Sarah Frijofson's portrait of Ancient Pipe Woman has the unmistakable combination of detail and decorative flair that distinguished Winold's portraits.

ANCIENT PIPE WOMAN
Pastel by Sarah Frijofson (born 1908), circa 1937
Collection of the artist

Winold's style also influenced the early work of Gerald Tailfeathers, one of three Indian artists who attended the Glacier Park art school as children. Winold's policy was to encourage the development of native artists by allowing any Indian with artistic talent to attend the school tuition-free. But Gerald Tailfeathers was Reiss's most important child prodigy. He began taking classes in 1935, at the age of ten. Reiss gave him personal instruction and attention. By day Gerald Tailfeathers worked along with the other students in the school, while at night he stayed with Percy Creighton, an interpreter for the school and a relative of the Tailfeathers family, in the tepees on St. Mary's Lake, listening to the stories of the old days from such elders as Shot Both Sides, Turtle, Big Bull, Bullhead, and Weasel Tail. He returned to the school for the next two summers, working under Link as well as Reiss, and in 1937 produced several portraits, most notably *Indian Head with Braids*, which exemplifies Reiss's sculptural approach to modeling the head. At twelve, he was already producing portraits on a par with those of much older students.[29] Attending the school at such an early age left a lasting impression on Tailfeathers. His portrait *Indian with Headdress*, produced after he left the school, shows his continuing exploration of Reiss's formal dress portraiture.[30]

INDIAN WITH HEADDRESS
Pastel on board by Gerald Tailfeathers
(1925-1975), circa 1939
Glenbow Museum

Living on the beautiful shores of St. Mary's Lake and in close proximity to their Indian subjects, the artists developed a sense of camaraderie. This amicability and mutual respect did not, however, extend to the tourists who came over each day from the lodge to see the exotic art colony. Link sketched scandalously cruel caricatures of the American tourists, while he and other artists welcomed those from Europe, often Germans glad to find their countrymen in the far West. Sheridan remembers speaking French with Erika Lohman, Reiss's mistress and one of Isadora Duncan's adopted daughter-dancers. Like some of the other female students, Lohman learned beadwork from the Indian women who accompanied their husbands to modeling sessions. A remarkable dressmaker and artist, she probably created the Indian outfit she wore in her portrait by Reiss.[31]

The summer school was not, however, without its stresses. Tjark recalls that *during the Depression, most of the people coming to an Art School out West were mostly young women, generally from New York, who were interested in getting away and having a good time as well as taking art lessons. They had to be entertained. There were dances up at East Glacier, but after awhile, we would take them over to a place where the students could dance with some of the local cowboys. You can imagine some of the problems when young women from New York met their first*

ERIKA LOHMAN IN HANDLOOMED
DRESS
(1899–1984)
Pastel and colored pencil on board,
date unknown
Renate Reiss

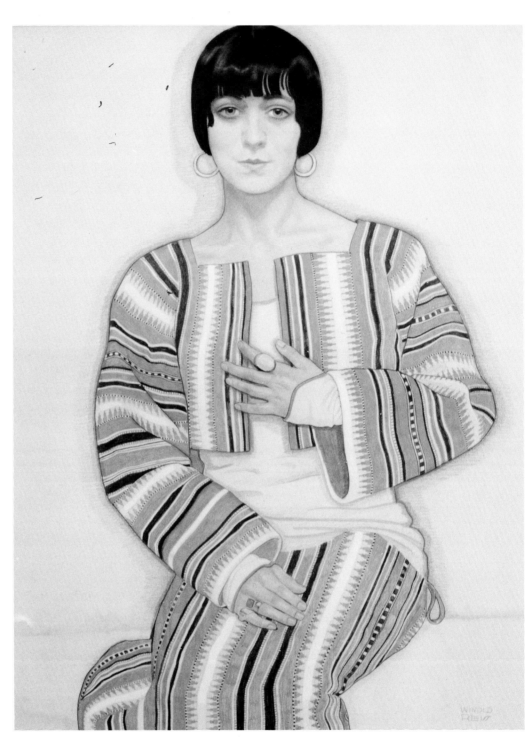

cowboy, and vice versa. Sometimes it was scary, but most of the times it was just funny.[32]

More serious conflicts developed in the school's relationship with the administration of the Great Northern Railway. The management insisted that all students at the school live in the camp's log cabins and then forced them to share rooms, a practice that many students objected to. Also, the electric lights were turned out every night at 9:30, creating something of a dormitory atmosphere for mature adults. But the most annoying practice of the summer was the daily visitation of tourists to the artists' studios, which was a stipulation of Great Northern's contract with Reiss. *For the special aggravation of the artists a steam-boat plied daily across the lake from Sun Camp, bringing tourists to visit the Reiss Art School. Every day at three o'clock when the steamer blew its whistle a groan went up from the students; for thirty minutes all work was held up. . . . I do not remember that a single visitor of any appreciation or understanding passed through the studios. [Most] would ask, "Is this a real Indian?" and "What do they eat?" as if the Indian was a strange wild animal. When Winold was called back to New York for a few days, the students united in revolt and decided to keep out the tourists. As soon as the steamer whistled, the studios were locked. The tourists beat upon the doors, demanding admission, and failing to be admitted, complained to the Manager. . . . The students pointed out . . . that as the Great Northern did not pay them to be a peep-show (but on the contrary made them pay dearly for the privilege of working in the studios), they were entitled to be left in peace. When Winold returned, although he sympathised, he would not allow the studio doors to be locked. So the students downed brushes and walked out during the half hour. It was wasted time and they never ceased to resent it.*[33]

As early as 1936, there were rumblings that the Great Northern Railway was not happy with the school arrangement either. Some management personnel complained that it was not profitable—there were too few students and most of them drove out to Glacier Park rather than take the train. Reiss responded that the number of students was less important than the fact that the school attracted many tourists to the park. In addition, he felt that if Great Northern would do more advertising for the school, enrollment would increase. Largely because of the lobbying of McGillis, the art school was approved for the summer of 1937.[34]

But in March 1938 Reiss wrote McGillis that he thought it "best not to organize the school this year."[35] In part, he may have been too busy to spend three months in Glacier Park. He had been commissioned by architects Reinhard & Hofmeister to design murals and the exterior wall decoration for the 1939 World's Fair Theatre and Concert Building and was already at work on "a huge mask of hammered brass symbolizing Drama, with a figure representing the Spirit of Music pouring notes from a cornucopia down toward earth."[36] Reiss was also designing for the fair the Doughnut Casino and Doughnut Palace concession in the Science and Health Building, and his mural of huge angels dunking giant doughnuts received national attention. In this period, he was also creating murals for a new Longchamps restaurant.

Yet it also seems likely that Reiss had been worn down by the demands of running the school. Tjark had gone to Austria to study architecture in the fall of 1935, so that Reiss had to manage the school himself in 1936 and 1937.[37] Entertaining twenty students, resolving conflicts, and teaching had limited the time he could devote to his first love, making portraits himself. By the end of the 1937 session, he was more than ready to return to the old arrangement, and even offered to pay his own transportation if he could shorten his stay at Glacier Park and only paint Indians, from which Great Northern could "make its usual selection of a picture." But the railroad declined Reiss's offer. Having decided that it could gain as much advertising value with just one

CHEWING BLACK BONES
(1867-1963)
Pastel and conté crayon on board,
circa 1937
Mr. and Mrs. W. Tjark Reiss

CHEWING BLACK BONES IN
MEDICINE ROBES
Pastel, circa 1937
Unlocated

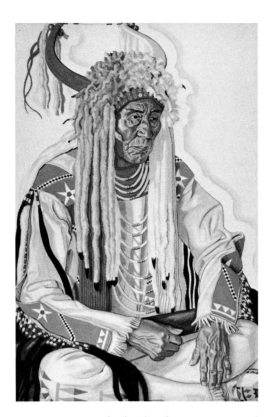

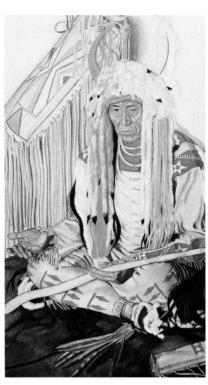

portrait per annual calendar, there was no need to increase the stock.[38]

Despite this setback, Reiss maintained a good relationship with Great Northern. Each year from 1938 until 1942, the railroad selected one of the portraits in Reiss's possession to which it had not purchased reproduction rights. Reiss received $800 for the reproduction of each portrait and for designing calendar borders. Although he missed the opportunity to go West, the money he received helped him make it through the hard times of the late 1930s.[39]

In the end, Reiss's relationship with Great Northern in the 1930s enabled him to do what was most important to him: to produce folkloric and even ethnographic portraits of Indians, even if he sometimes had to make more commercial images. His portrait of Chewing Black Bones is one of the finest representations of an elder statesman of the Blackfeet nations. This warrior-turned-medicine-man is distinguished not only by the chiseled treatment of his face and hands, but also by the remarkably detailed rendering of his extraordinary robes, which were accentuated with human hair. Concerning a second portrait of Chewing Black Bones, Reiss wrote to Ralph Mather, president of the Brown & Bigelow company, which printed the Great Northern calendars: "I painted him in a very old and valuable medicine costume which he always keeps in the paraflesh shown in the left upper corner of the picture."[40]

Reiss was even able at times to convince Great Northern to use some of his more folkloric portraits as calendar subjects. In 1939, for example, when he could not come out to Glacier Park, Reiss suggested *Sign Talkers* for the next calendar. After an initial rejection and much discussion, the railroad agreed.[41] While the figure on the left, Hairy Coat, was particularly decorative in his dress shirt and multicolored straight-up bonnet, the figure on the right, No Runner, with his bare back and elderly limbs, was probably not flattering enough for the railway. Nevertheless, Reiss shaped the taste of his Great Northern patrons by tactfully redirecting it to suit his conceptual and

aesthetic agenda. That agenda included not only producing high quality, realistic portraits of Indians, but also exploiting the use of color in the calendar design. In June 1939, he recommended a particularly bold color for the border of the next calendar. *As the picture is very colorful, it can stand a strong color frame. We had mostly in the past very neutral frames and I believe a frame of the type which I designed will be very appropriate for the present time, where, inspired by the World's Fair, people's leanings go much more towards brighter colors.*[42]

 The joy that Reiss received from this commercial work is reflected in a letter he wrote after the calendar was printed: *I think that Brown & Bigelow have done a wonderful job. The colors are bright and vigorous and I am especially delighted with the yellow border which makes it a gay and inspiring composition. Sitting on my chair, looking at the wall where I placed the calendar, I realize what a sunny and colorful spot this calendar will be in most of the gloomy offices where it probably will hang throughout the country. I congratulate you and Brown & Bigelow for their excellent work and for their courage in applying so colorful a border to their calendar in a time where [sic] everybody cries for color.*[43]

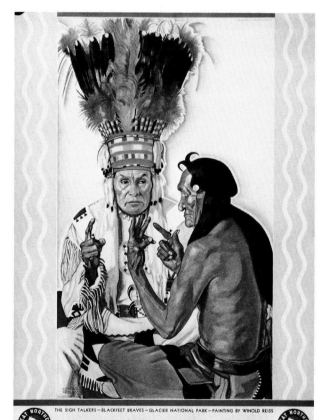

Great Northern Railway calendar for 1940 featuring Winold Reiss's Sign Talkers (Hairy Coat and No Runner) Southwest Museum

NOTES:

1. Interview with Tjark Reiss, July 25, 1987; interview with Ailes Gilmour Spinden, January 13, 1989.

2. Interview with Ailes Gilmour Spinden, January 13, 1989.

3. "The Gist of It," *Survey Graphic* 65 (January 1, 1931): 355.

4. *Ibid.*

5. Winold Reiss to O. J. McGillis, February 5, 1931, Reiss Papers, private collection.

6. *Ibid.*

7. McGillis to Reiss, May 28 and June 12, 1931, Reiss Papers, private collection.

8. Reiss to McGillis, March 4, 1932, *ibid.*

9. Mrs. Denny Carter, "Paul Philippe Cret & the Union Terminal," and Mrs. Frances Crotty, "The Cincinnati Union Terminal & the Art Deco Movement," in *Art Deco and the Cincinnati Union Terminal* (exhibition catalogue, Contemporary Arts Center, Cincinnati, Ohio, 1973), pp. 10, 12, 16.

10. Interview with Tjark Reiss, July 25, 1987.

11. The Cincinnati Union Terminal opened with great fanfare in 1933 (see *Cincinnati Times Star*, March 31, 1933). In 1972, the terminal closed and plans circulated to demolish the concourse; then in October, the Southern Railway obtained rights to the railroad, but couldn't get their piggyback freight trains into the terminal without removing the concourse. The concourse mosaics were thus removed and installed in an addition to the Cincinnati airport, where they are today. In 1989 work was begun by the Cincinnati Historical Society to transform the terminal into a museum of the city of Cincinnati. The rotunda mosaics will be used to surround an information center for the museum.

12. Eugene Clute, "Techniques in Modern Mosaics," *Architectural Forum* 56 (January 1932): 69-76, and Gerdt A. Wagner, "Mosaics," *Creative Art* 10 (April 1932): 264-67.

13. Cynthia Siu to author, September 15, 1987; *New York University Bulletin* 33 (1933-1934); Winold Reiss and Albert Schweizer, *You Can Design* (New York, 1939).

14. "Tact in Art," *Art Digest* 7 (September 1933): 24.

15. McGillis to Reiss, September 11, 1935, Reiss Papers, private collection.

16. Reiss to McGillis, September 22, 1937, *ibid.*

17. Reiss to McGillis, February 11, 1936, *ibid.*

18. Reiss to McGillis, February 11, 1936; McGillis to Reiss, February 25, 1936, *ibid.*

19. Mr. Aszmann to Reiss, March 19, 1936, *ibid.*

20. Interview with Tjark Reiss, July 25, 1987.

21. *Ibid.*

22. Claire Sheridan, *Redskin Interlude* (London, 1938), pp. 16-17.

23. Telephone interview with Sarah Frijofson, January 17, 1989.

24. Sheridan, *Redskin Interlude*, p. 18.

25. *Ibid.*, p. 97.

26. *Ibid.*, pp. 63, 90.

27. Telephone interview with Sarah Frijofson, January 24, 1989.

28. Sheridan, *Redskin Interlude*, p. 152.

29. Hugh A. Dempsey, *Tailfeathers: Indian Artist*, Art Series No. 2 (Calgary, Can., 1978), pp. 5-6.

30. Tailfeathers continued to evolve as an artist throughout his long career in the fine and commercial arts, moving

away from portraiture and Reiss's style in the 1950s and 1960s to paint scenes of nineteenth-century Indian life in the tradition of Frederic Remington and Charles Russell. Yet even in his works of the fifties, Reiss's influence remained. A review of a Glenbow Museum exhibition in which Tailfeathers's painting *Blood Camps* appeared, said that it retained "the most evidence of what the Blackfoot artist learned from the German-born Reiss in the use of clear, flat color, subtle modelling and line" (Nancy Tousley, "Exhibition reflects link between artists," undated clipping, Glenbow Museum Vertical Files).

31. Sheridan, *Redskin Interlude*, pp. 130-31.

32. Interview with Tjark Reiss, November 17, 1988.

33. Sheridan, *Redskin Interlude*, pp. 133-34. This incident is corroborated by Sarah Frijofson in a letter to the author, February 13, 1989, in which she notes that when Reiss returned, *there was an explosion. I had never seen him lose his temper before, but he really gave us the scolding of our lives. We found out that the tourist visit was in his contract with the Great Northern R.R. Any violation of that might terminate the contract and mark the end of the school. We made our point, which was that we were paying to study and not be exhibited ourselves.*

34. McGillis to Reiss, February 25, 1936, October 9, 1936, April 7, 1937, Reiss Papers, private collection.

35. Reiss to McGillis, March 9, 1938, *ibid.*

36. *Official Guide Book—New York World's Fair 1939* (New York, 1939), p. 178; Reiss to McGillis, March 9, 1938, Reiss Papers, private collection.

37. While abroad, he had furthered his father's interest by arranging, in 1936, an exhibition of fifty-three of Reiss's Indian portraits in the Künstlerhaus in Vienna. That exhibition then traveled to Budapest, Prague, and Berlin.

38. Reiss to McGillis, March 9, 1938; McGillis to Reiss, March 29, 1938, Reiss Papers, private collection.

39. Reiss to McGillis, May 11 and August 7, 1939, *ibid.*

40. Reiss to Ralph Mather, July 31, 1940, *ibid.*
Paraflesh is the sheaf or cover that appears in the background of the picture.

41. McGillis to Reiss, May 17, 1939, *ibid.*

42. Reiss to McGillis, June 23, 1939, *ibid.*

43. Reiss to McGillis, September 12, 1939, *ibid.*

WORLD WAR II AND THE PASSING OF THE PALETTE

By the early 1940s, Reiss was experiencing hard times. Although the coming of World War II revived American industry, the shift of national priorities to war preparation restricted travel, supplies, the demand for commercial advertising construction, and expensive interior decoration. Not only did the number of Reiss's commissions decline drastically, but even those he obtained were difficult to complete because of wartime restrictions on artists' materials.[1] As Reiss candidly explained to O. J. McGillis of Great Northern early in 1940, "this war has certainly knocked everything out of key and has ruined the art business entirely. I have lost many wonderful prospects for business like everybody else I guess and the future looks dark and uninspiring."[2] One potential client summarized the attitude of commercial enterprises in the months before America entered the war: *We have not given up the idea of enlarging our cocktail lounge and ski grille but with the present uncertainty of world affairs and Mr. Roosevelt's possible idea of "No Vacations," both my partner and I feel that* [the] *present is not the time to make any extensive alterations or improvements.*[3]

By early 1940, Reiss was having trouble paying his rent on West 16th Street and had to take out notes to meet the payments. In October, he moved his studio of thirteen years to smaller quarters on West 13th Street. That move ended the Winold Reiss Art School, since the new accommodations were not large enough for classes.[4] In July 1941, financial problems led New York University to discontinue its School of Architecture and Allied Arts, which ended Reiss's employment there. In December 1942, the Keramic Society and Design Guild of New York, where he had been teaching a series of classes for more than a decade, canceled his classes for the upcoming semester because of insufficient funds and low attendance.

Reiss did obtain a commission, completed in September 1941, to paint a mural for the Drum Room of the Hotel President in Kansas City. The job was a much needed source of income, as well as a boost to Reiss's self-esteem. Homer Neville, the architect who commissioned him, gave Reiss a glowing account of the effect of his work: *The Drum has so far had an almost unbelievable success. People have been turned away nearly every night since the opening so that Mr. Dean is really concerned to know whether the kitchen facilities will be adequate. . . . We have been overwhelmed with compliments on the atmosphere and general appearance of the room, and I feel that credit for this should go in large measure to you. The murals are a climax to the whole effect.*[5]

Reiss obtained two other significant commissions: one, in the fall of 1941, to remodel the Yorktown Hotel in York, Pennsylvania; the other, in 1942, to design the cover for another special issue of *Survey Graphic* edited by Alain Locke, "Color: The Unfinished Business of Democracy." The purpose of the issue was to argue that one of the outcomes of the latest "war to make the world safe for democracy" should be the resolution of the racial inequities in the United States.[6] Paul Kellogg, general editor of *Survey Graphic*, was sympathetic to Reiss's economic plight. In September 1942, he wrote his friend General F. G. Osborn, chief of special services of the War Department, attempting to obtain employment for Reiss's " 'brushes of comets hair' " in the war effort. He was not successful.[7]

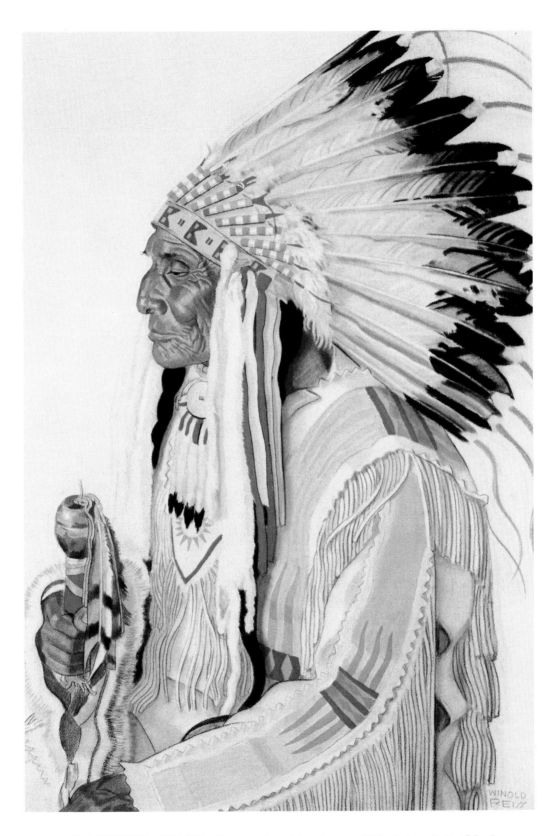

WADES IN THE WATER (1871–1947) Tempera, pastel, and charcoal on paper, 1943 Burlington Northern Railroad

These few assignments, however, did not cover Reiss's expenses. As a result, the Great Northern contract, which had represented only a fraction of his income in normal times, became much more important during the war years. McGillis nevertheless maintained that war restrictions on travel reduced the railroad's tourist business, and it could not afford to have Reiss come to Glacier Park to paint Indians. But in the fall of 1942, McGillis died, and the new advertising manager, Charles W. Moore, shortly informed Reiss that he wanted to continue the calendars.[8]

Yet Moore's takeover of the advertising department altered Reiss's relationship with the Great Northern Railway. Unlike McGillis, who had allowed the artist a good deal of freedom in designing the calendars, Moore had definite ideas of his own. Early in 1943, he asked Reiss to sketch an Indian in a military outfit with " 'vision-like' Indian life in the background" to bring the calendars into step with the war effort. He also wanted Indian "picture writing" and "simplified tools of modern warfare" on the borders of the calendars. The resulting drawing was a disappointment, even to Moore. He wanted a scene of Indians "charging, their spears thrust forward," but Reiss demurred, arguing that there "should not be too much savagery and suggestions of killing" in a calendar image of Indians. Eventually, that subject was abandoned and Moore selected Reiss's portrait *Seated Girl in Bead and Red Dress* for the 1944 calendar.[9]

Moore also asked that the Indian woman's name be changed and that activities of Blackfeet women such as "bead work, preparation of skins, cooking over outdoor fire, etc." be included in the border design. He thus rejected Reiss's bold red border. Reiss tried to explain the reasons behind his more abstract borders and his use of intense colors: "The activities of Indian women in tribal life should not be too realistic as they otherwise do not fit into the Indian design. We have always tried so far to use drawings which express the simplicity and simplification of Indian design." Moreover, "I personally do not agree that the red border would have been too red. A calendar which is supposed to express Indian atmosphere should be very colorful and sing right from the wall." Over Reiss's objections, the more literal designs and a gray border were used. Moore had changed the patronage relationship by asserting the right of the railway to produce a calendar more in step with advertising values.[10]

On the positive side, however, Moore had greater clout than his predecessor. Once he determined that he could work with Reiss, he recommended that the artist come out to Glacier Park during the summer of 1943. *The real Blackfeet types are vanishing with the years and constant mixing of Indian and white bloods. On the reservation today are a comparative handful of true Blackfeet types, such as Wades in Water; his wife, Julia; George Bullchild and Weasel Feather. If we are to continue the Indian calendar (and I am sure that no one desires its discontinuance) we should present true Blackfeet types. This will require a backlog of desirable subjects—more than now is available.*[11]

The new arrangement paid Reiss $5,000 to produce at least six acceptable portraits for Great Northern's use. On the way to Browning, he stopped in St. Paul to confer with Moore about which sitters he should draw. Moore indicated that he was particularly anxious for Reiss to portray Wades in the Water and his wife, Julia, who were employed by the railroad to meet tourists at the park. Since the hotels and chalets were closed, Reiss's subjects would be available for the entire summer. With unlimited access to his sitters and an enthusiasm built up during five years of absence from Montana, Reiss threw himself into his work and produced sixty-six portraits, surpassing the peak of fifty-two he had done his first summer at Glacier in 1927.[12]

Certainly the most important portraits were of Wades in the Water and Julia. A former

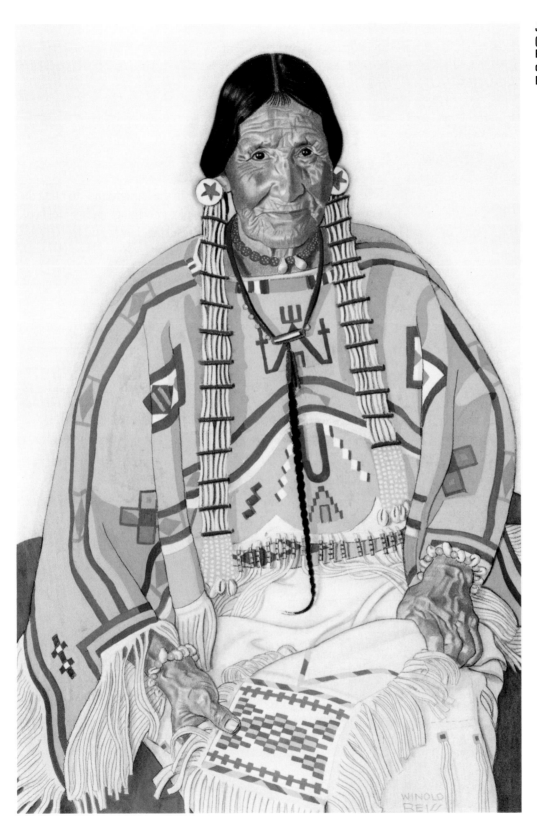

JULIA WADES IN THE WATER
(1870–1954)
Pastel, charcoal, and tempera
on paper, 1943
Burlington Northern Railroad

chief of police on the reservation, Wades in the Water possessed several full-dress outfits. Reiss pictured him in one of his most glorious shirts and with the Sioux headdress that was his preferred headwear. Similarly, Julia was represented in her beautiful blue beaded dress; she also sat to the portrait entitled *Under Owl Woman with Child.*

In these formal portraits, Reiss seems less concerned with the face as a sculptural, three-dimensional form and more attentive to the decorative splendor of the dress, as in his 1927 portrait of Home Gun [see page 74]. He even remarked that though his portrait of Julia was good, he wished there had not been so many lines in the elderly woman's face.[13]

Such portraits embodied the Great Northern style of monumental, highly decorated figures, even if the stylized background seemed to have disappeared from most of them. Not surprisingly, Mr. Moore was pleased: he especially liked the portrait of Julia, although he objected to the blue haze that Reiss used to encircle her body, which he thought detracted from her face. Reiss replied that "I put the blue outline around it to intensify her expression but if there is any objection against it, I of course can easily take it out."[14] He took it out.[15]

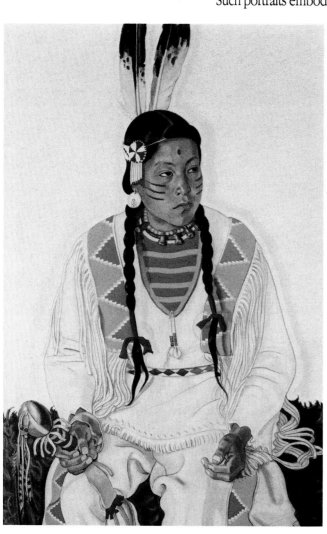

The railroad also liked Calvin Last Star's portrait. Calvin was the son of Bird Sings Different and Theodore Last Star, a man paid by the railroad to organize activities at the East Glacier hotels. He was later an actor in the film *Big Sky,* along with Kirk Douglas. Calvin Last Star's portrait presents a youthful figure, whose delicate features and beautiful outfit made him a typical study of an Indian in fancy dance dress. But when Reiss designed the calendar for this portrait, the railroad changed Calvin's name, which at the time was Flying Higher. Often the Blackfeet had two names—the first, more traditional one, such as Flying Higher, was bestowed by older people of the tribe upon the birth of a child. The other was a family name, such as Last Star, which was taken from the eldest member of the family when the federal government began keeping records. The latter became important in terms of inheritance, but at the time Reiss drew Calvin Last Star, he was still called Flying Higher. However, Great Northern felt that it sounded too much like an airline, so they called him Dancing Boy.[16]

Only 10 percent of Reiss's output that summer has been identified, but its decorative emphasis suggests that patronage had begun to shape, ever so subtly, the kind of images Reiss produced. Short of cash and needing this commission, the artist provided Great Northern with images he knew they would accept.

In one portrait, whose style dates it to the summer of 1943, Reiss combined all his gifts as an artist. In portraying Angry Bull, his friend Turtle's other name, he balanced the increasingly decorative treatment of Blackfeet formal dress with equally detailed depiction of the face. Not only does this portrait show Reiss's gift for detail—down to the stunning rendering of the weasel tail, the

CALVIN LAST STAR
Pastel, charcoal, and tempera
on paper, 1943
Burlington Northern Railroad

headband, and the designs on Angry Bull's shirt—but it also reveals his remarkable compositional sense in the flow of the lines created by the bonnet, shoulder, and arm extended by a rattle.

During the 1943 trip, Reiss met John Ewers, an anthropologist working as curator of the Browning Museum of the Plains Indian, who was conducting field research with such Blackfeet elders as Chewing Black Bones, Lazy Boy, and Weasel Tail, all of whom had sat for Reiss. In the admiration Ewers expressed for these portraits, the artist found confirmation of their anthropological value.[17] At the same time, Reiss became concerned with the contemporary plight of the Blackfeet. On his way back to New York, he stopped in Chicago and spoke with William Zimmerman, assistant commissioner at the Bureau of Indian Affairs, and lobbied for improved conditions on the

Blackfeet reservation. The Blackfeet population had grown from the time of his last visit in 1937, yet basic services had not kept pace with the increase. A pipe connection needed to be completed to bring much-needed water to Browning. And worse, because of World War II, Congress was considering a bill to reduce the appropriations for Indians living on the reservation. In a letter to George Bullchild, Reiss conveyed that he had been assured by Zimmerman that the bill was not likely to be passed. But he also encouraged Bullchild and the Blackfeet to continue their lobbying efforts. He concluded: "It is very hard to work myself into my New York activities again because I am still thinking and dreaming Blackfeet. Let me hear from you soon."[18]

Reiss feared it would be some time before he would see the West again. Now that Great Northern had calendar subjects for the next six years, it would not need to invite Reiss to Glacier Park until 1948, when he would be asked to produce another set. But in 1944, Reiss was invited to visit Rocky Boy Agency near Fort Belknap, east of the Blackfeet nation. Reiss traveled to Rocky Boy in the fall and did portraits of the Cree and Chippewa Indians. But when Reiss offered the railroad some of the portraits he produced during this trip, Great Northern declined to purchase them.[19] Reiss realized that he had to find alternative ways of financing his trips out West. He was uncertain when he would return there. As he wrote Bullchild in 1945: "I certainly plan to be out there next summer for a while but with the war probably coming to an end, one does not know for sure how things will turn out."[20]

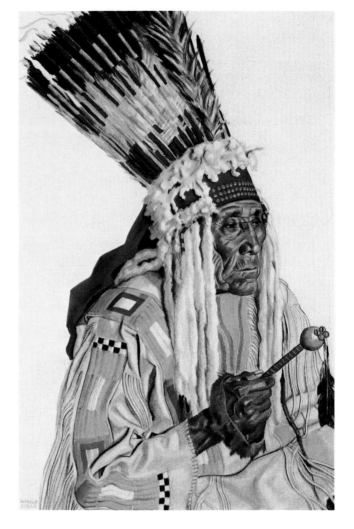

**ANGRY BULL
or TURTLE
(born 1877)**
Pastel, charcoal, and tempera
on paper, circa 1943
Burlington Northern Railroad
(color illustration on page 150)

In fact the end of the war brought renewed interest in Reiss's interior decoration. In 1945 he received a lucrative contract to create designs for the dining room of Mike Lyman's Grill in Los Angeles. Soon the postwar building boom led to many more commissions than Reiss could handle alone. Working with Tjark and his loyal assistants, Otto Baumgarten and Albert Schweizer, he entered one of his most productive periods of interior decoration. He also seemed to employ color even more dramatically. But the bold yellows, reds, and turquoises he used in these

118

PORTRAIT OF THE ARTIST'S SON
IN NEW YORK
(W. TJARK REISS)
(born 1913)
Pastel on board, 1938
Renate Reiss
(color illustration on page 13)

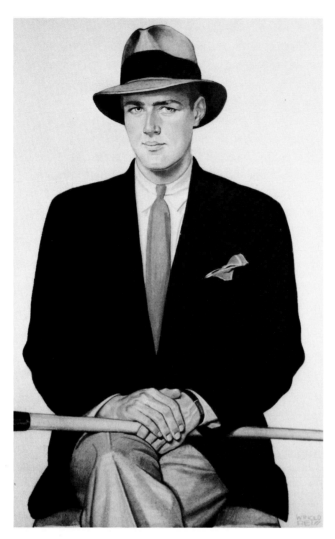

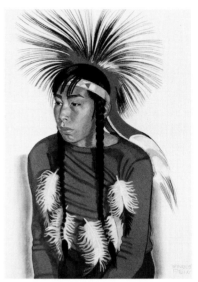

NOBODY HAS PITY ON ME
or BURTON BEARCHILD
Tempera, pastel, and charcoal on
paper, 1948
Burlington Northern Railroad
(color illustration on inside front
cover)

Color suggestion for Savarin
restaurant, Penn Station,
New York City
Gouache on board, 1948
Mr. and Mrs. W. Tjark Reiss,
courtesy Shepherd Gallery
Associates

commissions are the colors that predominate in Blackfeet dress. Even in interior decorations such as that for the Savarin restaurant in Penn Station, New York, which owed more to the delicate decorative style of the Wiener Werkstätte than to Indian design, Reiss still attempted to introduce Indian colors.

Reiss's most important commercial use of these colors as well as Indian motifs came in 1949 and 1950, when he designed an Indian Room for the Chic-N-Coop restaurant of Montreal. Reiss not only produced murals of Indians, but also designed the restaurant entrance, lobby, menus, napkins, tablecloths, ashtrays, matchbook covers, business cards, swizzle sticks, advertisements, and waiters' outfits, all on an Indian theme. This was, in one sense, the comprehensive Indian-style installation he had proposed to Great Northern in the 1920s and again in the 1930s. Ironically, two years after Reiss's death in 1953, Great Northern would finally decide to redesign the interior of its Empire Builder, using the motifs and colors of Indians from Washington State.[21]

During the summer of 1948, Reiss returned to Glacier Park for what would be his last visit. Once again, he made stunning, highly decorative portraits of the Blackfeet, but now with a focus on young people. His portrait of Nobody Has Pity On Me (whose family name was Burton Bearchild) renders the striking Blackfeet dancer in his red long johns with white feathers attached,

and a porcupine roach on his head. While less boldly colorful, Reiss's portrait of Floyd Middle Rider is even more complete. In his Great Northern style, Reiss blended a sensitive and monumental treatment of the handsome subject with accurate detailing of the formal dress and a stylized elaboration of the background.

Floyd Middle Rider recalls the events leading to the portrait and his sittings: *I was around 14 or 15 years old when he painted my portrait. It was arranged through George Bullchild. I was brought to a room in a Browning hotel— he had just painted Eileen Schildt* [called *Evening Star Woman* in her portrait]. *I was wearing Old Man Middle Rider's shirt in the portrait. He was buried with that suit. George Bullchild talked with Old Man and Old Lady Middle Rider and said let him wear the shirt. It took three days to paint the portrait. I was paid 2 dollars an hour. When he finished, nothing was filled in; it was just me alone. Old Lady Middle Rider did the beadwork, even on the moccasins.*[22] Reiss drew Chief Mountain in the background after the sitting.

Rather than attest to the persistence of traditional dress and ways among the younger generation of the Blackfeet in the 1940s, Floyd Middle Rider's comments confirm that such habits were fast disappearing. He was wearing, after all, the suit of an older generation, not his own. And he further recalls: "I was one of the few young men who still wore long braids in those days. A few years later, I cut my hair."[23]

Other signs of change were reflected in the controversy that later erupted over the portrait of Evening Star Woman. Eileen Schildt sued the Great Northern Railway, challenging their right to use her image without compensating her. The suit was apparently unsuccessful; but the fact that it was even made speaks for the changing times in Browning: the younger generation had a new, more militant consciousness about their right to control—and profit from—the dissemination of their images for commercial purposes.[24]

Reiss's declining relationship with Great Northern probably rekindled his fundamental impulse as a natural historian, his desire to record all the variations of Indian types, as if that collection would somehow preserve the spiritual values he believed Indians represented. He began to consider how he could make a permanent contribution, one that would attest to the art, culture, and humanity of the Indian people. His old idea for an Indian monument—to draw representatives of all of the Indian nations in the West—had foundered because of lack of support during the Depression and World War II. But another opportunity to bring recognition to Indian art and culture came in 1945, when the Phillips Foundation commissioned him to do a mosaic mural of five Indian figures for the semicircular entrance to their Woolarc Museum in Bartlesville, Oklahoma.

Reiss designed the mural with dancing Indians, stylized in the manner of those he had produced years before for the murals at the Longchamps restaurants. The most interesting of the Woolarc Museum murals depicted a ceremonial dancer of one of the Pueblos of the Southwest, evidently mistakenly labeled *Kiowa Indian*. As with his Cincinnati mural, Reiss had to create large (seven-foot-high) drawings and then supervise the production of full-color mosaics. Tjark, who had just returned from the army and had acquired his architect's license, drew the blueprints. At the completion of the project in November 1946, Winold wrote to Tjark: "Neville [the architect of the project] congratulated me today and said nobody expected such a beautiful result, which pleased me very much."[25] The mosaic stands today.

Reiss had also made plans of his own for a permanent commemoration of Indian civilization. As Tjark recalls, "He bought an old Chinese bank in Carson City, Nevada, which my uncle had rebuilt into a studio and exhibition building from plans that I had made. His idea was to

FLOYD MIDDLE RIDER
Tempera, pastel, and charcoal on
paper, 1948
Burlington Northern Railroad
(color illustration on page 145)

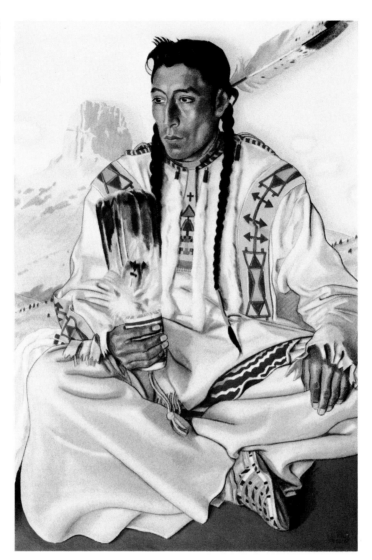

leave New York and live there."²⁶ In addition, Carl Link, who had assisted on the Woolarc installation, purchased a house nearby for his own studio. Reiss believed that by relocating in the West, he would be able to house his large number of drawings and paintings and continue his attempt to make a comprehensive record of the more elderly Indians who kept alive the old ways. Ultimately, he wanted to give the building, which occupied a small city block in Carson, to the state as a museum. But in the early 1950s, just as the renovations of the bank were nearing completion, Nevada decided to raze the structure and build state offices on the site.²⁷

Reiss was not alone in his mission to document the surviving members of an earlier generation. In 1937, the Indian artist Acee Blue Eagle had announced in Tulsa newspapers that he was going East to study with Winold Reiss.²⁸ Acee Blue Eagle was already an accomplished artist, who had developed a stylized version of the Indian pictographic tradition. But Acee was not a portrait painter, and therein lay the rationale for his trip to New York. Unfortunately, Reiss was in Glacier Park that summer, and it seems unlikely that Blue Eagle ever actually studied with Reiss at this time. In 1939 Acee again announced his intention to study with Reiss in New York. An Oklahoma newspaper explained his motivations: *Acee Blue Eagle, the Indian artist well-known*

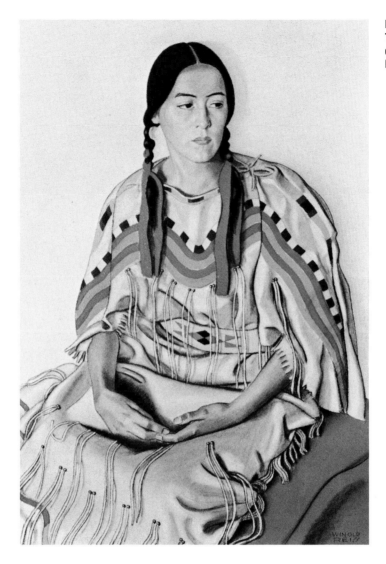

EVENING STAR WOMAN
Tempera, pastel, and charcoal
on paper, 1948
Louis W. Menk

here, will leave this week for New York where he will spend a month in study preparatory to
painting portraits of historic Indian oldsters who are fading rapidly from the current scene.
Although Blue Eagle has devoted much study and time to portrait work in previous years, he will
perfect his technique under the guiding hand of Weinold [sic] Reiss, considered the world's best
Indian portrait painter by the Muskogee artist.[29]

Blue Eagle had an exhibition at the Blanche Byerly Gallery in New York in September
1939, which indicates that he may have worked under Reiss's tutelage. Moreover, in the Acee Blue
Eagle Papers at the Anthropological Archives of the National Museum of Natural History, there is a
drawing Acee made of an Indian boy that seems to be a reworking of Reiss's portrait of First Nabor
[see page 100]; also in the archives is a copy of Reiss's Glacier Park Art School circular with its image
of First Nabor and a photograph of Acee with a portrait signed by him that shows an Indian man in
twentieth-century reservation dress drawn in Reiss's style.

Reiss's relationship with Acee Blue Eagle went beyond that of teacher-student. The
works of both artists were exhibited together, along with those of Charles Russell, in the Northwest
Art Exhibition sponsored by the Women's Club of Spokane in Washington in 1944.[30] Two years

later, Blue Eagle facilitated Reiss's access to Indian subjects in Oklahoma.[31] He also allowed Reiss to assist him in his own mission to document the Indian people.[32] The two men clearly had a special bond of mutual respect and admiration. Later in 1946, along with Carl Link and Woodrow Crumbo, another Oklahoma Indian artist, they met at the Philbrook Art Center in Tulsa for a "photo opportunity" that was recorded by the *World*. And in 1947, Reiss and Blue Eagle exchanged leads on potential purchasers of their art when Reiss's Indian portraits were scheduled to be exhibited in Tulsa and Oklahoma City.[33]

But their most important collaboration came in 1948, when Acee was definitely studying with Reiss in New York. During this visit, Reiss asked if he could draw Blue Eagle's portrait.[34] When Acee consented, Reiss, instead of searching for dress garments in museums as he had done in the past, relied on Acee to supply the costume. Acee made his own dress shirt and headdress and painted his face with red paint before each sitting. Because the winter of 1948-1949 was a particularly cloudy one and Reiss only drew in natural light, it took several months to complete. Acee was pleased when he received, in 1950, one of the two portraits that Reiss produced from the sittings and noted to reporter Frances Brown: *"It is amazing to watch Mr. Reiss paint. He gets everything exactly as it is, every bit of beadwork, every color true. Really wonderful." As he looked at this portrait of himself, Blue Eagle's eyes said how much he liked it. . . . They shone brightly with pride and pleasure at the work of a fellow-artist.*[35]

These two portraits represented a remarkable achievement for Reiss: his Indian subject was not just a sitter, but a co-creator. And by offering instruction to Acee, already an accomplished artist, Reiss was passing on, as he had done with Gerald Tailfeathers, Victor Pepion, and Albert Racine, his brush and palette.

He also passed them on in another way to a new generation of African American art students. In the fall of 1951, Reiss told Aaron Douglas, his former student, and Charles S. Johnson, president of Fisk University, that he wished to give several of his African American portraits to Fisk. Johnson visited Reiss's studio in New York to look them over.[36] Both Johnson and Douglas, who was a professor of art at Fisk, were ecstatic. Douglas wrote to Reiss in January 1952: *It was certainly one of the great moments of my life when you told me you were planning to present a collection of your*

"New Negro" portraits and Sea Island types to Fisk University. In its impressiveness it was a moment comparable to the time I first saw one of your magnificent drawings of a Negro head on the cover of Survey Graphic *more than twenty-seven years ago. It was similar, also to the feeling of elation I experienced when you consented to take me as a student in your school. Fisk University, as you know, already has several important groups of works which include the Cyrus Baldridge, the Rockwell Kent, and the Alfred Stieglitz collections. . . . Your pictures, over and above the fine aesthetic values, will hold a special meaning for us here. Yours were among the very first representations of contemporary Negro peoples executed with sympathy, dignity, enthusiasm and understanding.*[37]

Unfortunately, between the time of the visit and Douglas's letter, Winold Reiss had suffered a stroke that paralyzed his right side and prevented him from talking. Tjark Reiss, honoring the pledge, brought the group of portraits to his father, who selected twenty-six of them for Fisk with a nod of the head. Winold Reiss could not attend the ceremony in 1952 at which the school was to formally honor the gift and the giver. On August 29, 1953, he died in New York City. He was cremated and his ashes were spread over the Montana country by George Bullchild and other Blackfeet friends.

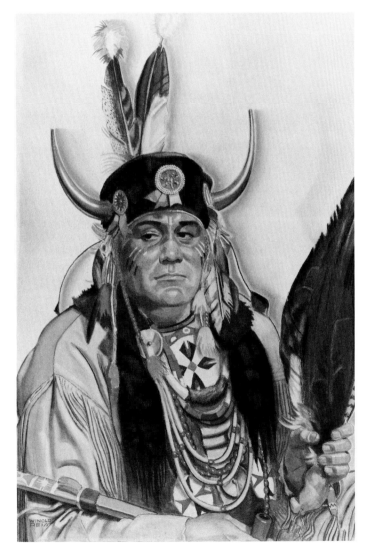

ACEE BLUE EAGLE
(1907–1959)
Watercolor and pastel on board,
1948–1949
The Thomas Gilcrease Institute of
American History and Art

NOTES:

1. One incident suggests that as the Nazis grew more oppressive in the period before the outbreak of World War II, Reiss was again the victim of anti-German sentiment. In 1938 he had been commissioned by the National Cash Register Company to make a mural for a new showroom they planned for one of the Radio City buildings. But the president of the company rejected the final sketches as unsuitable, even though they merely developed a scheme that had been previously approved. The architect told Reiss that the president "had been informed by some people that [Reiss] was an ardent Nazi [and] had gone to school with Adolf Hitler" (interview with Tjark Reiss, July 25, 1987). Reiss, of course, had no such connections, and even offered to obtain letters of recommendation from several Jewish clients. The offer was rejected, and he was forced to accept a settlement of the contract. The absurdity of the accusation suggests that Reiss may have been falsely slandered, perhaps by "some people" who were professionally jealous and wanted to compromise his career or at least rob him of the commission. Although such whisperings never reached the ears of those who awarded him commissions at the World's Fair that same year, they were enough to cost him the NCR contract, which suggests that Reiss's difficulty in obtaining other commissions during World War II may have been related to increased anti-German sentiment.

2. Winold Reiss to McGillis, June 14, 1940, Reiss Papers, private collection.

3. William Horrocks to Winold Reiss, May 15, 1941, *ibid*.

4. Winold Reiss to Mrs. B. M. Arras, April 26 and May 30, 1940, *ibid*.

5. Homer Neville to Winold Reiss, September 8, 1941, *ibid*.

6. *Survey Graphic* 31 (November 1942).

7. Paul Kellogg to General F. G. Osborn, September 25, 1942, copy in Reiss Papers, private collection.

8. McGillis to Reiss, circa February 5, 1942; Reiss to McGillis, February 11, 1942; Ralph Mather to Reiss, October 5, 1942; Moore to Reiss, January 26, 1943, *ibid*.

9. Moore to Reiss, January 26, February 23, and March 27, 1943; Reiss to Moore, February 1 and 26, 1943, *ibid*.

10. Moore to Reiss, March 27 and April 1, 1943; Reiss to Moore, March 31, April 5, and April 21, 1943, *ibid*.

11. Moore to Reiss, May 11, 1943, *ibid*.

12. Reiss to Moore, May 14, 1943; Moore to Reiss, May 17, May 20, and June 18, 1943, *ibid*. In his June 18 letter Moore wrote: *I should like very much to have you arrange your west-bound schedule so that you might spend at least a day in St. Paul. This would provide an opportunity for discussion of the project as a whole, principally the portraiture of certain Indian men and women, who, in our opinion, would make excellent subjects.*

13. Beaver Child [Winold Reiss] to George [Bullchild], November 9, 1943, *ibid*.

14. Reiss to Moore, November 15, 1943, *ibid*.

15. Moore to Reiss, November 3, 1943; Reiss to Moore, November 15, 1943, *ibid*. While Reiss claims here that the only reason for including the halo is to "intensify her expression," my sense is also that the halo might have been Reiss's way of indicating the spiritual power of the subjects. Hence, he may have made a copy of the portrait with the halo, since a photograph of his portrait with this same halo appeared on page 4 in *Indians of the Northwest by Winold Reiss*, one of the "How to Draw Books" published by Walter Foster. I am indebted to John C. Ewers for bringing this publication to my attention.

16. Interview with Calvin Last Star, October 16, 1988.

17. Telephone interview with Dr. John Ewers, March 3, 1989.

18. Beaver Child [Winold Reiss] to George Bullchild, November 9, 1943, Reiss Papers, private collection.

19. Moore to Reiss, November 17, 1944, *ibid*.

20. Beaver Child [Winold Reiss] to Bullchild, February 20, 1945, *ibid*.

21. Winold Reiss to V. Hill, Chic-N-Coop Limited, February 9 and 10 and March 1, 1949, June 11, 1950; Victor Hill to Reiss, December 22, 1949, March 8 and June 30, 1950, April 19, 1951, *ibid*.

22. Interview with Floyd Middle Rider, October 16, 1988.

23. Floyd would go on to attend Indian school, to learn English, and to run a profitable ranch. Now, however, he is compiling a Blackfeet-English dictionary (*ibid*.).

24. Interview with Floyd Middle Rider and interview with William S. (Billy) Big Spring, October 16, 1988.

25. Winold Reiss to Boykie [Tjark Reiss], November 20, 1946 (from Bartlesville, Oklahoma), Reiss Papers, private collection.

26. Interview with Tjark Reiss, July 25, 1987; Winold Reiss to Boykie [Tjark Reiss], November 4, 1946, *ibid.*

27. Interview with Tjark Reiss, July 25, 1987. Reiss also drew a number of beautiful landscapes while in Nevada.

28. Clipping, July 20, 1937, in "Clippings re Blue Eagle," Acee Blue Eagle Papers, Anthropological Archives, National Museum of Natural History, Smithsonian Institution (hereafter cited as Blue Eagle Papers).

29. "Indian Portrait Series Planned: Blue Eagle to New York to Study Under Famous Artist," *World* (Tulsa, Oklahoma), August 20, 1939, clipping in the "Clippings re Blue Eagle," Blue Eagle Papers. Others in same clipping file are: "Series of Indian Portraits Will Be Painted by Blue Eagle," *News*, August 22, 1939, "Indian Artist Studies in New York," *Oklahoman*, September 3, 1939.

30. [Mary Louise Lane] to Acee, [April 26, 1944]; Mrs. Charles E. Pond to W. G. Oves, April 24 and 25, 1944, correspondence (1944), Blue Eagle Papers.

31. Winold Reiss to Boykie, November 20, 1946, Reiss Papers, private collection. Reiss wrote his son after completing the Woolarc mosaic that he was going to Muskogee to be "taken into the real Indian country by a friend of mine named Ace [*sic*] Blue Eagle. I hope to do some paintings."

32. See article on Acee Blue Eagle's series in the *World*, August 20, 1939, Blue Eagle Papers.

33. Winold Reiss to Ace [*sic*], April 24, 1947, correspondence (1947), Blue Eagle Papers.

34. Frances Rosser Brown, "Oklahoma Indian Artist Takes New Role to Help Produce Own Portrait," *Tulsa World*, August 20, 1950, undated clippings, Blue Eagle Papers. Napoleon Moore noted to Acee Blue Eagle (February 20, 1948, correspondence [1948], Blue Eagle Papers): "Received your letter and am glad to learn that you are studying under Mr. Reiss. Am sure you will learn a lot and it will mean a great deal to you."

35. Brown, "Oklahoma Indian Artist," Blue Eagle Papers.

36. Charles S. Johnson to Winold Reiss, November 20, 1951, Reiss Papers, private collection.

37. Aaron Douglas to Winold Reiss, January 9, 1952, *ibid.*

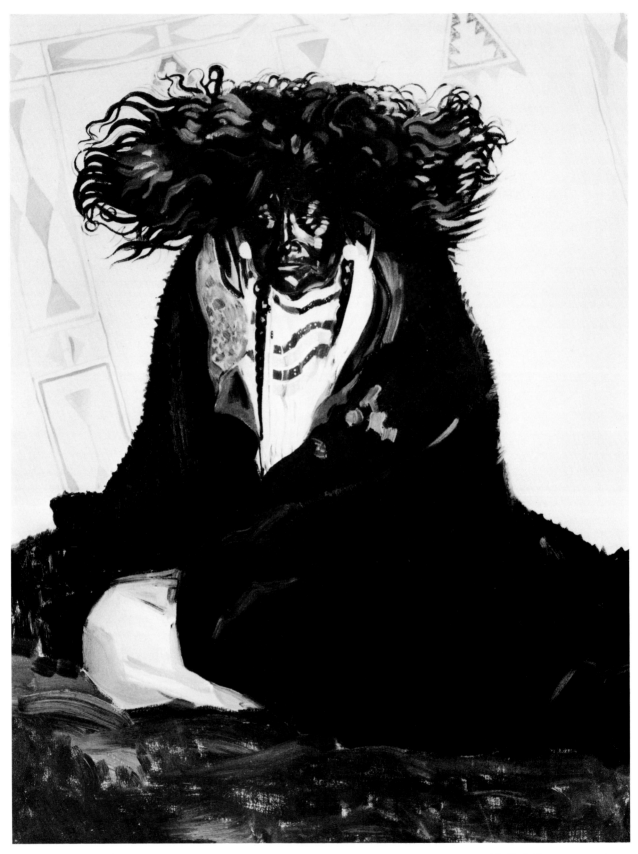

ALWAYS HOWLING WOMAN wearing the scabby buffalo bull headdress of the Matokiks, or Women's Society, of the Blood tribe
Oil on canvas, circa 1927-1928 The Anschutz Collection

WINOLD REISS AND THE BLACKFEET INDIANS

by John C. Ewers

I t was my good fortune to have known both Winold Reiss and many of the Indians whose portraits he painted from life in their own country between the years 1919 and 1943. They were Blackfeet Indians, who lived on the high plains within sight of the lofty, snow-capped Rocky Mountains, which they had long known as the Backbone of the World.

Although they were collectively referred to as Blackfeet, these Indians were members of four tribes. Three of them—the Siksika or Northern Blackfoot, the Blood, and the North Piegan tribes— occupied separate reserves in Alberta, Canada. The fourth, the South Piegan, lived on the larger Blackfeet Reservation in Montana, which borders the beautiful and spectacular Glacier National Park on the west.

During the days when buffalo were still plentiful—before the early 1880s—these four tribes comprised the most aggressive and powerful military alliance on the northwestern plains. Not only did they wrest some of the richest hunting grounds of the American West from other tribes; they also continued to send out raiding parties against enemy tribes both east and west of the Rockies, at the same time warding off both Indian and white intruders from their hunting grounds. Prior to the 1830s they twice drove white Americans, who had sought to trap beaver in the Missouri River headwaters, out of the present-day state of Montana.

Indeed, Blackfeet hostility prevented Americans from learning very much about these Indians until 1831, when the American Fur Company made peace with them by promising to henceforth trade with them for beaver and other furs, so that Indians, too, might profit from this wilderness enterprise.

During the very next summer—1832—the American artist George Catlin traveled up the Missouri River aboard the first steamboat to reach the American Fur Company's most remote post, Fort Union, at the mouth of the Yellowstone River near the present North Dakota-Montana border. During a brief stay at that fort, Catlin met and painted members of a party of Blackfeet Indians who were visiting there. These were the first portraits of Blackfeet. Catlin's subjects were mostly members of the Blood tribe, whose head chief was Buffalo Bull's Back Fat. The artist's very striking portrait of this chief is considered by some critics to have been his masterpiece. He himself must have thought highly of it, because in 1846 he entered it in the prestigious Paris Salon. French art critics who saw it there highly praised it.

The very next summer, Karl Bodmer, a young but extremely talented Swiss artist, accompanied the German naturalist Maximilian, Prince of Wied-Neuwied, up the Missouri to picture with amazing accuracy the country and its inhabitants—birds and animals, as well as Indians. They traveled upriver beyond Fort Union to the fur company's new post of Fort McKenzie at the mouth of the Marias River, in the heart of the Blackfeet country. During a month's stay at that fort, Bodmer painted portraits of an even larger number of Blackfeet Indians than had Catlin, including Buffalo Bull's Back Fat, clad in a different shirt from that worn in the Catlin sitting. His watercolor portraits reveal precisely the strong facial features of these Indians, as well as their colorful garments

BUFFALO BULL'S BACK FAT
Oil on canvas by George Catlin
(1796-1872), 1832
National Museum of American Art,
Smithsonian Institution
One of the first portraits of
Blackfeet Indians

of animal skins or trade cloth decorated with porcupine-quill embroidery, glass trade beads, and pendants of white ermine tails or the black hair of their enemies.

When Catlin and Bodmer pictured the Blackfeet, these Indians were at the height of their power—strong, self-assured masters of the vast region in which they lived. The buffalo, their staff of life, were plentiful. It was through widely distributed printed reproductions of Catlin's and Bodmer's paintings that the Blackfeet and other tribes of the Great Plains became known in Europe and eastern North America. These paintings went far toward making the Plains Indians the symbols of the American Indians *par excellence* for non-Indians in this country and abroad. They were looked upon as handsome, strong-featured, tall, and well-built men of action who hunted America's largest land mammal, the buffalo, from horseback, and rode fearlessly against their enemies, both Indian and white.

Even so, the heyday of the Blackfeet was short-lived. By the time they negotiated their first treaty with the United States in 1855, the white officials who signed this treaty knew that the range of the buffalo was contracting and that the animal would one day become extinct on the Great Plains. Buffalo remained longest on the northwestern plains in Blackfeet country. However, their final extermination occurred more quickly than government authorities had anticipated. When the buffalo disappeared during the early 1880s, they were not able to provide other food for these Indians quickly enough. Consequently, hundreds of Blackfeet died of starvation. The survivors of these formerly independent Indians were reduced to eking out a bare existence in a nearly gameless land, where they had to depend upon government rations of food, clothing, and other necessities.

During the years I lived on the Blackfeet Reservation in Montana—1941 through 1944—as the first curator of the Museum of the Plains Indian, just west of the headquarters town of Browning—many of the older Indians whom Winold Reiss had portrayed were still living, and they were the ones from whom I obtained firsthand memories of Blackfeet life in buffalo days. They had been born and raised in tepees, had learned to hunt buffalo from horseback, and had taken part in horse-raiding parties against such enemy tribes as the Crow, Assiniboine, and Cree east of the Rockies, and the Flathead and Kutenai to the west. They had learned the traditional arts and religious beliefs that were typical of their people when they were still independent, and they had observed and participated in the traditional social and religious ceremonies of buffalo days. They had, of course, also undergone the trauma of starvation and the difficulty of adjusting to reservation life. But they preferred to remember the more pleasant days of their childhood, and young manhood and womanhood. The men loved to tell of their personal hunting experiences and of the honors they and their comrades had won on repeated war parties. And it was in the true tradition of buffalo days for successful warriors and hunters to recount their noteworthy accomplishments.

In this exhibition are two portraits of Lazy Boy, whom I knew as the oldest Indian living on the Blackfeet Reservation during the early 1940s. As a teenager he had accompanied experienced older warriors on raids against the Crow Indian camps south of the Yellowstone River. In the collections of the Department of Anthropology at the Smithsonian's Museum of Natural History is a large steer hide, on the inner surface of which is painted a pictorial record of a number of the war exploits of Shorty White Grass, a noted band chief and leader of Piegan war parties. Two of the actions recorded on that hide were ones in which Lazy Boy took part as a follower of Chief White Grass. This hide was painted in 1891 by a young Indian named Sharp; it was acquired in that same year by the Smithsonian Institution, along with a detailed description of each action pictured. That written interpretation mentioned Lazy Boy's parts in the two actions. Actually, Lazy Boy

had told me of those exploits a few years before I became aware of the painted robe in the Smithsonian's collection.

This steer hide is but one of the many examples of painted war records of the Blackfeet that have been preserved in museums since the time of Prince Maximilian's expedition in 1833. Lacking a written language, these Indians learned to employ a simple form of picture-writing to preserve their war records. Over the years Blackfeet picture-writers remained quite conservative in their style of painting—picturing men as knob-headed, unclothed stick figures, and horses as stiff and static animals with their legs in line rather than paired—much as they had been presented in Prince Maximilian's time.

Winold Reiss saw the many examples of these war histories that had been painted on canvas or muslin during the late teens and early 1920s, and that were then being used to decorate the walls of public spaces in the large hotels in nearby Glacier National Park. Impressed by this primitive picture-writing that was so characteristic of Blackfeet graphic art, Reiss introduced it into the backgrounds in several of his portraits of Blackfeet elders. His *Lazy Boy* is a good example. Probably this was not a copy of any particular Blackfeet painting, but it shows me that Reiss had studied picture-writing and had become familiar with its basic characteristics.

Weasel Tail, whose portrait by Reiss is also in the Smithsonian, was a veteran of the Indian wars whose memory of tribal life in buffalo days was remarkably detailed. As a poor boy who sought to enhance his reputation among his people as well as to acquire property through participation in numerous horse-raiding parties, he had very rich memories of his adventures on the warpath. The record of his exploits, given to me by word of mouth, revealed that on several expeditions he had taken his wife along, and that she had counted coup by taking things from the enemy. He said, "My wife said she loved me, and if I was going to be killed in war, she did not want to live without me."

130

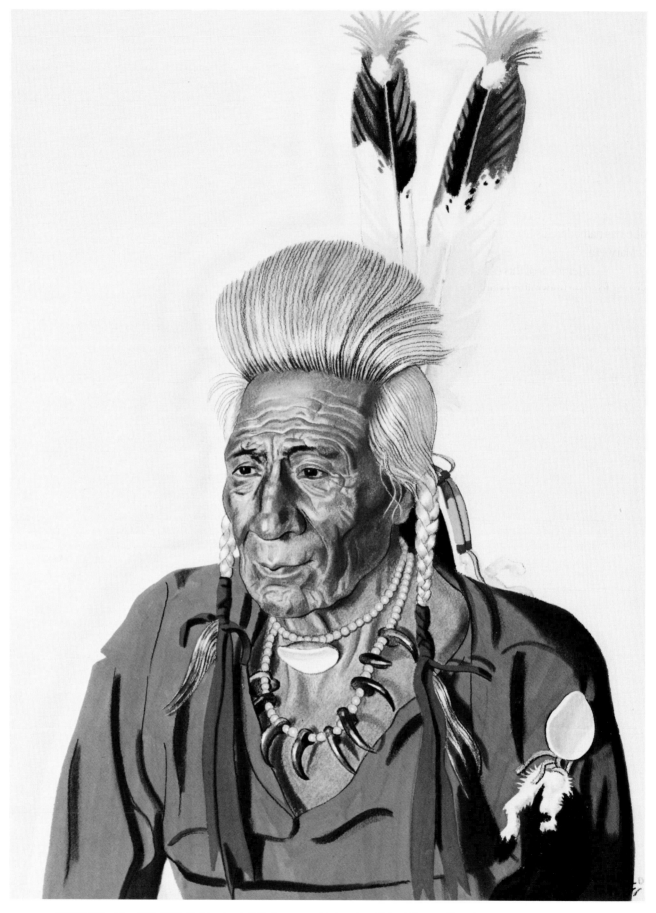

WEASEL TAIL (circa 1859–1950) Pastel on board, 1940 Department of Anthropology, National Museum of Natural History, Smithsonian Institution
Blood Indian of the intertribal wars and authority on tribal life in buffalo days

Wades in the Water was thought to be the last Piegan Indian to have taken an enemy scalp. In 1943 he told me of the small-scale action against the Assiniboine in which he scalped one of the enemy. Wades was but fourteen then. He said that he really did not know how to go about removing the fallen Indian's scalp but followed the verbal directions of an older brother who was with him at the time. Wades was a son of Running Crane, chief of the Lone Eaters band of the South Piegan.

Chewing Black Bones was the last surviving Blackfeet veteran of the intertribal wars. He remained active in the ceremonial life of his people when I knew him during the early 1940s. The tribe has named in his honor a recreational campsite it established on the east shore of Lower St. Mary's Lake.

Members of this oldest generation played another major role in Blackfeet cultural history, for they transmitted significant aspects of traditional religion into the twentieth century and preserved old-time ceremonials into the second quarter of that century. By the 1940s, less than 20 percent of the population of the Blackfeet Reservation in Montana was composed of full-bloods, and the very great majority of the others had been converted to Christianity. Yet the members of the older generation, nearly all of them full-bloods, clung to their traditional beliefs. And this small minority provided the core of that group of believers who continued to come together in a circle camp each summer to perform the sun dance, the major religious ceremony of their tribe.

During the early 1940s the sun dance camp was established on the flat between the Museum of the Plains Indian and the Agency Hospital. I was able to visit that camp on numerous occasions. I knew that Prince Maximilian had counted some 330 tepees in the great camp of the

WADES IN THE WATER
Tempera, pastel, and charcoal on paper, 1943
Burlington Northern Railroad

CHEWING BLACK BONES
Pastel and conté crayon on board, circa 1937
Mr. and Mrs. W. Tjark Reiss

Panoramic view of the sun dance encampment west of Browning on the Blackfeet Reservation, Montana, 1943
John C. Ewers

Piegan Indians near Fort McKenzie in 1833. I found less than thirty tepees in the camp circle, plus a goodly number of wall tents. Even so, a majority of the tepees bore traditional paintings handed down from earlier generations. The most striking of these were representations of supernatural birds, animals, or reptiles, creatures from the original tepee owners' dreams whose power was believed to have been transferred to them. Ownership of these lodges and their accompanying medicine bundles was transferred from one family to another in a solemn ceremony and at considerable cost to the purchaser. Some lodges were transferred from one Blackfeet tribe to another across the Canadian border. I recall that in 1943, Chewing Black Bones's family erected a lodge bearing a well-known design that had belonged to Red Crow, the Blood head chief, when it was photographed in the sun dance camp of that tribe in 1891. This design had been repainted several times since then on new canvas, but it was thought to possess the same power as the tepee that Chief Red Crow owned. It was known as the single-circle tepee, painted with an encircling dark brown band with sacred otters—supernatural creatures whose power had been transferred to the tepee's first owners. In his rendering of these otters, the Indian artist included lines leading from the animal's mouth to its heart and two round spots on its back. This symbolized the Blackfeet belief that the sources of a creature's supernatural power were located in its heart and kidneys.

Among the Blackfeet tribes the sun dance was initiated each year by a woman of flawless reputation, who vowed to the sun that she would assume the stressful role of giver of the ceremony if the sun would help her or one of her family who might be seriously ill or in danger of loss of life. During World War II the giver sought the sun's protection for the many young Indian men who were in the armed services. In buffalo days it was common practice for successful warriors to reenact, in the sun dance lodge, the coups they had counted upon their enemies. I saw Rides at the Door and Duck Head do that in the summer of 1943—some six decades after they had performed the deeds they were reenacting.

The director of the sun dance was a wise man who knew all the many prayers, songs, and ritual movements in this prolonged, complex ceremony and knew their proper sequence. This was no mean intellectual feat. During the 1940s, Swims Under, one of Reiss's Indian sitters, had this role.

Painted single-circle tepee with representations of sacred otters erected by Chewing Black Bones's family in the sun dance encampment of 1943
John C. Ewers

In the sun dance of 1943, I saw two of the Blackfeet elders, Lazy Boy and Chewing Black Bones, play other roles of importance. After the sun dance lodge had been completed in the center of the circle encampment, they were made responsible for insuring fair weather throughout the remainder of the ceremony. They took their places within a leafy bower on the west side of the lodge interior, opposite the entrance. From time to time they stood up, blew on their eagle-bone whistles, and danced toward the center pole of the lodge. Reiss's portrait of Lazy Boy [illustrated on page 129], shows him wearing the headdress and the fringed yellow shirt that were part of his weather dancer's regalia. His eagle-bone whistle is suspended from his neck.

Wades in the Water continued to observe another important aspect of the old-time religion. He owned one of the most powerful of the traditional Blackfeet sacred objects—a medicine-pipe bundle. It was thought to have been given to the Blackfeet in the very distant past by the Thunder. Its human owner promised to open the bundle each spring, soon after the first thunder was heard, and perform the ritual Thunder had taught him. In return, Thunder promised not to kill members of the Blackfeet tribe with lightning. When camp was moved, a medicine-pipe bundle would be carried by horseback at the head of the procession. There were several of those medicine-pipe bundles among the Blackfeet, and it is possible that at one time each band possessed one.

The Matokiks, the Women's Society of the Blood Indian tribe, also held its annual ceremony in the sun dance encampment. According to the tribe's elders, their Women's Society

JOSEPH SWIMS UNDER
Mixed media on board,
date unknown
C. M. Russell Museum; gift of
Peter Reiss

WOLF PLUME
or SUN LODGE DANCER
(1878–circa 1943)
Mixed media on board,
date unknown
Paul and Pamela Belli

Weather Dancer shirt worn by
Wolf Plume in painting by Reiss
Denver Art Museum

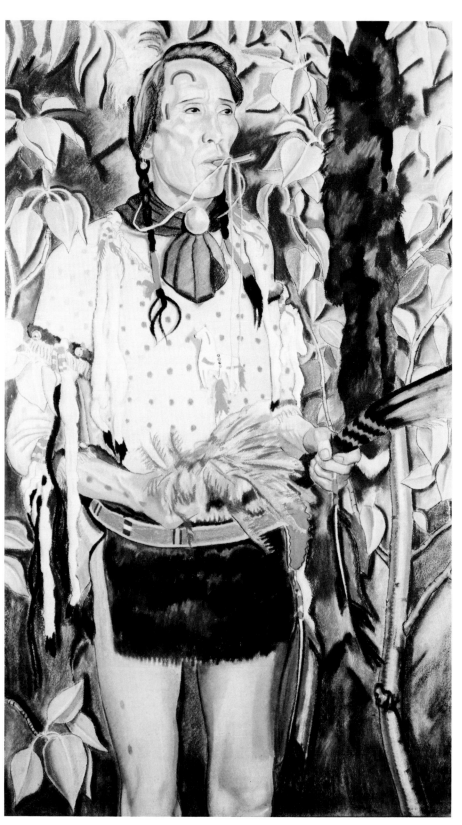

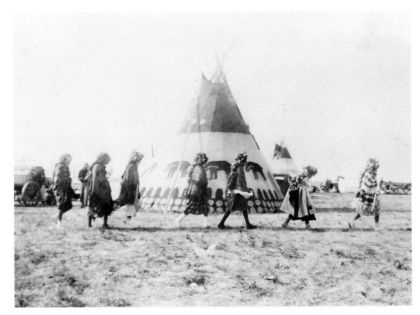

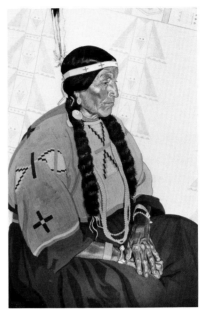

was derived from that of the Mandan Indians, earth-lodge dwellers and corn-growing Indians downriver in the Dakotas. They say that rights to the society were transferred to the wife of Chief Seen from Afar while she and her husband were visiting the Mandans during the winter of 1832-1833. Its first performance as a Blood Indian ceremony, near Fort McKenzie in the late summer of 1833, was observed and briefly described by Prince Maximilian.

Originally this ceremony must have been intended to bring success in buffalo hunting. In the course of it, the members left the lodge and moved out onto the prairie but were driven back into a circular lodge—specially constructed to symbolize the type of fenced enclosure used for corralling buffalo in the days before the Blackfeet obtained horses. Although the purpose of the ceremony changed over the years—by the 1940s it was thought to insure the health and well-being of the members and their tribe—the ceremony persisted. A photograph taken on the Blood Reserve during the 1950s shows members of the Women's Society being driven toward their lodge.

At least three of Winold Reiss's Blood Indian subjects were members of that Women's Society. One of them was Long Time Pipe Woman, wife of the Blood head chief, who died in 1955 at age eighty-seven. She was not wearing her society headdress when pictured by Reiss. However, Reiss portrayed Always Howling Woman in her scabby buffalo bull headdress, and Separate Spear Woman, wearing the elaborate bird headdress she donned as an officer of the society and holding her eagle-bone ceremonial whistle in her mouth. Separate Spear Woman was the wife of Plume [illustrated on page 138], another of Reiss's Blood Indian subjects.

Reiss pictured several of the older Blackfeet men wearing sacred headdresses. Two of their styles are especially noteworthy. One is the straight-up feather bonnet, a crown of vertical eagle feathers; this differs from the well-known Sioux type of feather bonnet whose feathers point upward and backward from a narrow browband. The upright feathers were anchored to a broad rawhide band that encircled the wearer's head; this was covered with red flannel decorated with brass tacks and long pendants of black-tipped weasel tails. The Blackfeet warriors admired the weasel for its fighting qualities and used its fur liberally to decorate war bonnets, shirts, and

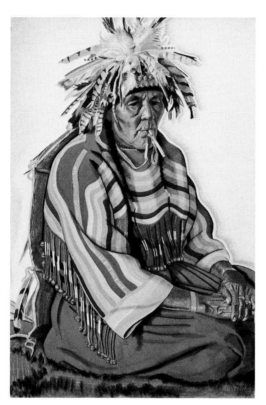

Separate Spear Woman, a Blood Indian, wearing her ceremonial bird headdress used to signify an officer of the Women's Society of that tribe Mixed media on board, date unknown
C. M. Russell Museum; gift of Peter Reiss

leggings. Bonnets of this style were worn by warriors of distinction in buffalo days—long before the Sioux type of bonnet was introduced among the Blackfeet during the 1890s, after intertribal warfare had ended. Several of these straight-up bonnets were bestowed upon Blackfeet men in dreams or visions and were considered powerful war medicines.

Another type of sacred bonnet owned by Blackfeet was a tight-fitting cap, flanked by real or artificial horns and covered with a thick mat of short strips of white weasel fur, with weasel-tail pendants. Winold Reiss pictured several Indians wearing sacred bonnets of this type. Chewing Black Bones [see page 131] wears one in which the weasel trim on one side has been dyed red. A number of these half-red headdresses were found among the Blackfoot of Canada. In 1953 I photographed Percy Creighton, a Blood chief who was Reiss's interpreter, wearing one of these bonnets while attending the ceremony for the induction of the governor general of Canada into the Blood tribe.

In 1927 Reiss executed a striking portrait of Night Shoot, a middle-aged man on the Blackfeet Reservation in Montana, wearing another noteworthy ceremonial garment. It is the perforated, smoked-buckskin shirt worn by one of the two members of the Brave Dogs Society who impersonated grizzly bears. In the 1830s there had been ten men's societies among the Piegan, each composed of men of about the same age who sometimes went to war together and were called upon to police the tribal buffalo hunt before the sun dance and to keep order in the great sun dance camp. But by the second quarter of the present century, the Brave Dogs were the only active Piegan men's society.

Some of Winold Reiss's subjects were leaders in their people's secular life. The office of chief was retained in Canada, under the terms of its Indian Act. Reiss portrayed Shot Both Sides, who served as head chief of the Blood Indians for forty-three years following the death of his father and former head chief Crop Eared Wolf in 1913. Weasel Tail told me that Shot Both Sides was the eighth head chief of the tribe since Buffalo Bull's Back Fat, whose portrait Catlin had painted in 1832. Even though this position was elective and not hereditary, it had been held by members of Shot Both Sides's family for several generations. One of them, Red Crow, signed Treaty Number Seven, negotiated between Canada and the Blackfeet in 1877.

I met Shot Both Sides on the Blood Reserve during the summer of 1947. Clad in his work clothes, he was literally mending one of his fences when we were introduced. The Blood Indians admired him, along with their other chiefs, for steadfastly refusing to accept any of the tempting offers to sell parts of their reserve to whites. It was the largest in Canada, but they knew that with their growing population, all of their land would be needed to support the tribe.

The United States government, on the other hand, allowed the position of chief to

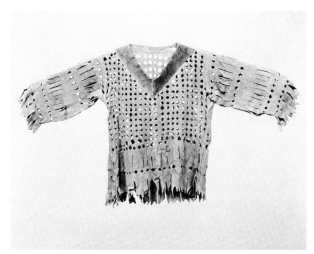

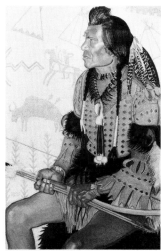

Shirt worn by member of the Brave
Dogs Society
The Denver Art Museum

NIGHT SHOOT—BRAVE SOCIETY
Mixed media, 1927
The Anschutz Collection

Half-red, half-yellow bonnet made
of leather, beading, and weasel
tails that belonged to Bullhead
Denver Art Museum

Straight-up bonnet owned by
Bird Rattler
Denver Art Museum

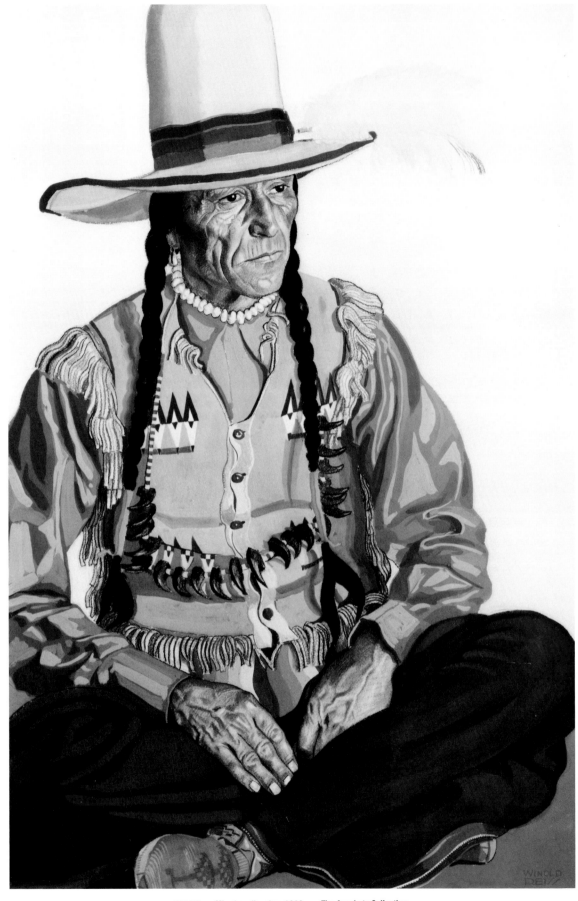

PLUME Mixed media, circa 1929 The Anschutz Collection

become defunct among the Montana Blackfeet after the death of Head Chief White Calf in 1903. Even so, one of his sons, Two Guns White Calf, gained considerable recognition as a showman and an artist's model. He became the leader of a select group of Blackfeet who were employed by the Great Northern Railway to visit the larger cities of the United States and attract tourists to Glacier National Park. His strong and handsome profile made him a favorite subject for artists and photographers who sought to picture an American Indian. It was sometimes claimed that he was the model for the Indian head on the buffalo nickel, a claim that persisted in spite of James Earle Fraser's insistence that Two Guns White Calf was not one of the three Indian models he used in his design of that coin.

 Two Guns White Calf's stunning profile was caught by a Smithsonian Institution photographer in 1923, when he visited Washington, D.C., as part of a delegation to meet with the Bureau of Indian Affairs. A three-dimensional, life-sized likeness of Two Guns appears on one of the costumed figures in the North American Indian Halls at the Smithsonian's Museum of Natural History. Reiss pictured Two Guns White Calf in crayon during his first visit to the Blackfeet Reservation in 1919 and also executed several other portraits of him.

 Another member of that 1923 Blackfeet delegation to Washington, Wades in the Water, wore his uniform as chief of police on the Blackfeet Reservation when he posed for the Smithsonian photographer. His wife, Julia, who accompanied him to the nation's capital, wore a typical Blackfeet-

SHOT BOTH SIDES
Pastel on board, 1927
Glenbow Museum

Shot Both Sides, head chief of the Blood tribe, photographed in 1947 by John C. Ewers

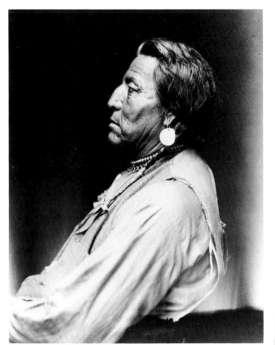

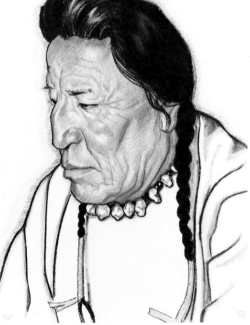

Two Guns White Calf, whose striking profile made him a much-sought-after artist's model, 1923
Photograph by DeLancey Gill
National Anthropological Archives, National Museum of Natural History, Smithsonian Institution

TWO GUNS WHITE CALF
Crayon, charcoal, and conté pencil, 1919
Bradford Brinton Memorial Museum

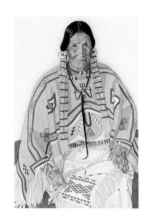

style beaded buckskin dress. After serving for more than twenty-five years as police chief, Wades in the Water retired. He and his wife were still very much in demand, however, during the summer season, when the Great Northern Railway employed them to dress in their finest traditional Indian clothing and greet tourists arriving on the Empire Builder at Glacier Park Station. They also entertained visitors to the large hotel nearby, welcoming them to their colorful painted tepees pitched on the lawn during the day and in the evenings presenting a program in the spacious hotel lobby. This program included demonstrations of the Plains Indian sign language, the telling of legends, singing, and dancing, with the tourists often joining in an Indian dance.

The Wades in the Waters, dressed in their colorful and sparkling-clean buckskins, were a handsome couple. Although no more than thirty men, and even fewer women, on the reservation owned decorated-buckskin outfits, the Wades in the Waters had several changes of them. Reiss painted their portraits separately, and each was reproduced on one of the very popular Great Northern Railway calendars from the 1940s, calendars that have become collector's items. Julia Wades in the Water was pictured in a dress of Sioux origin that had a fully beaded yoke with typical Sioux designs. I recall her wearing that same dress when she and her husband took part in the ceremony in which my wife and I received Blackfeet names shortly after the Museum of the Plains Indian opened in 1941.

Wades and Julia were among the few Blackfeet who owned such elaborate garments. Reiss frequently borrowed fine traditional garments for his sittings from the remarkable collection assembled by Jack Carberry, a merchant among the Blackfeet during the early years of this century, and preserved by his daughter Margaret. A large part of that collection was given to the Museum of the Plains Indian, as was a major portion of the large collection made by Louis W. Hill, Jr., former president of the Great Northern Railway, so that now this museum houses one of the finest and best-documented collections of Blackfeet clothing in the world.

I first met Winold Reiss during the early summer of 1943, when he was paying his first visit to the Museum of the Plains Indian. It was my pleasure to show him the large murals on the four walls of the museum's lobby. These were of special interest to him because they had been painted by Victor Pepion, one of the three talented young Blackfeet to whom Reiss had given free instruction in his summer school, near Upper St. Mary's Lake and one of the entrances to Glacier

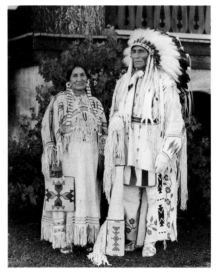

National Park, during the 1930s. The mentor expressed great pleasure with his former student's creation—a series of lively and very decorative paintings interpreting aspects of a buffalo hunt as it might have taken place on the museum's very site about a hundred years earlier.

Mr. Reiss kindly invited me to visit him in his temporary studio in Browning, where during that summer he executed some seventy-five more of his exquisite portraits of Blackfeet Indians. It was a rather small room, with a north light, in the Yegan Hotel, which was sometimes used as a display room by traveling salesmen. He set up his easel so that it would get the sunlight, and opposite it he placed a small table where his models could sit while he portrayed them. He told me that he hired a younger Indian to tell Blackfeet legends to the old people to keep them awake while posing.

Reiss worked very rapidly, transferring the likenesses of his sitters to Whatman board with a very sure touch. However, he told me that after several days of this he tended to lose that touch and would need to take a few days off for rest and relaxation in nearby Glacier National Park. Then he could return, refreshed and eager to continue picturing his Indian friends.

I could understand the mutual admiration that existed between this German-born artist and the Blackfeet Indians. The Indians readily recognized his unique ability to portray them truthfully and as individuals, not just as types. They gave Reiss the honored name of Beaver Man, because he worked so diligently. I never knew one of them who posed for him to say a harsh word about him. Reiss, in turn, learned to appreciate the Blackfeet as not only very picturesque human beings, but as men and women of great strength of character who had endured starvation and the loss of much of their traditional life, but had managed to preserve those parts of it that were most meaningful to them, while seeking to adjust to new conditions. What is more, these people did this with a keen sense of humor that made dealing with them a delight.

I can understand why Winold Reiss, a successful New York artist, returned again and again to the Blackfeet country over a period of a quarter century to paint these Indians. I can understand, too, why he wanted his ashes returned to the reservation after his death in New York, and why, on July 17, 1954, elderly Blackfeet Indians honored this German-American artist with songs and prayers before those ashes were scattered to the winds of his, and their, beloved Blackfeet Country.

Buffalo hunting scene painted on a wall of the lobby of the Museum of the Plains Indian in 1941 by Victor Pepion (1908–1956), Piegan Indian artist who had been a student of Winold Reiss. Museum of the Plains Indian

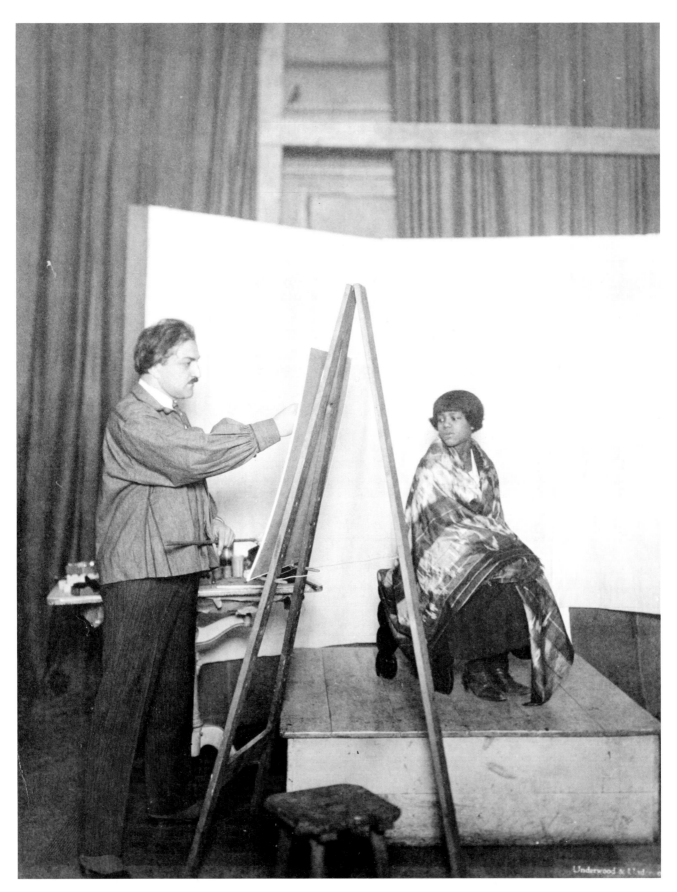

Winold Reiss drawing a Harlem girl in his studio at 108 West 16th Street W. Tjark Reiss

Endsheet of catalogue to the
exhibition of Reiss works at the
Anderson Galleries in New York,
December 22, 1922–
January 28, 1923
Private collection

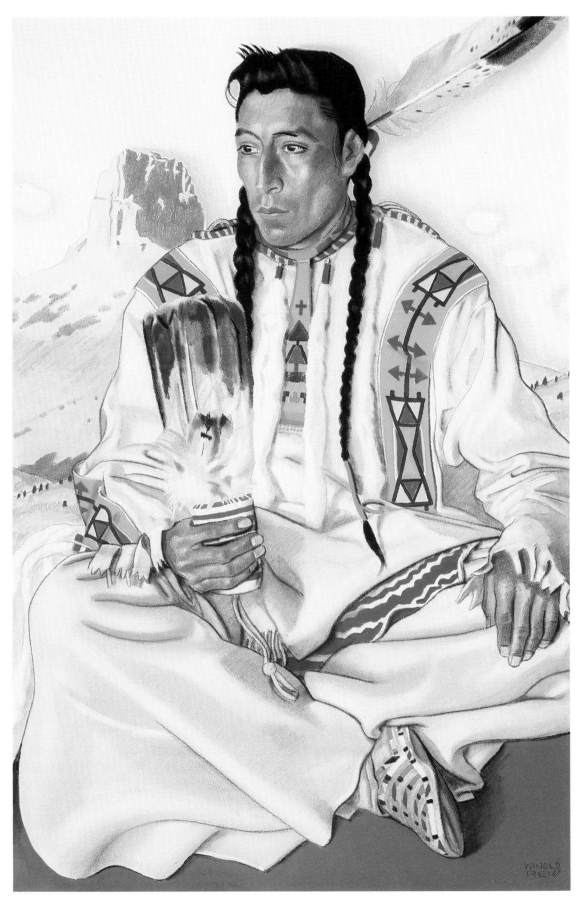

FLOYD MIDDLE RIDER Tempera, pastel, and charcoal on paper, 1948 Burlington Northern Railroad

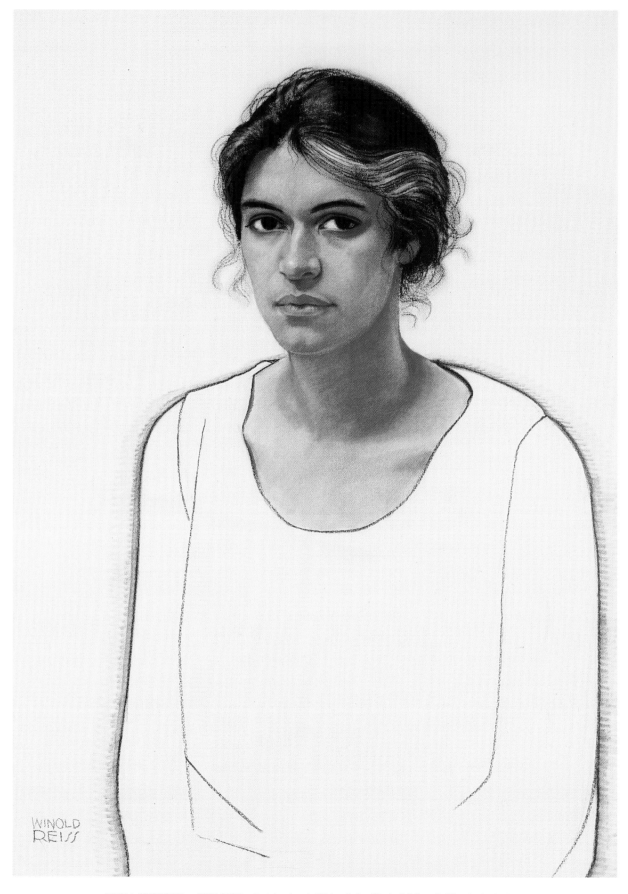

ELISE J. MCDOUGALD (1885-1971) Pastel on board, 1924 National Portrait Gallery, Smithsonian Institution;
gift of Lawrence A. Fleischman and Howard Garfinkle with a matching grant from the National Endowment for the Arts

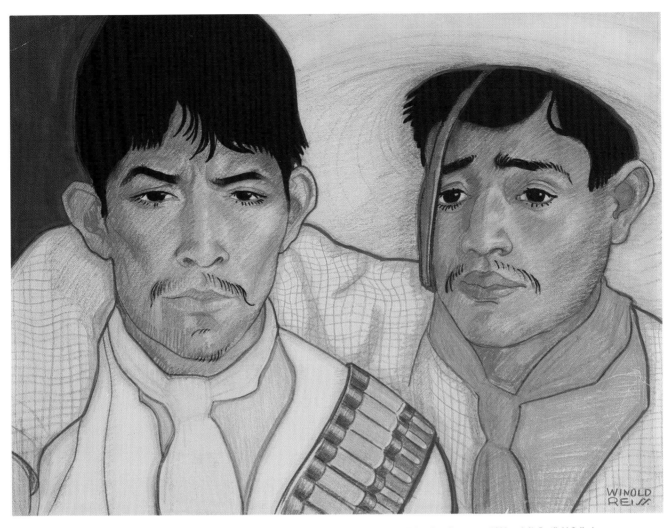

BROTHERS-IN-ARMS AT ZAPATA'S HEADQUARTERS, CUERNAVACA, MEXICO or ZAPATISTA SOLDIERS Pastel on paper, 1920 J. N. Bartfield Galleries

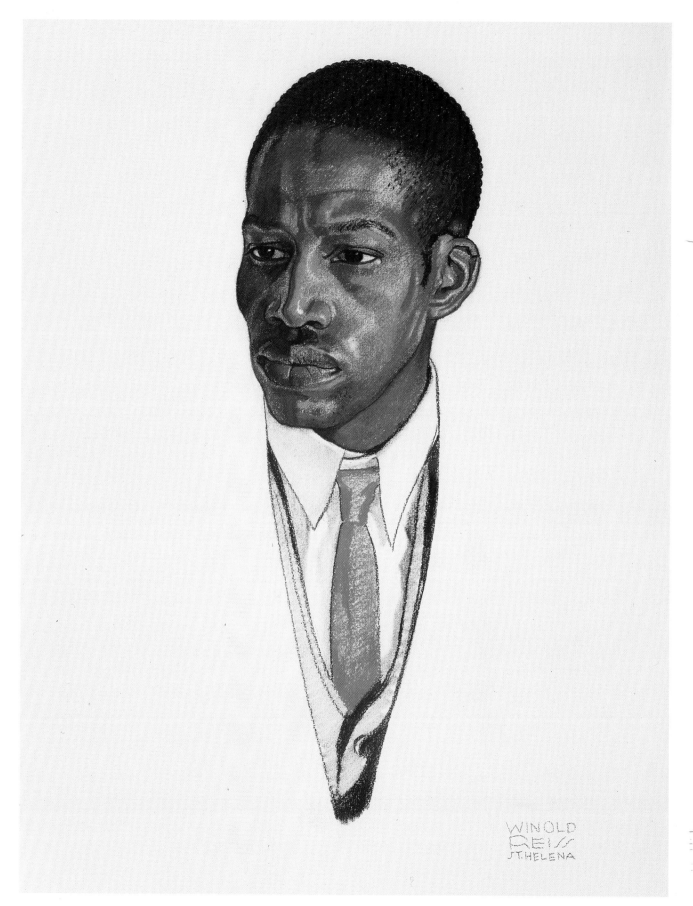

JAMES B. KING Pastel on paper, 1927 Laura Lee Brown Deters; promised gift to the J. B. Speed Art Museum

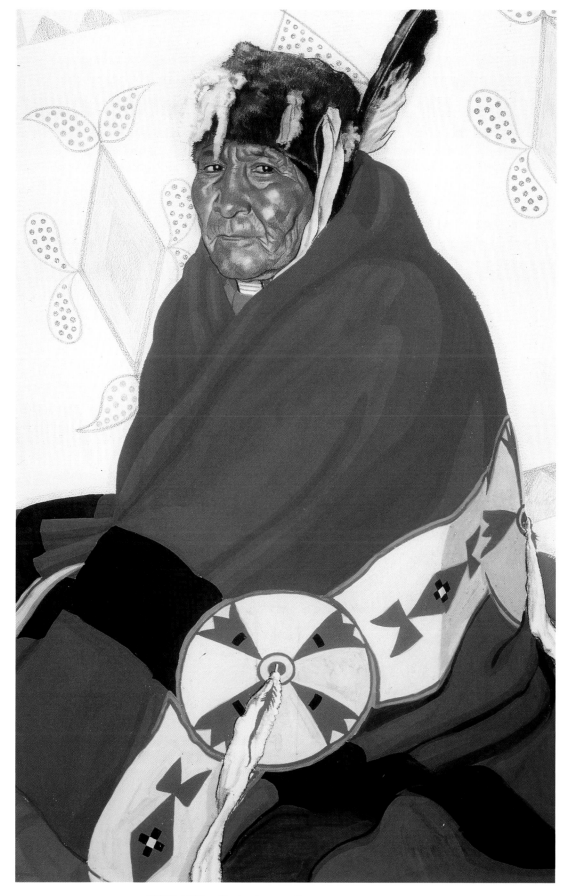

CLUMSY WOMAN Mixed media, circa 1927–1928 The Anschutz Collection

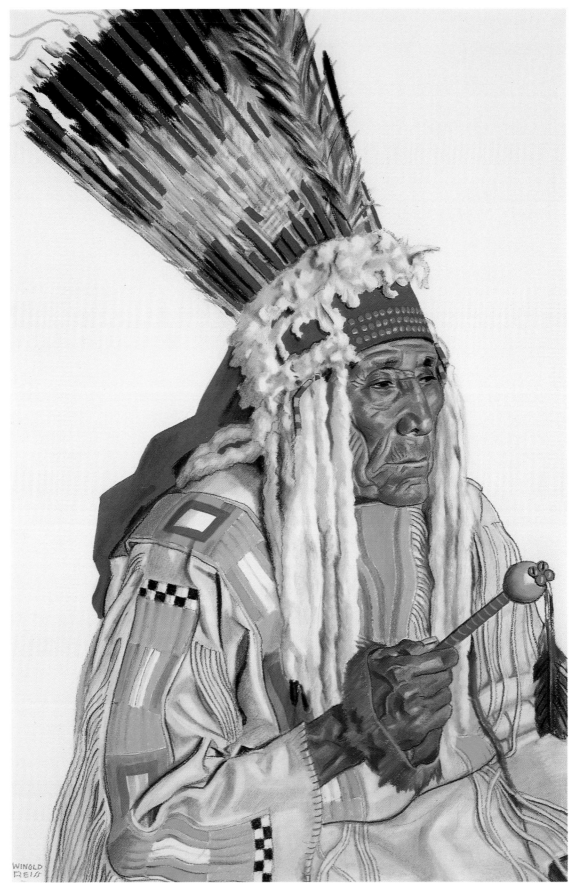

ANGRY BULL or TURTLE (born 1877) Pastel, charcoal, and tempera on paper, circa 1943 Burlington Northern Railroad

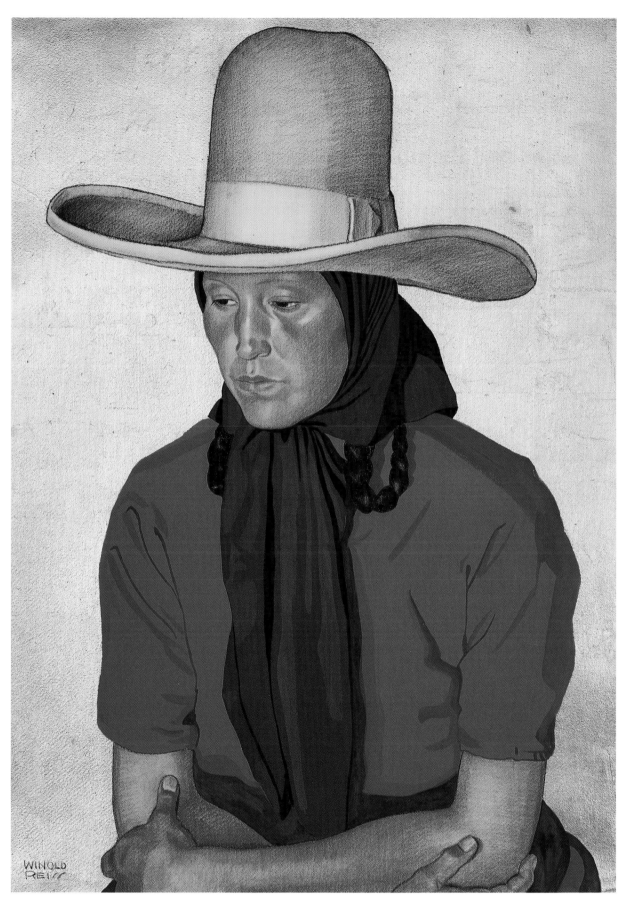

NENAUAKI (MRS. JOE DEVINE) Mixed media on paper, 1928 The Anschutz Collection

Albert Schweizer and Winold Reiss in front of the mirrored staircase they designed for the Restaurant Longchamps in the Empire State Building, circa 1939. W. Tjark Reiss

CHRONOLOGY

1886	September 16: Born in Karlsrühe, Germany.
1899	Family moves to Kirchzarten so that father, Fritz Reiss, may draw peasants. Winold studies with father.
Circa 1911-1913	Travels to Munich and attends Academy of Fine Arts under Franz von Stuck and the School of Applied Arts under Julius Diez.
1912	September 12: Marries Henrietta Lüthy, a fellow student at the School of Applied Arts.
1913	October: Immigrates to United States and settles in New York City.
	December 27: Son Tjark is born.
1915	Lectures before the Art Students League on the German poster, New York City.
	Designs and illustrates first issue of *Modern Art Collector*, first American magazine devoted to modern German decorative art.
	Illustrates *Mother Goose Rhymes Done in Poster Stamps*.
	Does interior design of Busy Lady Bakery, New York City.
	Begins Winold Reiss Art School, New York City.
	September-April 1919: Designs covers for *Scribner's* magazine.
1919	Designs interior of Crillon restaurant, New York City, in a modern decorative style.
	Holds first summer session of Winold Reiss Art School, Woodstock, New York.
	Winter: Takes first study trip to Browning, Montana, to draw Blackfeet Indians, accompanied by his student, W. Langdon Kihn. Produces approximately thirty-six portraits.
1920	March: Solo exhibition of his Indian portraits, E. F. Hanfstaengl Galleries, New York City. All works purchased by Dr. Philip Cole.
	Takes study trip to Mexico; produces forty portraits and imaginatives.

1921	May: Three Reiss pictures illustrate "Draughtsmanship and Racial Types: Mexican Character Studies by Winold Reiss" by M. D. R. Crawford, *Arts and Decoration*.
1922	Spring: Takes study trip to Black Forest, Germany, and to Sweden; produces portraits of nineteen Oberammergau Passion Players, seventeen Swedish peasants, and thirty-eight Black Forest types.
	July: Three of Reiss's Mexican pictures illustrate "Where Presidents Have No Friends" by Katherine Anne Porter, *Century Magazine*.
	September: Five Reiss portraits illustrate "The Oberammergau Players" by Reiss, *Century Magazine*.
	November 13-25: Shows 136 works, including German, Swedish, and Mexican pictures along with woodcuts and decorations produced in New York, in group exhibition (with Clara Tice), Anderson Galleries, New York City; accompanied by catalogue *The Passion Players of Oberammergau: Drawings by Winold Reiss*.
	November 18: Reiss portraits *Watchman of the Rothenburg Tower (Michael Ment)* and *A Typical Swedish Mother* illustrated in *New York Evening Post*.
	November 19: Portrait of Marta Veit illustrates "Clara Tice and Winold Reiss Exhibit," *Brooklyn Eagle*.
	December 22-January 28, 1923. Shows thirty-eight portraits from Oberammergau, Sweden, and elsewhere in solo exhibition, Memorial Art Gallery, Rochester, New York.
1923	Publication of *The Months*, portfolio of twelve woodcuts.
	April 6-28: Shows four portraits in "Exhibition of Boston Society of Watercolor Painters," Boston Art Club.
1924	May: *Brothers-in-arms at Zapata's Headquarters* illustrates "Bandit Colonies" by Robert Haberman, and three portraits and drawing of Cuernavaca illustrate "Mexican Types" by Reiss, *Survey Graphic*.
	December 23-January 25, 1925: Shows two works in twenty-third "Annual Exhibition of Modern Decorative Art," New York City.
1925	January: Illustrates cover and produces *Opportunity*; issue also contains editorial "The Art of Winold Reiss."
	March 1: Cover design, five imaginatives, and thirteen portraits by Reiss illustrate *Survey Graphic* special issue, "Harlem: Mecca of the New Negro."

March 1: *Interpretation of Harlem Jazz* illustrates front page of editorial section, *New York World*.

March 15: Shows thirty-seven portraits and imaginatives in solo "Exhibition of Recent Portraits of Representative Negroes," 135th Street Harlem Branch, New York Public Library.

October 27: Portrait of Countee Cullen illustrated in *Chicago Evening Post*.

November 19-December 20: Shows thirty-eight portraits of African Americans in solo exhibition, "Pictures by Winold Reiss," Utica Public Library, New York.

December: Cover, imaginative designs, and seventeen portraits by Reiss illustrate *The New Negro: An Interpretation*, edited by Alain Locke.

Provides additional interior design, Crillon restaurant, New York City.

Completes medieval murals, five metal panels, and tropical mural for Hotel Alamac, New York City.

1926	January: Reiss portrait illustrates "Nana Amoah" by Alain Locke, *Survey Graphic*.

May: Produces illustrations of Asians (including cover), *Survey Graphic* special issue, "East by West: Our Windows on the Pacific."

Redesigns Crillon restaurant, New York City. |
| 1927 | January 2: Interview with Olga Kaltenborn in *Brooklyn Eagle*.

January 28-February 28: Shows eight portraits in group exhibition of watercolor paintings, pastels, and drawings by American and European artists, Brooklyn Museum.

January 30: Portrait *Salomé* illustrates review of Brooklyn Museum show, *Brooklyn Eagle*.

February 6: Portrait of Langston Hughes illustrates review of *The Weary Blues*, Hughes's first book of poetry, *New York World*.

April 28-May 29: Shows two portraits in annual watercolor exhibition, Art Institute of Chicago.

June-September: Takes study trip to Glacier Park and Browning, Montana, and to Alberta, Canada, under auspices of Great Northern Railway.

October 25: Takes study trip to Penn Community School, St. Helena Islands, South Carolina; produces approximately sixteen portraits.

December: All fifty-two portraits done on study trip purchased by Louis Hill, the president of Great Northern. |

1928

Designs gates and interior for Weicker Apartments, New York City.

March 29-May 6: Shows *Russian Girl* in annual watercolor exhibition, Art Institute of Chicago.

April: Participates as a respondent in symposium "Should American Art Students Go Abroad to Study?" *Creative Art.*

April 14: Shows fifty-one works from the Louis Hill Collection of his Blackfeet portraits in solo exhibition, Belmaison Galleries in John Wanamaker's, New York City.

April 15: *Night Shoot— Brave Society* illustrated with notice of show at Belmaison, *Brooklyn Eagle.*

Hill Collection travels to University of Michigan, Ann Arbor.

June 2-October 1: Shows twenty-six works from Hill Collection in group exhibition of paintings, sculpture, and drawings by American and European artists, Brooklyn Museum.

June-September: Takes study trip to Glacier Park and Browning, Montana, to draw Blackfeet Indians.

July 22: Ten portraits illustrate interview with Lillian E. Prussig, *Brooklyn Eagle.*

August: Shows fifty works from Hill Collection in solo exhibition at Memorial Art Gallery, Rochester, New York.

August: *Both Striking Woman* (in Brooklyn Museum exhibition) illustrated in *Creative Art.*

November 2-30: Shows fifty works from Hill Collection in solo exhibition, "Paintings, Winold Reiss," Worcester Art Museum, Massachusetts.

November 4-December 9: Shows five portraits in annual group exhibition, Pennsylvania Academy of the Fine Arts, Philadelphia.

November 9-December 25: Designs "daughter's room" for group modern design show, American Designer's Gallery, New York City. Reiss a founder of ADG.

December 5-20: Shows works from Hill Collection in solo exhibition "Indian Portraits, Winold Reiss," Boston Art Club.

December 27-January 1929. Shows fifty-one works from Hill Collection in solo exhibition, Art Institute of Chicago.

Shows one work in group show, Philadelphia Watercolor Rotary.

1929	January: Five portraits illustrate "Winold Reiss Paints the Northern Indians," *Survey Graphic*.
	January: Shows *Russian Girl* in group show, "International Water Color Exhibit," Kansas City Art Institute.
	February: *White Dog* and *Striped Wolf* illustrate "Indian Portraits by Winold Reiss," *Milwaukee Art Institute Bulletin*.
	February: Cover design and two portraits, *The Prayer* and *Grandmother, Black Forest*, illustrate *Survey Graphic* special issue on Germany.
	March 4: Shows twenty-six works from Hill Collection in "American Indian Portraits, Winold Reiss," Detroit Institute of Arts.
	March 15: Designs living room for second group show, American Designer's Gallery.
	April: Shows eighty works (including the original fifty-one) from Hill Collection at Museum of Science, Buffalo, New York.
	May 1: Shows works from Hill Collection at Federation of Arts, Fort Dodge, Iowa.
	May 2-June 2: Shows *Woman from Leksand*, *Aunt Sophie Daise*, and *Uncle Sam* in annual group show, Art Institute of Chicago.
	June-September: Takes study trip to Glacier Park and Browning, Montana, under auspices of Great Northern Railway.
	June-July 6: Shows Hill Collection in "Indian Portraits by Winold Reiss," The Little Art Gallery, Cedar Rapids, Iowa.
	July: Shows at least nineteen portraits from Hill Collection at Glaspalast, Munich. Paintings apparently also shown in Hamburg and in Italy and France.
	August 31: Several Hill Collection portraits illustrate article, *London News*.
	September 26-31: Shows works in State Fair Art Exhibition, Wisconsin, under auspices of Milwaukee Art Institute.
	Shows Hill Collection at Montana State Fair, Helena.
	Does interior design, Tavern Club, Chicago.
1930	March 20-April 20: Shows *Blackfeet Indian* and *Portrait* in annual group show, Art Institute of Chicago.
	April 5-24: Shows Hill Collection at Cleveland Public Library; sponsored by Women's National League for Justice to Indians.

April: Completes interior design, Hotel St. George, Brooklyn, New York.

April 27: *Running Coyote* and *White Wolf* illustrated in *New York World*.

June: Shows works at Museum of Fine Arts, Santa Fe, New Mexico.

November 2-December 7: Shows six portraits, including *Miss Helen Coolidge* and *Isamu Noguchi*, in group exhibition, Pennsylvania Academy of the Fine Arts, Philadelphia.

Eight plates of St. Helena portraits in *School Acres: An Adventure in Rural Education* by Rossa B. Cooley.

Shows works from Hill Collection, Royal Academy of Arts, Stockholm.

Seven plates of portraits of Blackfeet Indians in *The Sun God's Children* by James Willard Schultz and Jessie Louise Donaldson.

1931	January: *Buy an Apple* illustrated in *Survey Graphic*.

Begins to solicit funding for the Indian Monument Museum.

April 30-May 31: Shows *Boy from St. Helena* and *Laughing Boy* in annual group show, Art Institute of Chicago.

May: Shows works in group exhibition by American and foreign artists, Montclair Art Museum, New Jersey.

Summer: Takes study trip to Glacier Park, Montana.

November 1-December 6: Shows *The Drummers*, *Long Time Calf Woman*, and *Yellow Mink*, Pennsylvania Academy of the Fine Arts.

Shows eighty works from Hill Collection in solo exhibition, Los Angeles Museum.

Shows Hill Collection at Municipal Art Gallery, Oakland, California.

Shows Hill Collection at International Colonial Exposition, Paris.

1932	January: Work illustrated in *Architectural Forum*.

April: Work illustrated in *Creative Art*.

August: *Juniper Buffalo Bull and Little Young Man* and others illustrated in *Chicago Visitor*.

1933	Circa March: Completes interior mosaics for Cincinnati Union (Train) Terminal.

April 1-May 28: "Cartoons, Drawings and Designs by Winold Reiss for the Mosaics in the New Cincinnati Union Terminal" exhibition, Cincinnati Art Museum.

July 9-August 13: "Drawings and Designs by Winold Reiss for the Mosaics in the New Cincinnati Union Terminal" exhibition, Cincinnati Art Museum.

August: Appointed assistant professor of mural painting at New York University. Also elected member of the school's Institute of Fine Arts Advisory Committee.

September: Interview, "Tact in Art," in *Art Digest*.

October 31: *James Weldon Johnson* illustrated in *New York Herald Tribune Books*.

November 5-December 10: Shows *Peekskill Graduate* and *The Old Glazier* in annual group show, Pennsylvania Academy of the Fine Arts.

December 9-January 28, 1934: Shows work in parallel exhibitions, "American Indians—Past and Present" and "Paintings by Winold Reiss," Cincinnati Art Museum.

1934

February: Shows eighty works from Hill Collection in solo exhibition, Minneapolis Institute of Arts.

June 15-September 15: Conducts Winold Reiss Summer School at Glacier Park, Montana.

1935

January: Shows *Yellow Kidney* and other Indian portraits in solo exhibition, Squibb Building Galleries, New York City.

February 1-28: Shows *Powder River Jack* and *Good Stealing Woman* in "Eighth Biennial Exhibition of Water Colors, Pastels and Drawings by American and Foreign Artists," Brooklyn Museum.

June 15-September 15: Conducts Winold Reiss Summer School at Glacier Park, Montana.

Circa July: *Home Gun, Shot Both Sides, Plume, Long Time Pipe Woman, Nenauaki—Mrs. Joe Devine, Many Horses, Little Rosebud, and Baby, Scalping Woman, Tough Bread, Cut Nose Woman, Good Striker*, and others (forty-nine plates) illustrated in *Blackfeet Indians: Pictures by Winold Reiss. Story by Frank Linderman*, published by Great Northern Railway.

October: Displays Indian portraits and other works at Pennsylvania Station, New York City.

October: Displays Indian portraits and other works at Utica Public Library.

November 19: Shows *Mike Short Man, Theodore Last Star*, and *Cecile Black Boy* at Marshall Field, Chicago, to promote Reiss-Linderman book. Mike Short Man and Theodore Last Star attended.

Shows work at exhibition, New York Public Library.

Designs interior of new Restaurant Longchamps at 59th Street and Madison Avenue. First complete design of a New York restaurant based on Indian portraits and design motifs.

| 1936 | Shows fifty Indian portraits in Europe. Tour, organized by Tjark Reiss, begins at Künstlerhaus, Vienna, and goes to Bratislava, Czechoslovakia; Budapest, Hungary; Berlin and Munich, Germany. |

Designs interior and produces murals of new Restaurants Longchamps on 42nd Street and at 12th Street and Fifth Avenue, New York City.

January: Shows Indian portraits and other works in solo exhibition, Faulkner Memorial Art Gallery, Santa Barbara, California.

February-March: Faulkner show at University of Wisconsin, Madison.

May: Reiss's concourse mosaics illustrate "Cincinnati at Work," *Survey Graphic*.

June 15-September 15: Conducts Winold Reiss Summer School, Glacier Park, Montana.

Fall: Shows Indian portraits and other works at Columbus Branch, New York Public Library.

October: Completes interior design, Future City murals, Album Room portraits of famous New Yorkers, and Presidents' Room portraits for Restaurant Longchamps at 41st Street and Broadway, New York City.

December: Completes interior design of Restaurant Robert, New York City.

| 1937 | June: Shows *Sundance*, *Hairy Coat*, and *Shell Woman* at New York Public Library. |

June 15-September 15: Conducts Winold Reiss Summer School, Glacier Park, Montana.

| 1938 | February: "A Portfolio of Indian Portraits" illustrated in *Scribner's*. |

Begins work on exterior of the Theatre and Concert Building for World's Fair in New York City.

Completes interior design and murals for Restaurant Longchamps International at 253 Broadway, New York City.

Completes decorations and murals for Hess Brothers restaurant, Allentown, Pennsylvania.

Completes interior design and murals for Restaurant Longchamps at 79th Street and Madison Avenue, New York City.

1939	Designs exterior mosaic and interior for Theatre and Concert Building with architects Reinhard and Hofmeister and paints mural for Montgomery doughnuts concession for World's Fair, New York City.
	Completes interior design for Restaurant Longchamps, Empire State Building, New York City.
	Publication of *You Can Design*, co-authored with Albert Charles Schweizer.
1940	Reissue of *Blackfeet Indians: Pictures by Winold Reiss. Story by Frank Linderman*, with twenty-four plates.
	Publication of *Indian Legends: Piegan Indian Legends of Rock and Crow Woman as told to Beaver Child* [Winold Reiss] *by Chief Little Dog*.
1941	March: Cover design, *Survey Graphic*.
	April 3-27: Shows twenty-one portraits with his brother, Hans, who shows six sculptures, Montclair Art Museum.
	May: Silkscreen *Twilight of a Winter's Day* illustrated in *American Artist*.
	September: Completes mural for the Drum Room of the Hotel President, Kansas City.
	Completes interior design of Restaurant Longchamps (Bar and Roof Garden) at 49th Street and Madison Avenue, New York City.
1942	November: Cover design for *Survey Graphic* special issue, "Color: The Unfinished Business of Democracy," edited by Alain Locke.
1943	July-September: Takes study trip to Glacier Park, Montana; completes sixty-six portraits of Blackfeet Indians.
1944	Spring: Shows work in Northwest Art Group Exhibition, Spokane, sponsored by the Women's Club of Spokane, Washington.
	September: Takes study trip with Carl Link to draw Indians at Rocky Boy Agency, Box Elder, Montana.
1945	February: Cover design for *Survey Graphic*.
	October 16-27: Shows *Chief Goes Out* at Grand Central Art Galleries, New York City.
	Completes interior design of Mike Lyman's Grill, Los Angeles.
	Completes interior design of St. James Restaurant, New York City.

1946	Purchases Chinese bank building in Carson City, Nevada, as retirement home and studio.
	April: Shows *Long Time River Woman* at Grand Central Art Galleries, New York City.
	July: Interview in *Apparel Arts*.
	November: Completes mosaic murals for Woolarc Museum entrance, Bartlesville, Oklahoma.
	Takes study trip to Muskogee, Oklahoma, with fellow artist Acee Blue Eagle.
	Completes interior design in Roger Smith Hotel, Washington, D.C.
1947	January: Shows Indian portraits in solo exhibition, Arizona State Museum, Tucson.
	February: Arizona State Museum show travels to Southwest Museum, Los Angeles.
	March 1-14: Arizona State Museum show travels to The Heard Museum, Phoenix.
	May 11: *Long Time River Woman* illustrated on cover, *Graphic* magazine in *Chicago Sunday Tribune*.
	August-September: Shows twenty Indian portraits in solo exhibition, Philbrook Art Center, Tulsa, Oklahoma.
	October: Philbrook Art Center show travels to University of Oklahoma, Norman.
	November: Shows Indian portraits in solo exhibition, Thayer Collection, University of Kansas, Lawrence.
	Shows Indian portraits in solo exhibition, Oklahoma Art Center, Oklahoma City.
	Shows Indian portraits in solo exhibition, University of Arizona, Tucson.
	Shows Indian portraits in solo exhibition, Kansas State Federation of the Arts, Kansas State College, Manhattan.
1948	Takes last study trip to Glacier Park, Montana, to draw Blackfeet Indians.
	March: Cover design for *Survey Graphic*.
	April: Shows *The Red Coat* at Grand Central Art Galleries, New York City.
	May: *Floyd Middle Rider* illustrated on cover, *National Future Farmer Magazine*.
	Illustrates cover, *War Path and Fire Council* by Stanley Vestal.

1950	August 20: *Acee Blue Eagle* illustrates "Oklahoma Artist Takes New Role to Help Produce Own Portrait," *Tulsa World*.
	Completes interior design, murals, and portraits for Indian Room in Chic-N-Coop restaurant, Montreal, Canada.
1951	Illustrates *The Lewis & Clark Expedition* by Richard Neuberger.
	Circa June: Suffers stroke in New York City.
	Completes interior design and murals for Restaurant Longchamps, Washington, D.C.
	Decides to donate Harlem and St. Helena portraits to Fisk University, Nashville, Tennessee.
1952	January: Suffers second stroke, which leaves him paralyzed.
1953	August 29: Dies in New York City.
1954	July 17: Blackfeet Indians scatter Winold Reiss's ashes in Montana.

SELECTED BIBLIOGRAPHY

Art Deco and the Cincinnati Union Terminal. Cincinnati, Ohio: Contemporary Arts Center, 1973.

Banger, Gabriele, and Albrecht Banger. *Jugendstil, Art Deco.* Munich: Battenberg, 1979.

Barba, Preston A. "Cooper in Germany." *Indiana University Studies* 2 (May 15, 1914): 52-72.

Billington, Ray Allen. *Land of Savagery, Land of Promise: The European Image of the American Frontier.* New York: W. W. Norton & Co., 1981.

Blackfeet Indians: Pictures by Winold Reiss. Story by Frank Linderman. St. Paul, Minn.: Great Northern Railway, 1935.

Brauen, Fred. "Winold Reiss, 1886-1953: Color and Design in the New American Art." Unpublished manuscript, 1980.

Cooley, Rossa. *School Acres: An Adventure in Rural Education.* New Haven, Conn.: Yale University Press, 1930.

Crawford, M. D. R. "Draughtsmanship and Racial Types: Mexican Character Studies by Winold Reiss." *Arts and Decoration* 15 (May 1921): 28-29.

Denvir, Bernard. *Fauvism and Expressionism.* Woodbury, N.Y.: Barron's, 1978.

"East by West: Our Windows on the Pacific." *Survey Graphic* 9 (May 1926).

Einstein, Carl. *Negerplastik.* Munich: Kurt Wolff, 1920.

Ewers, John C. *The Blackfeet: Raiders on the Northwestern Plains.* Norman: University of Oklahoma Press, 1958.

Fechheimer, Hedwig. *Kleinplastik der Ägypter.* Berlin: Bruno Cassirer, 1922.

Frobenius, Leo. "Der Westafrikanische Kulturkreis." *Petermanns Geographische Mitteilungen* 43 (1897): 225-36, 262-67.

Geary, Christaud M. *Images from Bamum: German Colonial Photography at the Court of King Njoya, Cameroon, West Africa, 1902-1915.* Washington, D.C., and London: Smithsonian Institution Press, 1988.

German Realism of the Twenties: The Artist as Social Critic. With an introduction by Gregory Hedberg and essays by Istvan Deak, Peter Selz, Wieland Schmied, Emilio Bertonati, and Robert Jensen. Minneapolis: Minneapolis Institute of Arts, 1980.

Glassgold, C. Adolph. "The Modern Note in Decorative Arts: Part I." *The Arts* 13 (March 1928): 153-67. "Part II." *The Arts* 13 (April 1928): 221-35. "Decorative Arts Notes." *The Arts* 13 (May 1928): 296-301.

Goldwater, Robert. *Primitivism in Modern Art.* New York: Vintage Books, 1967.

The Handbook of North American Indians. Vol. 4, *History of Indian-White Relations.* Edited by William Sturtevant. Washington, D.C.: Smithsonian Institution Press, 1988.

"Harlem: Mecca of the New Negro." *Survey Graphic* 53 (March 1, 1925).

Harlem Renaissance: Art of Black America. With an introduction by Mary Schmidt Campbell and essays by David Driskell, David Levering Lewis, and Deborah Willis Ryan. New York: Harry Abrams, Inc., 1987.

In the Deco Style. Essays by Dan Kelin, Nancy A. McClelland, and Malcolm Haslam. New York: Rizzoli International, Inc., 1986.

Kaltenborn, Olga. "Interprets Racial Types in Oils." *Brooklyn Eagle,* January 2, 1927.

Karl Bodmer's America. With an introduction by William H. Goetzmann and an artist's biography by William J. Orr. Lincoln: Joslyn Art Museum and University of Nebraska Press, 1984.

Koch, Ronald P. *Dress Clothing of the Plains Indians.* Norman: University of Oklahoma Press, 1977.

[Locke, Alain]. "Harlem Types: Portraits of Winold Reiss." *Survey Graphic* 53 (March 1, 1925): 653.

——. "To Certain of Our Philistines." *Opportunity* 3 (May 1925): 155, 156.

——, ed. *The New Negro: An Interpretation*. New York: Albert and Charles Boni, 1925.

Logan, Rayford W., and Michael R. Winston, eds. *Dictionary of American Negro Biography*. New York and London: W. W. Norton & Co., 1982.

May, Karl. *Winnetou*. Translated by Michael Shaw. New York: The Seabury Press, 1977.

Mosse, George L. *The Crisis of German Ideology: Intellectual Origins of the Third Reich*. New York: Grosset & Dunlap, 1964.

Die Münchner Schule, 1850-1914. Munich: Haus der Kunst, 1979.

Die Münchener Secession und ihre Galerie. Munich: Stadtmuseum, 1975.

Park, Edwin Avery. *New Backgrounds for a New Age*. New York: Harcourt, Brace and Co., 1927.

The Passion Players of Oberammergau, Drawings by Winold Reiss. Also Drawings of Sweden, Blackforest, Mexico, and Portraits, Woodcuts, and Decorations. With essays by Winold Reiss and M. D. R. Crawford. New York: The Anderson Galleries, Inc., 1923.

Porter, Katherine. "Where Presidents Have No Friends." *Century Magazine* 104 (July 1922): 373-84.

Primitivism in 20th Century Art: Affinity of the Tribal and the Modern. Edited by William Rubin. 2 vols. New York and Boston: New York Graphic Society Books and Little, Brown, and Co., 1984.

Prussig, Lillian E. "Captured on Canvas: The Spirit of the Races." *Brooklyn Eagle*, July 22, 1928.

Reiss, Winold. "The Modern German Poster." *Modern Art Collector* (1915).

Rosengarten, Dale. *Row upon Row: Sea Grass Baskets of the South Carolina Lowcountry*. Columbia: McKissick Museum, University of South Carolina, 1986.

Sander, August. *August Sander: Photographs of an Epoch, 1904-1959*. Philadelphia: Philadelphia Museum of Art, 1980.

Sheridan, Claire. *Redskin Interlude*. London: Nicholson and Watson, Ltd., 1938.

Siegel, Linda. *Caspar David Friedrich and the Age of German Romanticism*. Boston: Branden Press, 1978.

Siu, Paul. *The Chinese Laundryman: A Study of Social Isolation*. With an introduction by John Tchen. New York: New York University Press, 1987.

Stewart, Jeffrey C. *The Critical Temper of Alain Locke*. New York: Garland Publishing, 1983.

Stratz, C. H. *Die Rasenschönheit des Weibes*. Stuttgart: Ferdinand Enke, 1927.

Truettner, William H. *The Natural Man Observed*. Washington, D.C.: Smithsonian Institution Press, 1979.

Walton, Ann T., John C. Ewers, and Royal B. Hassrick. *After the Buffalo Were Gone: The Louis Warren Hill, Sr., Collection of Indian Art*. St. Paul, Minn.: The Northwest Area Foundation, 1985.

Weiss, Peg. *Kandinsky in Munich: The Formative Jugendstil Years*. Princeton, N.J.: Princeton University Press, 1979.

Winold Reiss: Portraits of the Races, "Art Has No Prejudice." With an introduction by Ray Steele and essays by Paul Raczka. Great Falls, Montana: C. M. Russell Museum, 1986.

Winslow Homer's Images of Blacks: The Civil War and Reconstruction. Peter Wood and Karen Dalton. With an introduction by Richard Powell. Austin: University of Texas Press, 1988.

INDEX

Italicized page numbers refer to illustrations.

PHOTOGRAPHY CREDITS

Michael Bodycomb: inside front cover, pp. 25, 113, 115, 116, 117, 118 *(Nobody Has Pity on Me),* 120, 131 *(Wades in the Water),* 145, 150
Joseph Callahan, Concept Photography: p. 134 *(Wolf Plume)*
Gregory Engleberg: pp. 52 *(Congo),* 58, 67 *(Eric Walrond)*
Wayne David Geist: pp. 11, 42, 43 *(Zapatista Soldiers; Aztec Indian from Tepozotlan),* 76 *(Lazy Boy)*
James O. Milmoe: pp. 71, 126
Rolland White: cover, pp. 2, 3, 4, 8, 13, 14, 16, 22, 29, 31, 37, 38 *(H. V. Kaltenborn),* 40, 45, 47, 48, 49, 52 *(Alain Locke),* 53 *(The Librarian),* 55, 56, 59, 63, 64, 65 *(Mrs. Tabusa),* 66 *(Chinese Woman in Headdress),* 79 *(Heavy Shield),* 82, 85, 86 *(Veronica Smalls),* 94, 103, 106, 118 *(Tjark Reiss),* 122 *(Kiowa Indian mural),* 143, 146
Photograph courtesy of Shepherd Gallery Associates: p. 148
Photograph courtesy of C. M. Russell Museum: p. 1